Natural History Painting

with the Eden Project

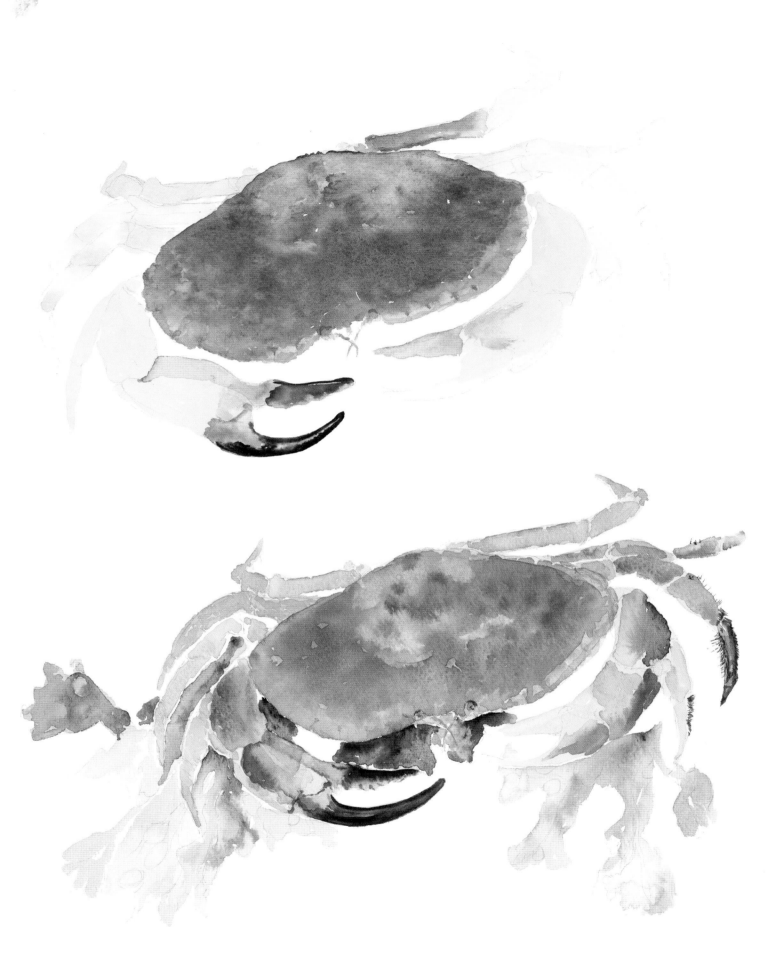

Natural History Painting

with the Eden Project

Rosie Martin & Meriel Thurstan

BATSFORD

Dedications

Rosie: For Ione, Jasper and my new granddaughter.

Meriel: For Ali and in memory of my father, Commander Ronald McClellan Powning Jonas, DSO, DSC, RN, who instilled in me a love of the natural world.

'It is through the limits of discipline that we can glimpse and take part in the harmony of the cosmos'.
The Power of Limits: Proportional Harmonies in Nature, Art and Architecture
Gyorgy Doczi

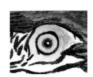

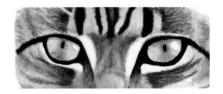

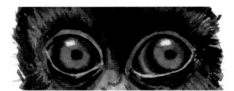

First published in the United Kingdom in 2009 by
Batsford
10 Southcombe Street
London W14 0RA

An imprint of Anova Books Company Ltd

Copyright © Batsford
Text © Rosie Martin and Meriel Thurstan
Illustrations © as credited on page 141

The moral right of the authors has been asserted.

ISBN-13: 9781906388492

A CIP catalogue record for this book is available from the British Library.

10 9 8 7 6 5 4 3 2 1

Reproduction by Mission Productions Ltd, Hong Kong
Printed and bound by Craft Print International Ltd, Singapore

This book can be ordered direct from the publisher at the website: www.anovabooks.com, or try your local bookshop.

Distributed in the United States and Canada by Sterling Publishing Co.,
387 Park Avenue South, New York, NY 10016, USA

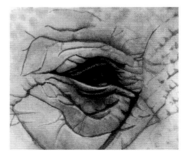

Above: The eyes have it – from top, blue tit, long-eared owl, mackerel, parrot, tabby cat, 10-month-old gorilla and elephant.

Opposite: This stylized portrait of a pelican shows every feather and wrinkle lovingly portrayed.

Previous page: By making quick watercolour sketches of a crab, the artist learns the subject, its shape, colours and tones.

Contents

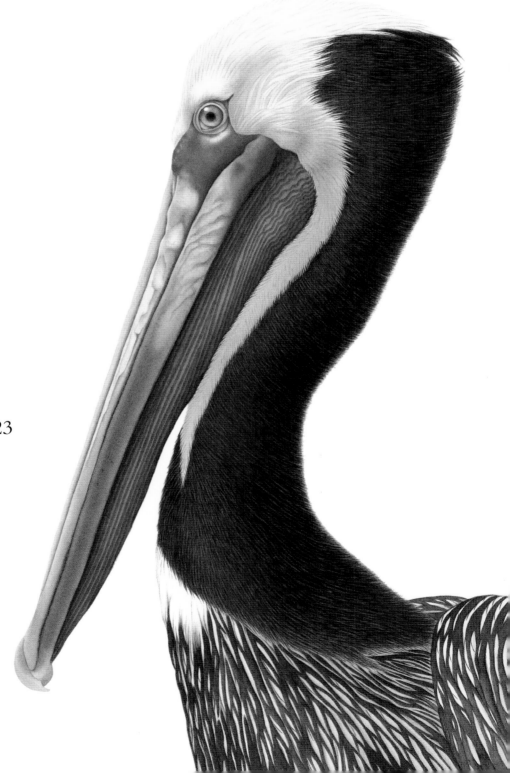

Foreword

You never know where drawing and painting the natural world may lead you, nor what you might quietly achieve or inspire. To learn to do it well is to explore life in a new dimension, which alters perceptions and enriches lives. If this sounds like hyperbole, consider the life of one of my great uncles, Uncle Ted.

Above: Edward A. Wilson painting in the hut at Cape Evans, 1911. He used to paint standing up, so as not to fall asleep at his desk.

Edward Adrian Wilson was born in Cheltenham in July 1872. By the age of four he was often drawing. His parents encouraged him and taught him to observe the natural world and draw exactly what he saw. With this inspiration he was soon exploring the countryside, becoming a self-taught naturalist and artist. He collected many pictures in his *Nature Notebooks*; the less good he learned from and threw away.

It was not until he went to Cambridge in 1891 that he first visited the art galleries of Europe, where he realized that even the great artists had had to learn their technique, practising with their paints and pencils until they became masters of their media. Artistic skill was learned, not inherited. Uncle Ted now developed a desire for art lessons that was never fulfilled; neither, alas, did he have books like this one; but he persevered, even when he became a medical student and moved to London. Here he contracted tuberculosis from his social work in the London slums. Despite his limited life prospects, he painted with a new passion throughout his recuperative trips to Norway and Switzerland. Although his illness nearly killed him, remarkably perhaps, he recovered.

At this point Uncle Ted decided that his artwork was unsatisfactory. Victorian wildlife art was based on detailed studies of dead specimens; he wanted to paint the life of the animal onto the page. So he went to the London Zoo to re-train himself, inadvertently putting himself at the forefront of wildlife painting. It was at the zoo that his talent was spotted and he found himself appointed to the British National Antarctic Expedition as Junior Surgeon, Vertebrate Zoologist and Artist. He went against medical advice but nevertheless achieved a record 'Farthest South' with Captain Scott and Ernest Shackleton in 1902. When the expedition returned, his accurate images of Antarctic landscapes and wildlife earned him many admirers.

Uncle Ted's passion for recording the natural world as accurately as possible had transformed his life. The Antarctic hero was now in demand as a wildlife illustrator. He also pioneered modern field ornithology as Field Observer to the Grouse Disease Inquiry and he started a campaign to save the penguin, lecturing against the practice of boiling penguins for their oil. When Captain Scott announced a new expedition to reach the South Pole it was, perhaps, inevitable that Uncle Ted would go with him again, this time as Chief of the Scientific Staff. Their story is well known. They reached the South Pole together on 17 January 1912 to find that the Norwegian, Roald Amundsen, had beaten them to it. They died with the rest of Scott's Polar party on the return journey. Uncle Ted's final sketchbooks were recovered by a search party, along with Scott's famous last diaries. In these, as he lay dying on the Great Ice

Barrier, Captain Scott had written the following words to his widow regarding their son, Peter: 'Make the boy interested in natural history if you can, it is better than games; they encourage it at some schools.' The words were inspired by the life and art of his friend, Edward Wilson, who lay dying by his side.

Yet how do you 'make' anyone interested in natural history? The answer lies in encouraging them to draw and paint the natural world around them. This in turn leads to wonder, which in turn leads to a profound love of nature and learning to care for it. So from a simple instruction from his father, the boy who would become Sir Peter Scott was placed on just such a path through encouragement, becoming in his turn a great naturalist and artist who inspired much of the 20th-century conservation movement, touching the lives of us all.

So, as I say, you never quite know where drawing and painting the natural world may lead you, nor what you might quietly achieve or inspire. It seems clear to me that if people (particularly the younger generation) are to be motivated to take care of the planet, the first step is to encourage them to observe and accurately draw and paint the natural things around them – and the rest takes care of itself.

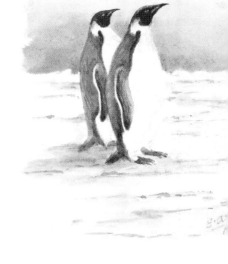

Above: Emperor penguins, 1904, by Edward A. Wilson.

Shockingly, today, learning the art of natural history drawing and painting is little easier than it was for Uncle Ted 100 years ago. It can be difficult to find a course locally, and there are currently few books on the market specifically covering natural history illustration. Art has become attached to mere imagination rather than to scientific observation and recording. Given all that it can achieve in people's lives, this seems to me to be rather a pity.

Below: Willow grouse, 1900, by Edward A. Wilson. This previously unpublished study was a favourite.

It is something of a relief, therefore, to be able to welcome this volume into print, from two experienced and popular natural history illustrators. Rosie Martin and Meriel Thurstan have already won awards for their practical approach to teaching botanical art in previous books and I have no doubt that they will do so again with this volume.

This is the sort of book that Uncle Ted would have greatly treasured, full of practical advice and techniques which are accessible to all. You will be able to work through it whether or not you are able to find a teacher and a class. Step by step, it will lead you along a path of endless fascination. This is an irreplaceable gift. So I commend this book to you – and to your friends – and to your friends' friends – and may the art of natural history become your transformation!

Dr David Wilson FZS
January 2009

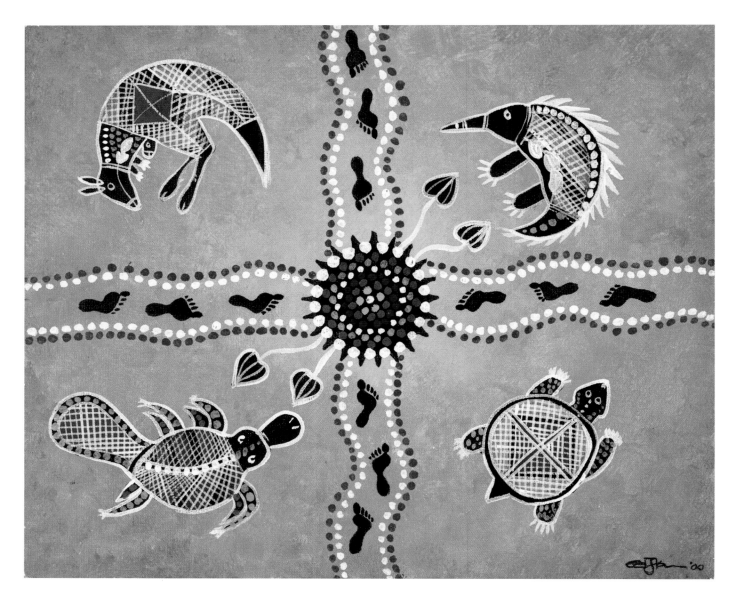

Above: Earth colours and an awareness of the surrounding natural life are demonstrated by this aborigine-style painting.

1. In the beginning

Throughout the ages there has always been a desire to record the world as we see it, using whatever means are at our disposal. In prehistoric times our ancestors used natural materials that came readily to hand. With the development of civilization came the invention of paper, canvas, paints – and eventually film and computers – enabling the implementation of this art form to become progressively more sophisticated.

Our Palaeolithic ancestors shared our need to explain the world around us, using earth pigments to decorate the walls of caves and rock shelters with pictures of themselves and the animals they hunted. It is quite possible that they decorated other surfaces too – bark, wood, their own bodies, or drawing pictures on the ground, like the Australian aborigines. Even today, the Australian aborigines have no written history, their myths and legends being passed down by word of mouth and by means of pictures, linking both the tribe's ancestors and the natural world, thus suggesting communion with both nature and the past. But bark and wood rot, body paint wears or washes off, soil weathers.

Fortunately for us, many rock paintings and engravings have survived and tell us much about early human life. For instance, the Painted Gallery at Lascaux, in France, has been likened to the Sistine Chapel, 'the pinnacle of Palaeolithic cave art'. The entire upper reaches of the walls of the gallery, as well as the surface overhead, are covered with wholly credible animal figures – aurochs (an extinct wild ox), horses, ibexes, stags, red cows, a great black bull and a bison.

Like us, artists of the time employed the best materials for the job in hand. For fine work they probably used brushes and stencils made of organic materials, such as wood, but we cannot be sure because none of these survive. The colours were earth pigments: ochre for yellow and orange; haematite for red; charcoal for black and grey; chalk for white. Some were applied direct to the walls, used like crayons. Others were ground up to make powdered paint.

These days we have the benefit of modern materials, a wide range of art papers, glorious paints and fine brushes. No longer do we need to grind our own pigments: manufacturers such as Winsor & Newton or Schmincke Horadam do it for us. But like our ancestors, we can make every colour we need from a limited palette.

There is nothing to stop us painting on unusual surfaces either. Indeed, many artists still use skins, in the form of vellum. We also have fine specialist papers from manufacturers such as Arches, Sennelier and Fabriano. We have full-bellied, fine-tipped brushes made of Kolinsky sable. We can use modern scientific equipment to enable us to study and understand our subject better.

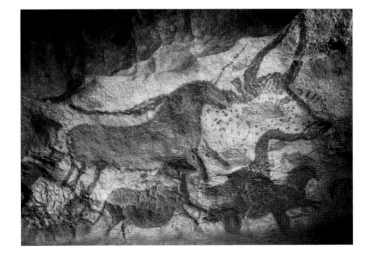

Above: The Painted Gallery at Lascaux has been likened to the Sistine Chapel and is the pinnacle of Palaeolithic cave art.

But despite all these modern aids, we still need to be able to see and be aware of the character of our subject in order to draw accurately. We need to be able to study it, to look at it from all angles and to interpret it so as to gain as much information as possible.

Imagine yourself living in the days when intrepid sailors were discovering new worlds and telling stories of the strange flora and fauna they had seen; and that one of these sailors is trying to describe to you the wonder and excitement of seeing his first elephant (or camel, or tiger) – when all you are familiar with is cows (or horses, or the domestic cat). How on earth would you begin to draw it?

Contemporary artists made a good attempt, but it is not the same as seeing the real thing. Herodotus and Pliny, as well as later chroniclers, told of the crocodile, 'a beast that weeps after eating a man'. While their descriptions were no doubt extremely good, artists of the time found it impossible to translate the words into paint realistically. As Sir David Attenborough said, when talking on BBC Radio 4 about the 2008 exhibition Amazing Rare Things at The Queen's Gallery, Buckingham Palace in London, 'It is impossible to make an accurate drawing of an animal unless you understand it, and how it moves'.

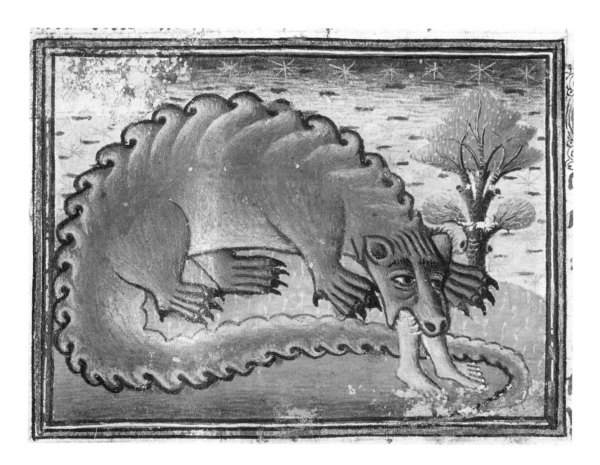

Above: This picture of a crocodile is from a medieval bestiary, and was obviously drawn by someone who had heard the tales but never seen the real thing.

At its highest level, therefore, familiarity with the common principles of growth and structure in nature is an integral part of natural history illustration proper. To record, at research level, the details of a natural history subject so that it can be used for historical, reference and identification purposes requires great skill and years of training and experience.

At less exalted heights, there is an increasing demand from people of all ages and ability to be able to record natural things realistically and competently, with a reasonable amount of detail but without becoming fanatical.

With the ever-changing conditions of the world, many species have already died out, and it is inevitable that other species of both flora and fauna will falter and eventually die too. If we can learn how to record these species before that happens, not only will it be a lasting record of something no one will ever see again, but, who knows, by concentrating on endangered species we might also play a small part in raising awareness sufficiently to halt the destruction of so much that is rare and wonderful on our planet.

The good thing is that there are so many ways now to understand nature and to pass on our knowledge. While not all of us can visit polar regions, most of us have zoos and wildlife parks within easy reach. Museums have comprehensive collections of birds, animals, insects, crystals and fossils. Countless television programmes take us vicariously into the jungle, to the desert, the North and South Pole, and even under the oceans.

In this book

In this book we endeavour to maintain the balance between finely detailed work and a standard of competence that is achievable by a non-specialist who nevertheless wishes to 'get it right'.

Of all the ways to record the world about us, ordinary graphite pencils, coloured pencils and watercolour paints are probably the most easily obtained and widely used, and are therefore mostly employed throughout this book. You will gain the confidence, licence and skill to observe your subject so as to portray it in the most pleasing and informative way, rendering a three-dimensional subject onto a two-dimensional surface.

You will learn how to set up your workplace, using light and shade to explain your subject; techniques in pencil drawing with line and tone; how to mix the colours you need and the best ways to apply them; how to portray iridescence as well as difficult texture and pattern. We will discuss the qualities of different papers, paints and brushes, sketchbook work for research and information, and some of the myriad ways of depicting your chosen subjects.

In the end you, too, like countless artists before you, will be able to explain visually the natural world around you in an accurate and wholly delightful way.

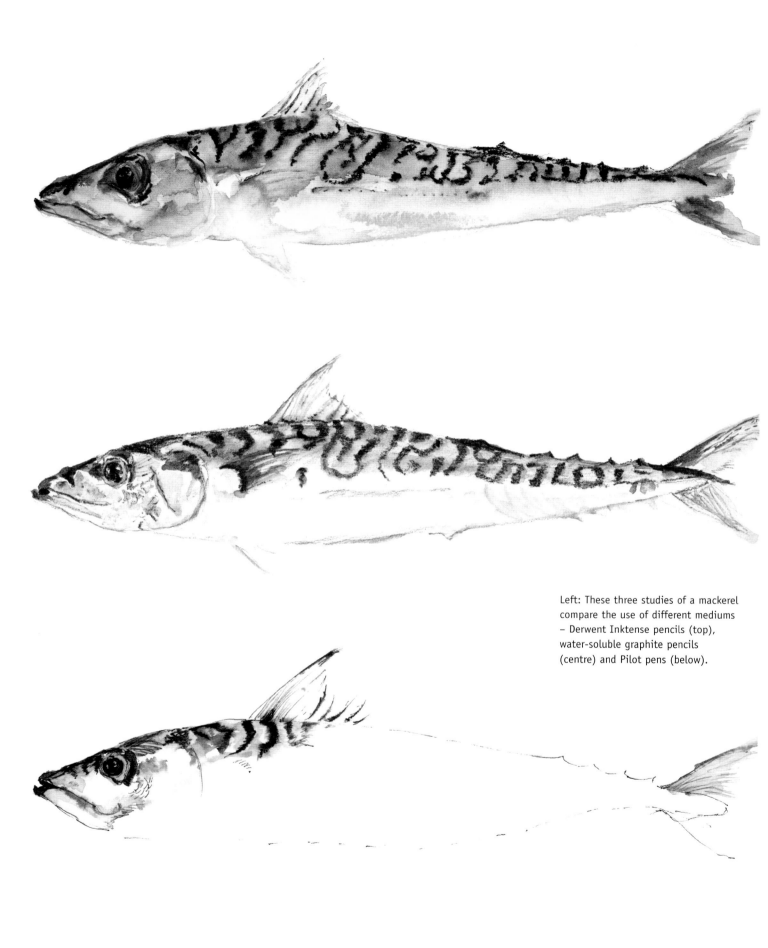

Left: These three studies of a mackerel
compare the use of different mediums
– Derwent Inktense pencils (top),
water-soluble graphite pencils
(centre) and Pilot pens (below).

2. Setting up

Before you even pick up a pencil, do give some thought to how and where you are going to work.

Wherever you paint, try to arrange things so that you do not need to clear everything away at the end of a painting session. You will find that you take a while to get into the mood each time you start to paint, and your mind will be clearer and more stable if you have a dedicated place to paint, with everything in its place and ready to use.

How you arrange your workplace depends on the medium you are going to use. For instance, if you plan to use acrylics or oils and paint on a large scale, you might be most comfortable standing at an upright easel. (It is worth emphasizing here that this book concentrates mainly on the use of water-based paints and coloured pencils. Oil paints need a very different technique.)

If, on the other hand, you intend to use watercolour, coloured pencils and graphite pencils, and to show your subject life-size and in detail, then you would do better to sit at a comfortable table in good light. Use a table easel or support your drawing board at a comfortable angle on books, a brick or block of wood.

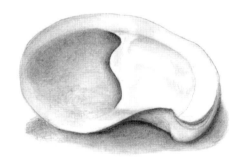

Your comfort is important and you should arrange things so that you sit as straight as possible, thus putting the minimum amount of strain on your spine. Sitting slumped at a table in a chair that is the wrong height will soon lead to aching muscles and stiff joints. For the sake of your back and your eyes, stand up and move around frequently. Fetching yourself a drink now and again is a good idea, as it makes you get up twice!

Right and below: Many shells are monochromatic, lending themselves to delicate pencil portraits.

Materials

Many students take the attitude that 'anything will do until I get good at it'. This is false economy. A workman is only as good as his tools – the old proverb was never truer. If you buy poor-quality materials, your work will never progress past a certain point and you will be limiting your true potential. Take courage, believe in yourself and buy the very best you can afford. We recommend only the best, whether it is paper, brushes, paint or any other material, as with these you will give yourself the greatest advantage. But where economies can be made without detriment we do suggest them, such as using a cheap white china plate in place of a ceramic palette, or a roll of corrugated paper in place of a custom-made brush case (see page 24).

Lay everything out in a way that allows the most economy of movement. Place your palette, together with your paintbox, in the most convenient position. Try different positions until you find the one that suits you. If you have them too far away, or on the 'wrong side' so that you are reaching across your work with a wet or paint-laden brush, there is a real danger of splashing your work and spoiling it.

If you are using coloured or graphite pencils, arrange them so that they are close by and in a familiar order, so that you can lay your hand on the one you need when you need it. It is most frustrating to have to rummage around to find a particular pencil in a forest of others when you are in the middle of some intricate work.

In between sessions it can be useful to stand your picture at eye level, perhaps just inside the door of a room that you frequently enter. This will enable you constantly to see it anew and any changes you might need to make will become apparent.

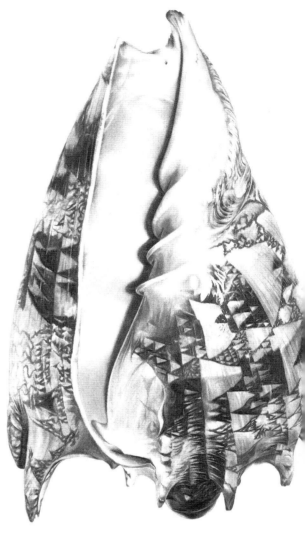

Above: This pencil drawing of a large shell ably demonstrates its extremely smooth and shiny texture as well as the intricate patterning. It benefited from an extremely good light source.

Light

As an artist you are essentially depicting the way that light falls on your chosen subject. Without light there would be nothing to see – no shapes, no colours, no shading, no shadows and therefore no indication of the three-dimensionality that gives life to your painting.

Make sure that both your paper and your subject are well lit. The light falling on your subject should be from the side, not full on or from the back, so as to accentuate the shapes and give good light/dark contrasts.

An example of this is the intricate pencil drawing of a large shell shown above. Judicious use of light falling on the subject accentuates the form of the shell as it curves round towards the inside. By clever use of shading and high contrast, the artist has imparted a highly pictorial finish to the drawing, as well as showing the intensely complex pattern by carefully grading the pencil tones.

Try to sit sideways to a window with a northern aspect (southern in the southern hemisphere). North light is more consistent than that from a south-facing window and tends to be blueish or neutral. If you work in artificial light, set up your worktable with a lamp fitted with a daylight bulb, which mimics north light.

Light both your subject and your worksheet, using two lamps if necessary. Position the light source (or yourself in relation to the window) so that your working hand does not cast a shadow – if you are right-handed, your light source should be from the left; if left-handed, it should be from the right.

Whether you show backgrounds and shadows is purely a matter of personal choice. Try placing your subject on a plain white ground. Observe any reflected light this may cause, and consider what effect it has on your picture. Objects in the background can cause confusion and distract the eye. Try pinning a sheet of white paper behind your specimen or prop up a white board to accentuate the outlines and make it easier to see them.

Sometimes it helps to mark the direction of your light source with an arrow on your preliminary drawings. Keep these to hand, perhaps pinned on the wall above your worktable, so that you can refer to them when working on the finished piece.

Paper

At this point, think about the type of paper, or support, you are using. If your style is loose and flowing, perhaps depicting your subject larger than life, it could be said that anything goes. Try using different coloured or textured paper with different mediums. It is up to you what you choose and how you use it, and some fantastic results can be achieved by varying colours and texture.

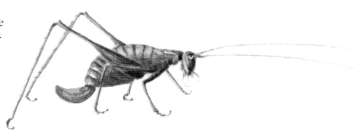

Above: For small, detailed work, like this cricket, you will need to use very smooth paper.

If you are going to show your subject in fine detail, then you need to think carefully about the materials you will use. The smoother the paper, the finer the detail you will achieve.

Paper is measured by weight in grams per square metre (gsm). For pencil work you can use a good quality, smooth, white cartridge paper (200gsm). Layout paper (approximately 45gsm) is inexpensive and provides a good smooth surface for experimental, swift, concise, general and detailed pencil work and is invaluable for preliminary drawings that can later be transferred to watercolour paper.

When you begin to paint you will need a heavier white paper, made of 100 per cent cotton. The ideal weight is 300gsm (also shown as 140lb), as this takes quite wet washes without the need for stretching beforehand. Stretching HP paper (see page 16) may result in a furring of the surface; this is not conducive to detail and it is therefore not recommended. Papers thicker than 300gsm are available. Look for acid-free paper, which is archivally preferred, more sympathetic to the paint and has a longer life.

Watercolour paper

Watercolour paper comes in a range of surfaces. The most suitable for this type of painting is hot pressed (HP), which is extremely smooth, making it easier for you to portray fine detail. It does not take kindly to lots of rubbing out, which roughs up the surface and alters the performance of the paint. This is where your layout pad comes into its own, as all changes and experiments can be done before transferring the image to your HP paper, either with a light box or traced (see also page 28).

Some artists use paper with a NOT surface (NOT means quite simply that it is not HP), although they may find it hard to produce fine details.

Paper is sold in bound pads, blocks and by the sheet. Papers from different countries vary in their measurements, but as a general rule most sheets of paper are about 56 x 76cm (22 x 30in) and many retailers offer a free service to cut the paper in halves or quarters if you ask.

You will find that most paper has a front and a back – usually the back is slightly rougher than the front. If you buy loose sheets of paper you can determine the front by looking for a watermark or manufacturer's embossing. Mark each sheet of paper lightly in one corner to indicate which surface is which, and experiment with painting on both to see which one suits you better.

Left: Hard, smooth paper such as hot pressed (HP) is needed for techniques like stippling.

Some papers are whiter than others. Some suppliers offer mixed packs of different makes of paper so that you can try all of them at minimal expense. Brands to look for are Arches Aquarelle, Fabriano Artistico, Fabriano 5 and Sennelier.

The smoothest paper of all is Bristol board, which is thick and stiff (115lb/250gsm), as its name would suggest. It is suitable for pencil, pen and ink, airbrush, light wash and coloured pencils.

Bristol board is useful for very dry watercolour work involving stippling rather than washes; or for pencil work, either graphite or coloured, where its intense smoothness works with you to give good coverage and extremely fine definition. It also allows quite a lot of erasing with minimal disturbance to the surface.

All watercolour papers absorb the oils in human skin, which even in tiny quantities can alter the performance of the paint. Mask your work by keeping a piece of paper under your hand at all times. Ideally it should be the same colour and texture as your picture, as it is then good for testing brushstrokes and paint colour. Or you could paint through a hole cut in the centre of a sheet of acetate, which allows you to see the whole picture at all times.

Pencils

It is important to consider the quality of pencils and how to use them. Different brands of graphite pencil have differing values, even though they are marked as the same strength. Generally speaking you will use a range in strengths from the very hard 6H to a medium soft HB.

Some of the illustrations in this book have been done using extremely soft (but very sharp) graphite pencils, 6B or even 8B; but take care with the Bs, the softer the pencil (i.e. the higher the B number), the more it is liable to smudge. To a certain extent you can counteract this by keeping a spare piece of paper under your hand at all times. If you use very soft pencils (2B upwards) you might try using a fixative, but be aware that this changes the nature of the drawing and it could be difficult to add further details after fixing. For this reason we do not recommend its use.

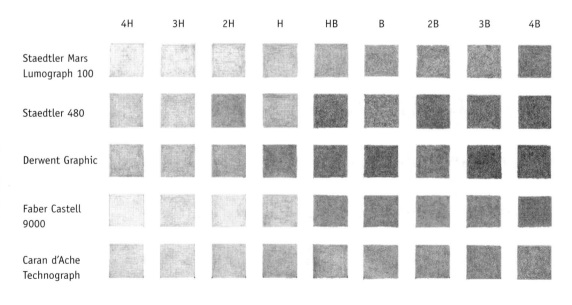

Left: A comparison between different makes of graphite pencil, showing the differences between hard pencils (4H to H) and softer pencils (HB to 4B).

The above chart shows the characteristics of five different brands of graphite pencils in a range from 4H to 4B. The same pressure was applied to all samples when making the chart, but you can see how the pencils vary. A 4H in one brand, for instance, has much the same tonal value as an H in another.

'A pencil is only as good as its point'

Keep your pencil sharp at all times – correctly sharpened, a pencil should have such a fine point that it hurts when pressed into a fingertip. A well-sharpened pencil can give more variety of line and offers a wider selection of marks and effects. A blunt pencil will lead to an indistinct drawing over which you have limited control.

Pencils can be sharpened in several ways. Electric or mechanical pencil sharpeners are probably the most sympathetic to the pencil lead but tend to 'eat up' the pencil and can therefore be rather wasteful. Many traditional artists prefer to use a sharp blade or craft knife, as this strengthens the wood in the process.

You might prefer to use a hand-held pencil sharpener, ideally one that collects the pencil shavings. If you use a hand-held sharpener, use it little and often and do not use excess force. This lessens the chance of the lead breaking. It goes without saying that the blade should be sharp.

Finally, refine the point of the pencil by holding it a few degrees off horizontal, rotating while rubbing gently on fine sandpaper or an emery board.

Some people prefer to use a mechanical or clutch pencil. The main benefit is that they always remain the same size in the hand and are therefore consistently balanced. The recommended size of lead is 0.3mm or 0.4mm, and leads are available in a range of strengths. Many specialist art or graphics shops or suppliers via the Internet should be able to provide them or be able to obtain them. The finest of these pencils give an even and fixed line but still need to be honed to give a fine point.

Pencil exercise – scales

You might like to do some research into scales, which are a good subject for pencil drawing. The drawings shown opposite contrast the scales of pangolin, plant and snake.

The pangolin is the only living mammal to have evolved scales, hence its common name, scaly anteater, although it is only distantly related to the anteater. When threatened, the animal rolls into a ball and is protected by its armour plating. The plant scales are from a fossil remnant of *Lycopodendron*, a group of tree-like plants that were common 300 million years ago and grew to a great size. They are known as scaly trees. The snake is a western diamondback rattlesnake from America, which has particularly tough scales with a pattern that both provides camouflage and warns off would-be aggressors.

If at all possible, draw from life, but if the subject does not allow for this it is permissible to use good-quality photographs. If you must work from a photograph as a reference, try altering its form or tonal values, having made every attempt to understand and correct the limitations of photography. Try heightening tonal contrast with stronger lights and darks.

A photograph can be very focused, with consistently hard edges. You could lose these edges entirely by blurring them with light layers of graphite. This is a way of emphasizing certain

Opposite: Scales (pangolin, plant and snake) are a good subject for drawing and demonstrate the range of tones achievable with graphite pencils.

areas that you consider to be more significant in the subject. In the case of a moving subject, such as a bird in flight, you might soften almost all the edges (see the drawings shown on page 127). This is closer to our normal visual experience and much better than the unnatural, intense focus of some photographic images.

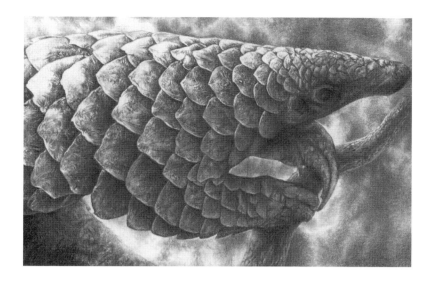

When working from life you will be able to create a more realistic level of contrast. You will find this easier if you have your subject strongly lit from a single direction, giving you the range of light to dark on which to work. A consistent artificial light source will allow more distinct edges than comparatively diffused window light. If you are working with graphite pencils, the colour of your light is immaterial, but make sure you remove secondary light sources and strong reflected light from nearby surfaces as this can create confusion.

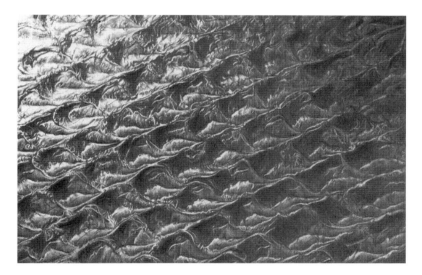

Begin with a very faint but accurate outline drawing, using a hard lead such as a 2H. When this is finished, begin rendering the tonal values. You could put down the darkest dark with a soft pencil such as a 6B, or you might prefer to leave such a strong and permanent statement to a later stage of the drawing. Be careful about applying a lot of graphite in very dark areas. This is acceptable if the drawing is to be scanned and reproduced. On display it causes an undesirable shine, which many artists prefer to avoid by putting on less graphite. The majority of the drawing will be done with a 2B pencil sharpened to a fine point with smooth grade sandpaper.

In certain areas (such as for soft edges) try manipulating the graphite using a cotton bud or a paper-blending stump. This can give a rather bland appearance and you may find that you have to add more pencil over the top to counteract it. A putty rubber shaped to a point is a useful drawing tool, using it to press into dark areas to lift out the graphite in an interesting manner.

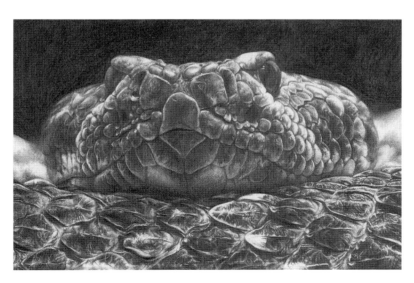

Practise, experiment and make trial pages to see how many ways you can devise to produce textures, layers and ways of handling your pencils.

Paints

Although you will potentially be using every shade of every colour throughout the whole colour spectrum in your finished paintings, there are only six that you really need. Buying every colour available will not make you a better painter, whereas learning to mix colours efficiently may.

Essential for the artist are a warm and a cool yellow, a warm and a cool red, and a warm and a cool blue. In this chapter we give four examples of each warm and cool primary. You need only one from each list: for example, Indian yellow (warm) and lemon yellow (cool); French ultramarine (warm) and Prussian blue (cool); scarlet lake (warm) and alizarin crimson (cool). (See Chapter 5, A world of colour, for more on warm and cool colours.)

Whether you use pans, half pans or tubes is entirely up to you. Pans and half pans are easy to store and use. They can be replenished from tubes, or you can squeeze paint from the tube directly onto your palette. If you use tubes, don't waste the paint you don't use – allow it to dry out and you can reconstitute it with water again and again.

Paints are expensive regardless of what shape and form they come in. Always buy artists' quality paints even though they are more expensive than the student range. Your work will benefit from their finer quality. Even though you might be tempted to buy the cheaper ranges, you should be aware that this is a false economy as you will soon become dissatisfied and replace them with artists' quality paints.

It is a good idea to buy an empty paintbox and fill it with your own choice of paints. Although we recommend a limited palette for beginners, we mention more colours than just the primaries. As you progress you will probably want to add your own favourite colours, so make sure that the box is large enough to take extra paints in the future. You will find that similar colours produced by different manufacturers often have different qualities.

Recommended watercolour paints are produced by Schmincke Horadam (SH) or Winsor & Newton (W&N). European paints are generally considered to be brighter than Winsor & Newton, a British manufacturer attuned to the British palette and British light. It is a matter of personal preference which you use. As well as the two makes mentioned, the authors also use Old Holland Classic, Holbein and Sennelier. If you choose to use paints from other manufacturers, refer to their colour charts to find the most suitable colours.

The colour examples illustrated opposite are shown full strength and watered down.

You may also wish to have some white paint to add fine details to finish off a painting, in which case we suggest you invest in a small tube of white gouache or titanium white watercolour paint.

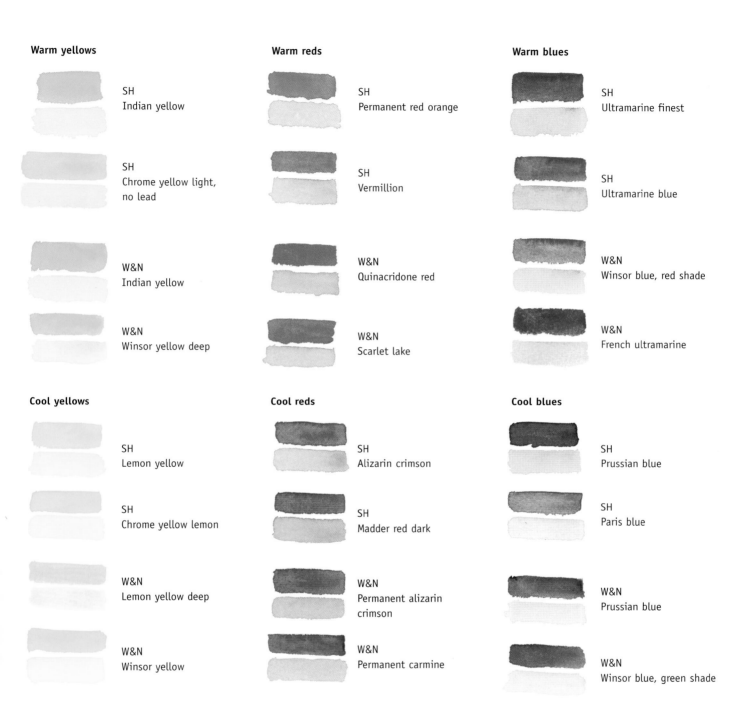

Warm yellows

SH
Indian yellow

SH
Chrome yellow light,
no lead

W&N
Indian yellow

W&N
Winsor yellow deep

Cool yellows

SH
Lemon yellow

SH
Chrome yellow lemon

W&N
Lemon yellow deep

W&N
Winsor yellow

Warm reds

SH
Permanent red orange

SH
Vermillion

W&N
Quinacridone red

W&N
Scarlet lake

Cool reds

SH
Alizarin crimson

SH
Madder red dark

W&N
Permanent alizarin
crimson

W&N
Permanent carmine

Warm blues

SH
Ultramarine finest

SH
Ultramarine blue

W&N
Winsor blue, red shade

W&N
French ultramarine

Cool blues

SH
Prussian blue

SH
Paris blue

W&N
Prussian blue

W&N
Winsor blue, green shade

Make a map of your paintbox, because it is not always easy to tell the precise colour of a particular paint from looking at a pan or tube. Cut a piece of watercolour paper to fit inside the lid and rule squares to represent the position of your paints. Colour these, label with the name of the paint and cover with transparent, waterproof material such as the corner of a plastic folder or a sheet of kitchen film. Don't forget to update it when you add new colours. This will be a unique and valuable instant colour reference.

Above: The basic paints needed in your paintbox are these warm and cool primary colours. They are shown here at full strength and watered down. Choose just one from each list.

Coloured pencils and their uses

There is a growing interest in the use of coloured pencils. Although the majority of this book deals with watercolour, you might like to experiment with coloured pencils. Specialist publications are available, and organizations such the UK Coloured Pencil Society or the Colored Pencil Society of America can be extremely helpful.

Left and below: Try out your coloured pencils on a worksheet, using different strokes and shading before applying them to your picture. On the left is the worksheet for the quartz crystal shown on page 74.

It goes without saying that, as with watercolours, you need good-quality products to achieve a good result. An inexpensive set of children's coloured pencils may be easy on your purse, but it will not give you satisfactory drawings. Brands differ in their strength, some being really quite soft. This can make hard, crisp edges difficult to achieve, so try different brands and see which are best suited to your particular style and subject.

Most of the top artists' ranges have a very wide selection of colours available, which can make buying a complete set very expensive. If you choose a brand that is available to buy singly, not only can you replace colours easily but you can also gradually increase your palette. Remember, however, that it is possible (as with watercolours) to make many colours by mixing different ones together, so a basic set of 24 or 36 pencils should provide everything you need to begin with.

You may also like to experiment with water-soluble coloured pencils, which are widely available but have been little used in this book. Where they have been used, they have generally been treated as a dry medium, using no water with them.

Coloured pencil techniques

When choosing coloured pencils, look for their ability to draw a fine line and to be burnished, indented and lifted. Burnishing is done with a burnisher or pale pencil such as white or champagne-coloured, pushing the pigment into the paper and filling in the tooth (the slight roughness of the paper).

Blending is when two or more colours are laid one over another. They may then be burnished if required. See the blue agate, on page 75, for more on blending and the use of coloured pencils generally.

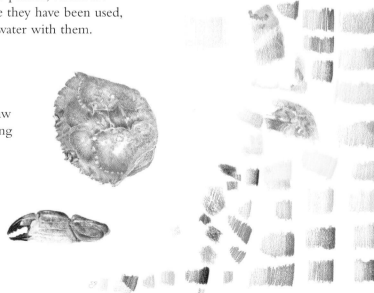

To achieve a highlight, either leave the white of the paper and work round it, or lift the colour off carefully with a scalpel, scraping or picking it out where required. This needs some skill and it is worth practising on scrap paper first.

For lowlights and dull shine, first rub out the colour using an eraser (sharpened into a point if necessary) and then apply white pencil.

 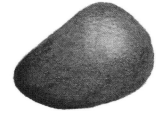 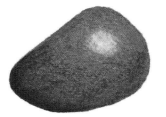

Left: A pebble worked in coloured pencils showing, from left, unhighlighted, erased lowlight and scalpel-picked highlight.

It is also possible to lift off small areas of colour, such as the vein on a leaf, with a small piece of low-adhesive masking tape. But be warned – this needs extreme care and patience. First of all, remove most of the adhesive quality of the tape by pressing it onto the back of your hand or wrist and then peel off. Do this several times until there is very little adhesion left. Place it lightly over the area to be lifted off and draw onto it with a well-sharpened pencil. Don't press too much; you don't want to score the paper underneath. When you lift off the masking tape, the colour should lift off too. You can do this several times with the same piece of masking tape until you have achieved the result you desire. Again, practise this technique before using it on your picture.

Erasing around coloured pencil work can be tricky, especially if you want to erase your original graphite drawing without disturbing the colours. Erasing shields are available from art and graphics suppliers. They are made of very fine metal with cutout shapes of various sizes. Carefully lay the shield over your work to protect the bit you don't want to erase. Alternatively, one solution might be to do your original drawing in colour.

Left: It is easy to show small dots or fine lines if you indent the paper first with a blunt pointed instrument. The coloured pencil will then skim over the surface, leaving them untouched.

If you have a subject that is covered in tiny white or light-coloured spots or fine pale lines, indent these first by pressing lightly on the paper with a blunt pointed instrument (such as a spent ballpoint pen or knitting needle) so that when you apply the coloured pencil it will skim over the surface, leaving the spots or lines untouched. If you wish, you may then fill them in with a very fine coloured pencil.

The type of paper to use with coloured pencils is a matter of personal choice, but most artists in this medium would agree that to achieve fine detail it is important to use a smooth, firm paper such as heavyweight cartridge paper or HP watercolour paper. Although smooth, the paper should have a fine tooth to it to catch the pigment as it comes away from the pencil. Look for acid-free paper with a clean, white, strong surface for repeated working and erasing.

Some artists use coloured pencil in conjunction with watercolour, either shading the work first then applying watercolour washes on top, or using the pencils to add fine detail at the end. Others use the coloured pencils on their own, with no further painting. Like so much of this type of illustration, you will need to try it out to see which method you prefer.

Brushes

The perfect brush for detailed work is full-bellied with a fine point. The best and most expensive brushes are made of sable, and of these the crème de la crème are Kolinsky sable. To begin with you will need a minimum of three brushes, sizes 1, 3 and 6 – so treat yourself to the best you can afford. Winsor & Newton Series 7 are a good make, as are Da Vinci Maestro, Raphaël, Isabey and Escoda. In time you may need smaller brushes for detailed work, such as 3/0 or 4/0.

You will also need a fairly large, cheap synthetic brush (size 6–8), which you will use primarily for mixing paint.

Compare prices from mail-order companies with those of your local art shop. There is often quite a difference.

It pays to look after your brushes carefully:
• Never leave your brush standing in the water pot. Rinse carefully and dry it before putting away.
• When not in use, keep your brushes wrapped or in a wallet or container that protects the points. A sheet of corrugated paper, rolled and secured with a rubber band, is a cheap method of keeping your brushes safe.
• If the brush becomes damaged, gently work some soft soap into the hairs, mould to the correct shape and leave to dry. Rinse thoroughly before use.
• Try to keep your good brushes for watercolour only, as other materials can damage them or shorten their life.
• After using white paint, wash the brush well in warm soapy water, rinse and dry.

Other studio equipment

You will need a method of keeping your specimen in the correct position. Different specimens have different needs, so be inventive. Whatever you do, don't fall into the trap of holding it in your spare hand, as this can distort your viewpoint. Try weighting a small bottle with sand, cut the top off a plastic milk bottle, use crumpled wire netting or the flower-arranger's friend, Oasis floral foam. Or drill a hole in a cork, use a bulldog clip, or buy a model-maker's third arm, a contraption of swivelling and extending arms and clips.

Masking tape is good for all sorts of uses, from securing your paper to the board to positioning your specimen.

A pair of **dividers** with very fine points is a good tool for making accurate measurements and transferring them to the paper. Art and graphics dealers can usually supply them even if they are not held in stock. It helps if you can train yourself to use them in your non-painting hand, manipulating them rather like chopsticks, so that you are not forever changing from brush to dividers and back again.

A **magnifying glass** is essential for detailed work. Different types of magnifying glass include hand-held, a binocular magnifier that clips onto spectacles, a headband magnifier with a choice of magnification, a free-standing goose neck magnifier and a magnifying desk lamp that clamps to your worktable and has the advantage of a built-in lamp with daylight bulb. These are available from opticians or mail-order miniaturists' suppliers. One of our students even wears a second pair of reading glasses over her normal pair. It would be wise to check with your optician before doing this.

A **pencil sharpener** or sharp knife (see page 18).

An **eraser**, either putty or hard white such as Staedtler or Faber Castell, is essential. Extremely detailed rubbing out can be achieved by cutting a slice of hard white eraser into a fine point.

To get rid of eraser sweepings, use a **feather** (such as the wing feather of a goose or seagull) stuck into a cork. This avoids touching the paper with your hands. Wash the feather first in a solution of detergent, rinse and dry thoroughly before use.

Use two **water containers**, one to wash your brush in and the other for mixing paint. Change the water often, so as not to contaminate your colours.

A white **palette**, preferably china not plastic, or a large, plain white china dinner plate is a useful surface for mixing paints.

There are some instances when **masking fluid** can be useful, particularly if you wish to blank out small areas before applying a wash, as with the guinea fowl feathers, shown right, but it can be difficult to use accurately. The masking fluid is applied to dry paper and allowed to dry completely before painting over it. When the paint is dry, remove the masking fluid gently with a hard eraser. Exposed areas can then be touched up with a fine brush. Practise on a scrap of paper first, as masking fluid often has its own ideas.

Note: do not use a precious brush for masking fluid because it will be no good for anything else afterwards. Keep a cheap, fine-tipped brush especially for the purpose and wash it immediately after use with soap and warm water, then rinse well. Or you could use a fine-nibbed pen, a sharpened quill or even a clean, sharpened twig.

These are just some guidelines as to what you need to start off as a natural history painter. Inevitably, as you become more experienced, you will find your own favourite materials and ways of doing things.

Above: It would have been very difficult to paint the fine lines of these guineafowl feathers accurately without first blanking out the spotted areas with masking fluid.

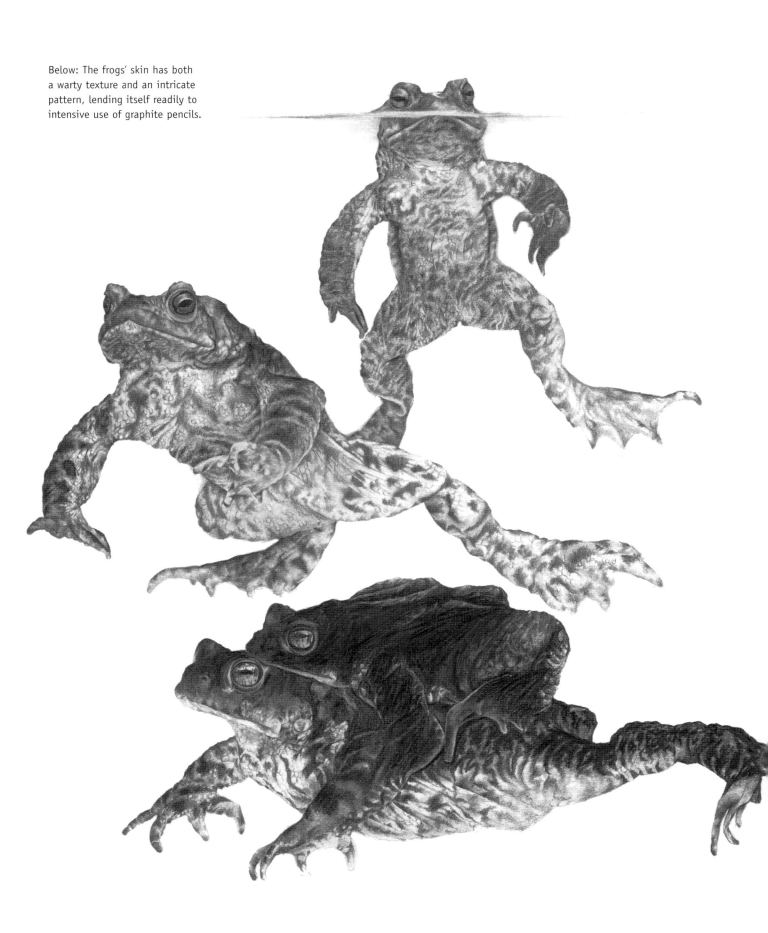

Below: The frogs' skin has both a warty texture and an intricate pattern, lending itself readily to intensive use of graphite pencils.

3. Drawing

Drawing and painting may be likened to walking and running – try to master the former before attempting the latter! The discipline and observational attention needed while drawing are also important to painting. Both disciplines require understanding, dexterity and skill, and can complement one another.

Good, well-rounded observational techniques are essential for recording the natural world successfully, whether you are using the humble pencil or more complex mediums such as paint, pastels or coloured pencils.

Understanding the underlying structure of things will give you more chance of your finished work looking realistic. Remember that what you see on the surface is underpinned by a specific structure. Find out as much about this structure as possible before starting a drawing. Have a look in your local library for books that can assist you in this understanding, or use the internet for visual information.

Drawing procedures are many and varied. For our purposes it is a matter of summing up the basic shapes, plotting the course of the drawing and carrying on from the beginning to the end through all the intermediate stages. What we are trying to do is produce an accurate and efficient representational image of the subject.

Write a list of adjectives that describe your subject. This can help you to understand its individual character. Is it hard, soft, shiny, matt, textured, smooth, patterned, dull, sharp, glassy, glossy, hairy, brittle, delicate, heavy, light, fluffy, furry? The list goes on and on.

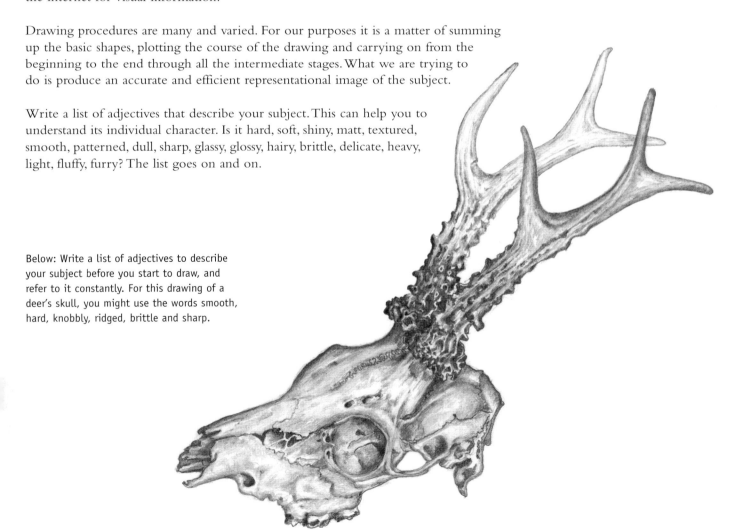

Below: Write a list of adjectives to describe your subject before you start to draw, and refer to it constantly. For this drawing of a deer's skull, you might use the words smooth, hard, knobbly, ridged, brittle and sharp.

Sum up the subject and do some preliminary drawings. If your subject is small, try enlarging it in order to get in more detail. This will have the benefit of making you look at it more closely. Always make a note of how much you have enlarged the subject, showing on the page 'x2' (twice as large), 'x3' (three times as large) and so on. See the seaweed exercise on page 66 for a good example of this.

Layout paper is essential for preliminary drawings. Look at the overall shape, the space that the object or objects occupy on the page. Break the subject down into any basic geometric shapes and angles.

The drawings on these pages show ways to help you understand and plan your subject. See if you can find any shapes into which parts or the whole of the subject fit. There may be cones, spheres, cylinders, hemispheres, squares, circles, ellipses or rectangles. You can mark strategic points and observe distances from point to point. Check angles. Is something on the vertical, horizontal, diagonal or angled to one side or the other?

When you are satisfied that your basic shapes and structures are in place, assess the relationship of one part to another, then to the whole. At this stage keep it simple; don't even think about putting in any detail. Look at the distance from one point to another, the overall length and width, thicknesses, where markings and patterns begin or end, and their direction.

If you rush it and draw without thought, feeling and understanding, then your picture simply won't work. By looking carefully you can plan and execute a competent drawing with a basic step-by-step approach. If you use this method of construction each time you begin a new subject, your draughtsmanship (and confidence) will improve.

When you have put down as much information as you need, refine and shade your drawing to a desired level to remind you where to add colour with paint or coloured pencils. The advantage of preliminary drawing on a separate piece of paper is that you can correct any mistakes beforehand, without spoiling your watercolour paper. Many watercolour papers do not take kindly to a lot of erasing, so carefully transfer the drawing to your paper by using a light box; or trace through a sheet of graphite carbon paper; or fix your layout paper or initial drawing to a windowpane with masking tape, stick your watercolour paper on top and trace the under-image lightly, using a fairly hard pencil (2H) but not pressing hard.

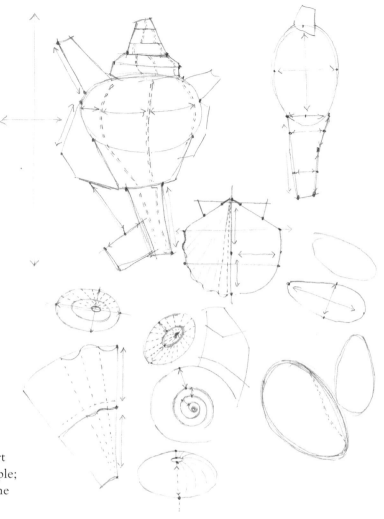

Above: Look at the overall shape of an object and the space it occupies on the page. Break it down into different geometric shapes. Mark strategic points and observe distances and angles between them.

Do not skip pencil work in order to rush on to paint. Pencil work is effective, informative and builds confidence. You only have to refer back to the quantity of drawings and preliminary sketches by old masters and artists through the ages to see that time spent exploring and evaluating your subject is never time wasted. There are many skills to be learned before moving into paint.

By doing rough drawings you will also begin to understand about placing your subject on a page, its composition and arrangement. You will become familiar with what does or does not work well on the page, and also with what you like or dislike, and why.

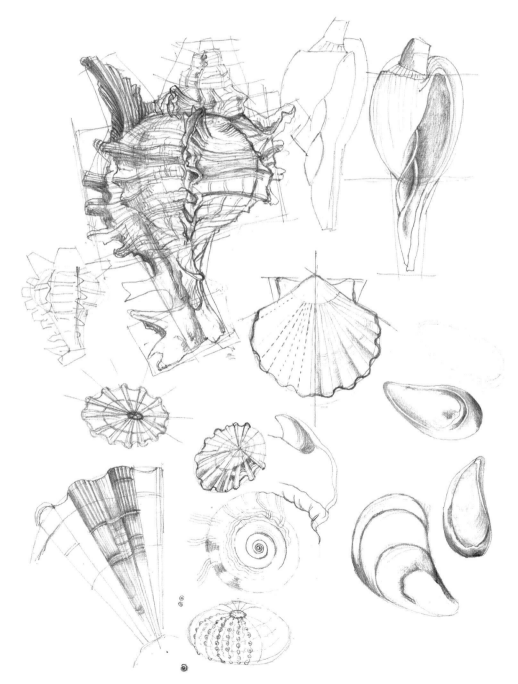

Left: When your basic shapes and structures are in place, elaborate, refine and shade your drawing.

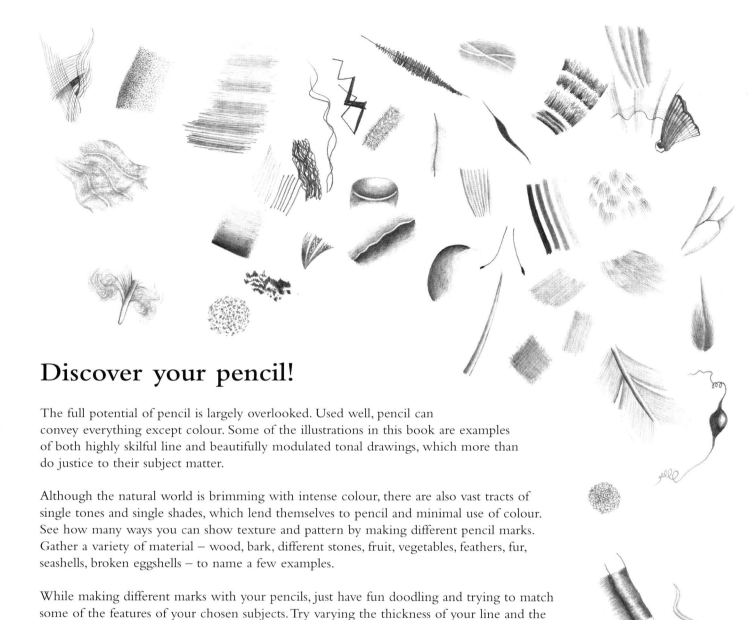

Discover your pencil!

The full potential of pencil is largely overlooked. Used well, pencil can convey everything except colour. Some of the illustrations in this book are examples of both highly skilful line and beautifully modulated tonal drawings, which more than do justice to their subject matter.

Although the natural world is brimming with intense colour, there are also vast tracts of single tones and single shades, which lend themselves to pencil and minimal use of colour. See how many ways you can show texture and pattern by making different pencil marks. Gather a variety of material – wood, bark, different stones, fruit, vegetables, feathers, fur, seashells, broken eggshells – to name a few examples.

While making different marks with your pencils, just have fun doodling and trying to match some of the features of your chosen subjects. Try varying the thickness of your line and the strength of tone. Don't worry about making mistakes; they are the best teachers. Try again, and again. The more you experiment, the more becomes possible.

Before attempting to move into colour, spend time getting to know shapes, texture, pattern, tonal variation, changes and distribution. The art of looking should never be underestimated. In our busy lives there is often little time just to contemplate the elements that make up our world. How often do we give time to studying closely, say, one single seashell? What shape is it? Is it smooth or textured? What are its markings like? Is it dark or light in colour?

Or how many times do we notice the difference between the birds that fly around us every day – their plumage, size, colours, shapes, songs, flight patterns and so on?

To begin painting the natural world it is necessary to spend a little time observing it. The more you look the more you will notice that there is method and reason behind all things.

Above: Try making different marks with your pencils, doodling or matching some of the features of your chosen subject.

Exercise – tonal strip

This tonal strip exercise will help to increase awareness of how many tones, or shades, exist within a subject. It is a good idea to make a tonal strip for every pencil you use, from 4H through to 6B or even softer. It will help you to understand the capabilities of your tools and where and how to apply tones.

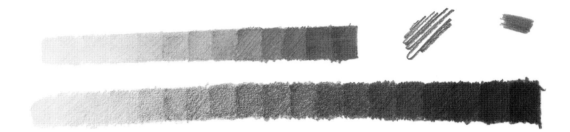

Left: See how many tones you can get from a single pencil. The two tonal strips on the left were made with a 2H (top) and a B (bottom).

Try experimenting with different ways of shading, as shown right. See how the pencil strokes affect the type of tones you produce and also the tonal transition.

1 Non-directional shading is the most useful for natural history illustration. It gives a smooth, even transition from light to dark without heavy lines and is good for a three-dimensional effect. It is good for building form and provides an even coverage of tone. The movement of your hand should follow a small, circular, burnishing motion, which helps to smooth the shading. Start very light, getting gradually darker. Try to show clear differences from one tone to the next. When you get to the mid-tones, this can initially be tricky; separating the mid-tones takes more practice.
2 Hatching is most used for general sketching.
3 Cross-hatching is also for general sketching.
4 Stippling, sometimes called pointillism, is a mass of small dots laid side by side and on top of each other, either in pencil or fine pen. The intensity of tone is built up with increased coverage.
5 Vertical fine-line stippling is similar to 4, above, but uses fine strokes rather than dots. It is difficult to achieve smooth tonal gradation as the edges show and this tends to cancel out the three-dimensional effect.
6 Horizontal fine-line stippling is similar to 5, above. It is not good for smooth tonal gradation as the individual lines and edges can be misleading. It also tends to cancel out the three-dimensional effect.

Mastering the art of subtle tonal change is more to do with a state of mind, not talent. Slow down and work carefully and deliberately. You will find that the simple act of slowing down can greatly improve your capabilities.

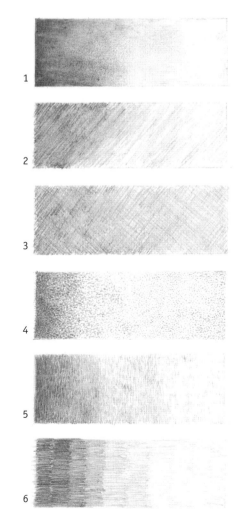

Drawing bones

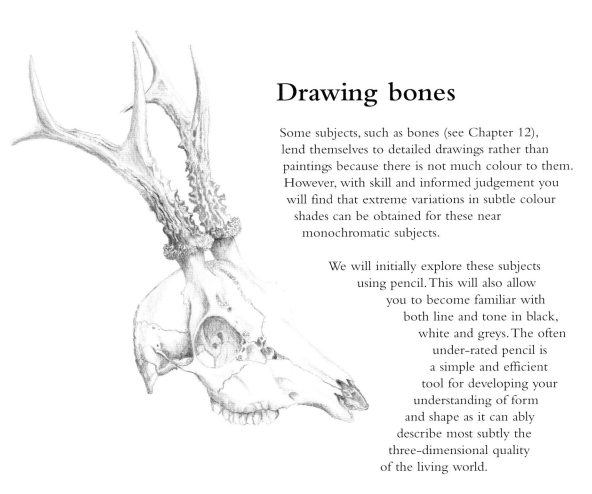

Some subjects, such as bones (see Chapter 12), lend themselves to detailed drawings rather than paintings because there is not much colour to them. However, with skill and informed judgement you will find that extreme variations in subtle colour shades can be obtained for these near monochromatic subjects.

We will initially explore these subjects using pencil. This will also allow you to become familiar with both line and tone in black, white and greys. The often under-rated pencil is a simple and efficient tool for developing your understanding of form and shape as it can ably describe most subtly the three-dimensional quality of the living world.

Left: Bones are often monochromatic, and thus lend themselves to detailed drawings.

Arsinoitherium zitteli was a large mammal that looked similar to a rhinoceros but in fact it was more closely related to elephants and manatees. It lived in Egypt 35 million years ago and is now one of the prize exhibits of the Natural History Museum in London. A fine pencil drawing, such as the one shown below, tells us a lot about this extraordinary creature.

There are many tones used in this drawing. They subtly display the three-dimensionality of the skeletal structure. The heightened contrast gives the drawing a feeling of drama and tension, and lends the subject a strong sense of prehistory.

To do intricate pencil drawings like the ones in this section, you will need some smooth, hard paper and a range of pencils from 6H (hard) to HB or even 6B (soft) or 8B (very soft). (See page 17.)

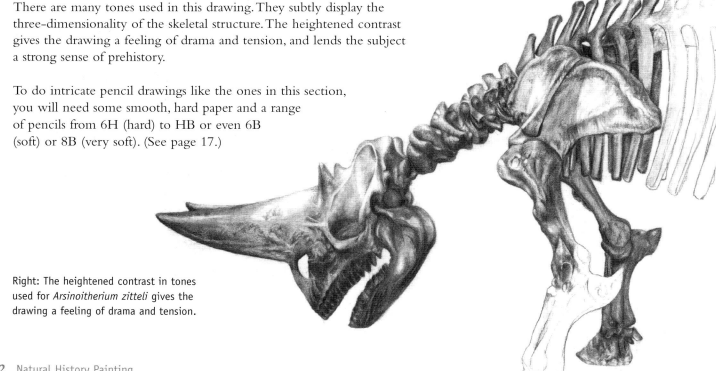

Right: The heightened contrast in tones used for *Arsinoitherium zitteli* gives the drawing a feeling of drama and tension.

Drawing texture

You will find many examples of how to tackle texture and pattern in Chapter 7, but here is one example of each using graphite pencils. Note the wide range of tones that can be achieved with two very complex subjects. Both pictures were done on very smooth paper.

The first, concentrating on texture, is the illustration of an unidentified large snake's skull (right), possibly that of a python. This is no museum piece, but was found in a dilapidated state in a garden in China, in many pieces, and was glued together and brought home as a memento by a friend of the artist. Notice how it is the texture of the surface of the skull bones that forms the pattern. The skull is covered with tiny lumps of different sizes that create whorls, borders and lines radiating from core points.

You will need a range of pencils, such as 4H, 2H and HB, giving a range of tones from very light to very dark. As in this example, you might finally like to apply a very small amount of colour on top of the graphite drawing using yellow, brown and grey coloured pencils.

Drawing pattern

Notice how the skin of the frogs shown on page 26, depicted in a fine pencil drawing, has both a warty texture and a distinct, intricate pattern. Unlike the snake's skull, the two things are not connected in any way – the pattern does not affect the texture, nor does the texture determine the pattern.

Your pencil drawing needs gradually to build up tonal contrast, giving the frogs' skin a complex and lively appearance. Even though the skin has a surface pattern, the rich textural shading gives depth and dimension, adding something more to the existing two-dimensional surface.

You could, if you wish, put a wash of colour over the top of the finished drawing, but it is really not necessary.

Right: Notice how the snake's skull is patterned with tiny lumps that form whorls and radiating lines.

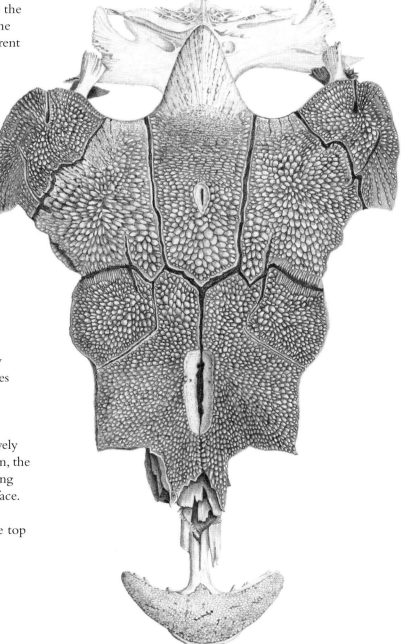

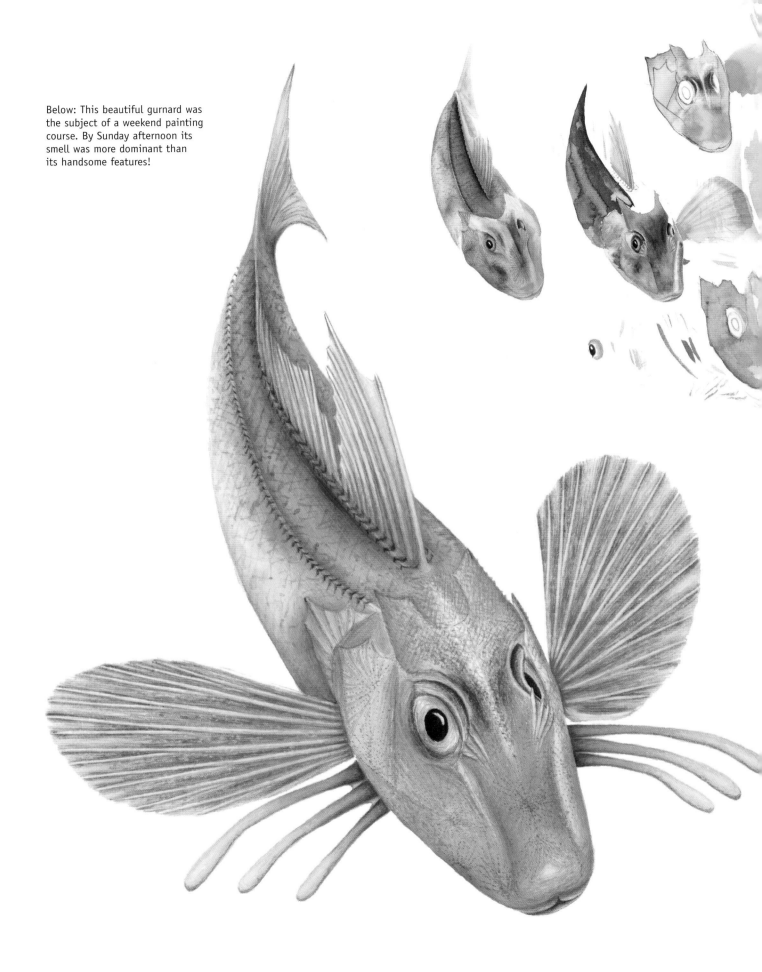

Below: This beautiful gurnard was the subject of a weekend painting course. By Sunday afternoon its smell was more dominant than its handsome features!

4. Sketchbook

Start a sketchbook and keep visual and written notes. To begin with, you will probably find it easier to use subjects that don't move. You might pick up items on a walk, or see them by the roadside – a dead insect, a decorative seed head, an empty crab shell, a feather, an abandoned bird's nest.

Be aware that some of your subject matter may get quite whiffy! A weekend class featuring crabs or Bernard the Gurnard (shown here), or even some species of fungi, could by the end of a hot Sunday afternoon turn even the stoutest of stomachs.

In order to build up confidence, you might try making quick drawings of pets or wild birds or animals. A lot of observation is needed, plus the ability to get lines onto the paper with speed and accuracy. See also the notes on drawing dragonflies on page 90.

Take a sketchbook with you when out walking, when on holiday or whenever you travel. A few swift lines might be all it takes to remind you of what you saw, and be the inspiration for further drawing at a later date. Some sketches can be so colourful that they are pictures in their own right.

Keep your sketching equipment down to a minimum – a small sketchbook, pencil, pencil sharpener, eraser, paintbrush and a small box of watercolour paints or some coloured pencils. Coloured pencils are a very convenient way of transporting a colour medium around when out sketching. They are capable of producing highly detailed drawings and many people find them more natural to use than a paintbrush – and you don't have to wait for them to dry, as you would with paint. Half-a-dozen pencils are capable of producing colour reference notes in the field that can be invaluable when you are back in the studio.

Above: Sketchbook work and trial pages are vital, especially for subjects that will quickly deteriorate.

Right: Creatures that are constantly moving demand lightning sketches with the minimum of detail.

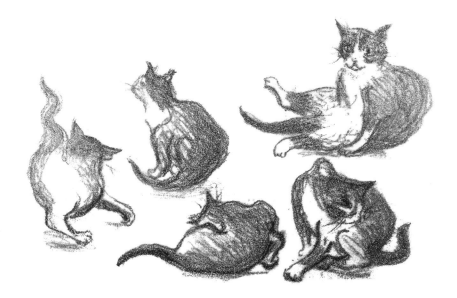

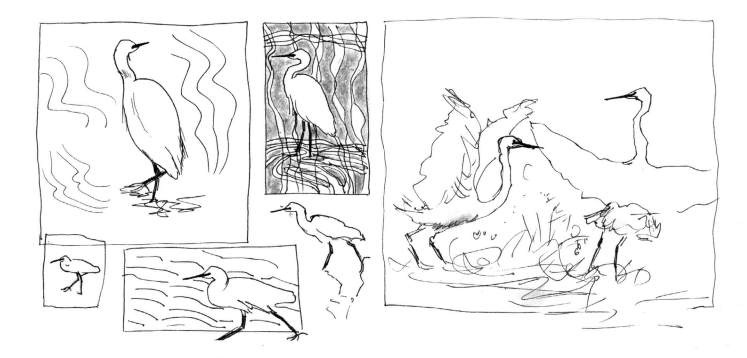

The usefulness of a sketchbook cannot be overstated. Your sketchbook will build confidence and greatly enhance your powers of observation. It can give you ideas about the suitability of different techniques for different subjects. You can also look back over previous pages and note how your skills have developed.

The small sketch below, of lapwings in a winter field, was made very quickly from memory after a winter walk. The artist was trying to extract the elemental characteristics of a flight of lapwings – their bold, dark bottle-green and black-and-white plumage almost flickering on and off as they flapped through the sunlight and shadows of a wintry afternoon: 'I have tried working something more substantial from this idea by projecting an image of the thumbnail idea onto a huge wall and then drawing from that to see what emerges. So far there is no positive conclusion!'

Above: Your sketchbook will be an invaluable reference, building confidence and enhancing your powers of observation.

Left: The elemental characteristics of a flight of lapwings in a winter field were quickly captured in this thumbnail sketch.

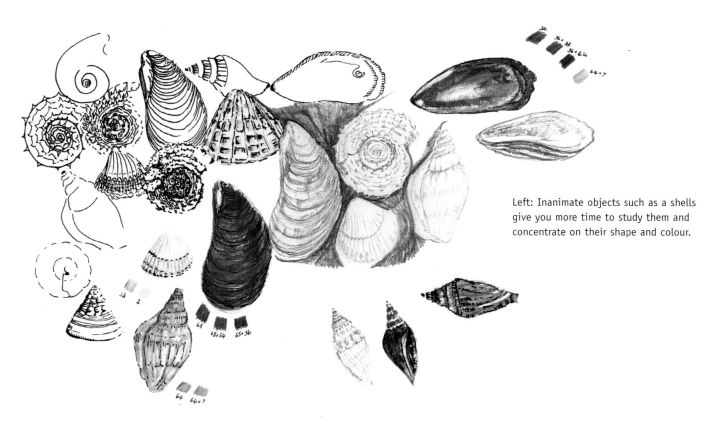

Left: Inanimate objects such as a shells give you more time to study them and concentrate on their shape and colour.

If you prefer to concentrate on subjects that are either inanimate or already dead, then animal parts such as snakeskin, pheasants' feet, skulls, wings and feathers can be borrowed from friends, museums or natural history collections. Fish and shellfish can be bought at the fishmonger. Pebbles and seashore finds are there for the taking.

Use a rough page to limber up and experiment first. Try out patterns, smudge your work, blur colours with your finger and use an eraser to create impressions. If you are able to attend a class, never hesitate to ask others how they achieved their effects.

Consider the size of your drawing. Will you paint your subject life-size, or will you make it larger? Some subjects are improved by being expanded in size, which in turn helps you to see finer detail.

Right: Try using different mediums for the same subject, such as pencil, pen-and-ink and coloured pencils. Don't be afraid to smudge, blur or erase to create impressions.

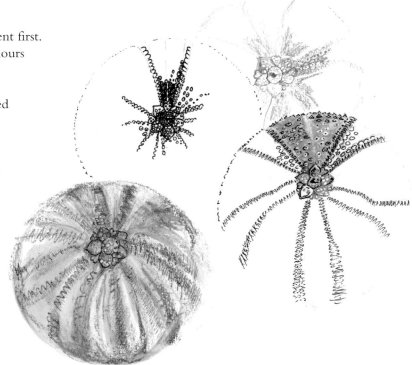

When you begin to construct your drawing of a subject with a view to painting, the question often asked is, 'How much drawing should I do?' This can be difficult to answer. Suffice to say that initially you include as much drawn information as you may need for a painting – size, shape, structure, pattern, tone, texture and so on. See Chapter 3, Drawing, for more on this.

The artist of the zebra lionfish *(Dendrochirus zebra)*, shown below, says:

'The majority of my paintings are created from the wealth of information in my sketchbooks, mostly drawn from life. I sometimes take photographs in order to capture a particular pose and to help with the composition of a painting. Occasionally I work entirely from photographs if I am unable to see an actual live specimen, though I always find this a very uncomfortable experience as I can never be sure that the photograph accurately shows what I need to draw.

'I make several drawings, often drawing individual parts such as the fins on this sketchbook page where I felt I needed more information. If I am in the aquarium, I make colour notes with dry Caran D'Ache watercolour pencils – the low-level lighting in the aquarium makes accurate mixing of watercolour paints rather difficult.

'I also make written notes as it may be some time before I am able to make a watercolour painting from my sketchbook pages – for example, "main body stripes blotchy, not even".

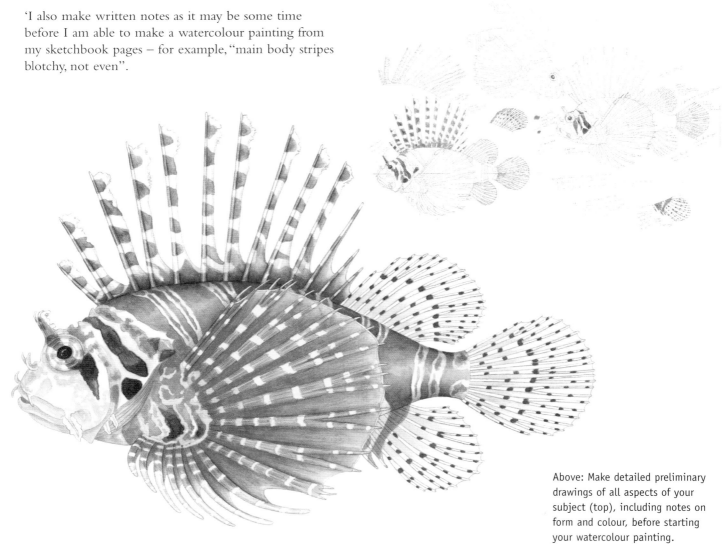

Above: Make detailed preliminary drawings of all aspects of your subject (top), including notes on form and colour, before starting your watercolour painting.

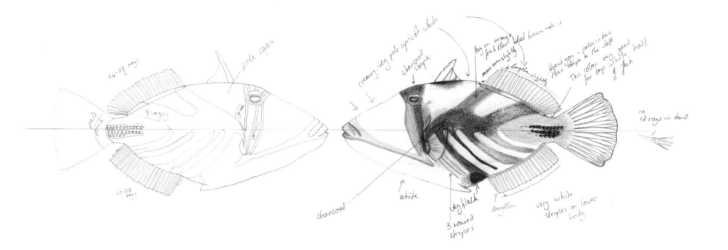

'I transfer the drawing by tracing, very carefully draw around the outline and then lift off the graphite with a putty rubber, leaving just a pale outline. The watercolour paint is applied first in a very thin pale wash, then gradually building up the colours with a drier method.'

The same artist was looking for something in the aquarium that she could use for her address card. The small triggerfish, shown below, aptly named Picasso because of its rather abstract markings, was the perfect image. It was drawn from life, using watercolour pencils for the markings, with written notes and an idea for a composition showing two fish facing each other.

If you are working in coloured pencils (see page 22), use a blue or blue-grey pencil to map in as much information as you need as lightly as possible, or use an extremely pale grade of graphite pencil such as 2H or 4H before proceeding to add more colour. A soft graphite pencil can give problems under coloured pencils as it cannot be erased from underneath and may change the quality of the colour.

Above: Worksheet for a composition of two Picasso triggerfish *(Rhinecanthus aculeatus)* facing each other.

Right: The Picasso triggerfish was drawn from life, using watercolour pencils for the markings.

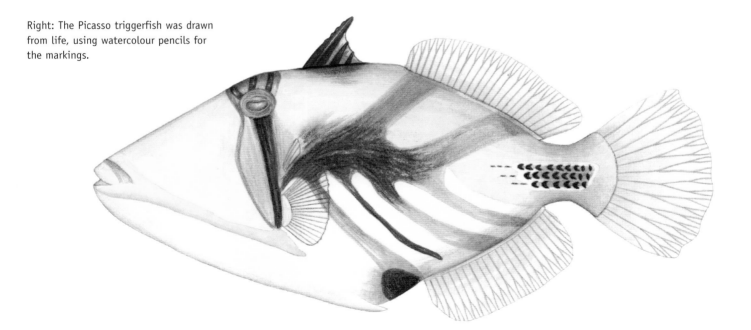

 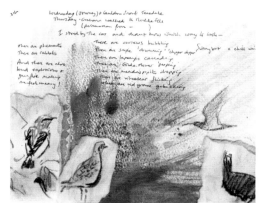 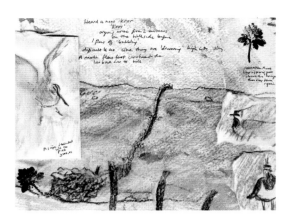

With experience you will be able to use more colour in the field. The picture of puffins in Arctic Norway, shown above left, was very quickly done using wax crayons, which were then scraped over to give an impression of the bleak habitat.

Even when travelling by car, you will be surrounded by things to draw and paint. The drawings shown above centre and above right were made on a car journey to Scotland, and show individual portraits of birds as well as their typical habitat. Again, the artist has sketched in colour, very quickly, giving a vibrant and immediate effect.

The drawing below captures the moment with a quick sketch in pen and ink. The artist calls it a nosy rook, which perfectly describes his cheeky attitude when alighting on a wall overlooking St Michael's Mount in Cornwall.

It is interesting to contrast this image with the series of sketches shown opposite. They are a fastidious study of the skull of a seagull, and when comparing the two you can see quite clearly how the structure of the bones and beak as shown for the seagull are also present in the nosy rook, despite the sketchiness of its drawing.

Above: Quick colour sketches made in Arctic Norway (far left) and on a car journey to Scotland (centre and right).

Right: A nosy rook alighting on a wall overlooking St Michael's Mount in Cornwall. Pen-and-ink and wash.

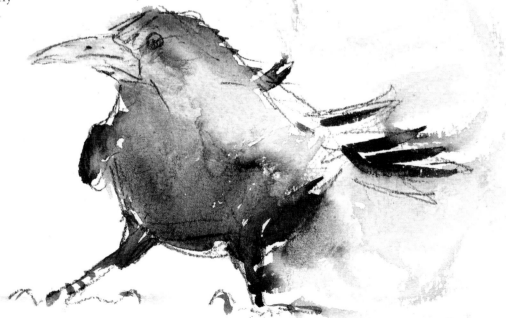

Exercise – bird's skull

You may find the initial drawing difficult to get exactly right. Use layout paper and if it goes wrong, stop and consider. Make several drawings on trial sheets and choose the best one to transfer to your watercolour paper.

When mixing colours, make more than you need – it is easier than trying to remember the exact recipe once you have run out. Having said that, it is often a good thing to run out of paint, as you then have to mix it again, and this is good practice for your colour-mixing abilities. Start painting the palest area first, in this case the skull itself, which is a very pale creamy-brown (see page 110 for examples of bone colour). Build up the colours using superimposed washes, finally putting in the details with a fine brush. (See pages 56–58.)

You might like to leave the beak until last, as it is the focal point of the painting and by this time you will be familiar with the subject and will have practised all the colours you need.

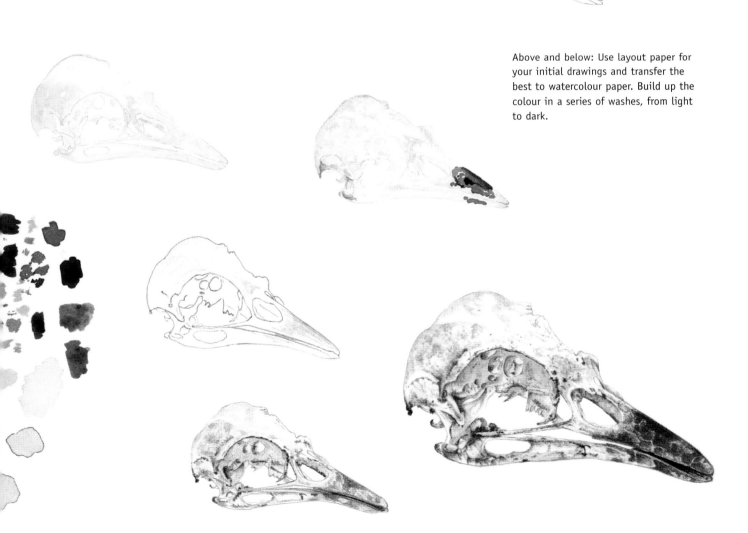

Above and below: Use layout paper for your initial drawings and transfer the best to watercolour paper. Build up the colour in a series of washes, from light to dark.

Polar sketchbooks

Drawing and painting the polar regions means working outside in all weathers, in all lights and at all times of the day. You might have to work quickly between showers or hurry a painting along in advance of an approaching storm. Sometimes the elements can take a direct hand in the work – the paper is soaked by rain, or splattered by snow; it has even been known for watercolours to freeze.

It is the rhythm and restlessness of nature and the landscape that fascinates the polar artist. Those elements are laid bare and are more challenging creatively. There is no natural clutter of foliage to hide the raw landscapes, or to provide cover for birds and animals.

Your sketchbooks have an importance in their own right. Also, as half-finished scribbles, written thoughts, thumbnail sketches or incomplete drawings to be searched through for fresh ideas and starting points, they give you the chance, back in the studio, to consider different ways of working – printmaking, for example, or any medium that forces another creative response to the enthusiasm and excitement of the original encounter.

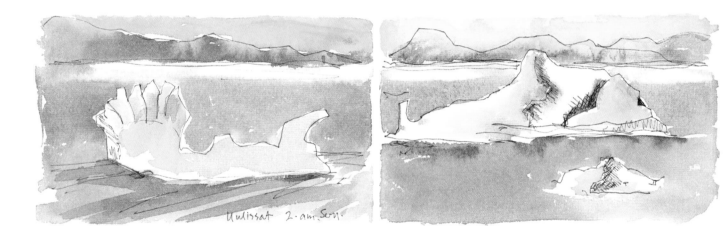

Polar light has an extraordinary quality, especially at midnight. At those latitudes in midsummer there is no sunset or sunrise. Instead, the sun drops through the night in a low arc halfway down towards the horizon and then climbs again in the early hours.

Ilulissat at 2am, shown above, is a good example of painting during the polar night. The conditions are often surreal. The colours are bleached and the icebergs take on the appearance of milky junket. The artist of *Ilulissat at 2am* says, 'I drew the picture very quickly in waterproof pen. It had to be very quick because the ship was travelling fast and at the same time the icebergs were moving in the opposite direction. The scene remained intact for no longer than three minutes. I had to record all the information during that short space of time. I laid the colours on as single washes, allowing them in places to merge together. At no time was it ever possible to consider the next move; it was all done using instinct and experience.'

Above: *Ilulissat at 2am*. The 'midnight sun' bleaches colours; icebergs take on the appearance of milky junket.

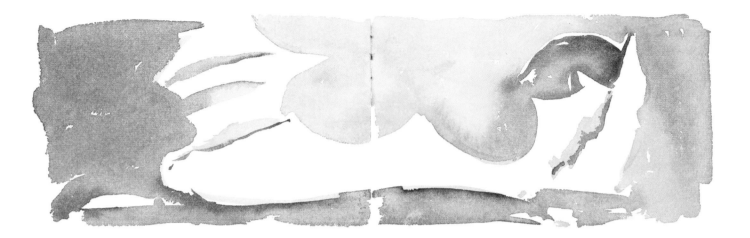

The blue and white iceberg shown above was painted in one single action with a large, size 16 brush, hardly taking the paintbrush off the paper. In order for this to work, the eye has to register the entire shape before committing to paper. The whole exercise took no more than one minute.

The colours used in *Storm over South Georgia*, shown below, are typical of the extreme conditions experienced in the Southern Ocean. The scene was heralding a hurricane force 12, which forced the artist and all the other passengers off the deck and into their bunks.

The gathering gloom rightly gives a feeling of oppression and impending doom. The painting required a change in palette from the brilliant turquoises, yellows and pinks that had been used before the storm clouds gathered. But, contrary to expectation, this did not present a problem. As we say in Chapter 6, Painting, if you mix all the primary colours you will get a grey-brown. By the same token, all the colours needed for *Storm over South Georgia* were obtained by simply mixing up the remaining paints on the existing palette, to give dark browns, greys and dark greens. This is testimony to the often-held belief that you should never wash your palette!

Above: Speed is vital when painting moving icebergs from a moving ship.

Below: *Storm over South Georgia*. These oppressive and doom-laden colours were obtained by mixing together the turquoises, yellows and pinks that were on the palette before the storm clouds gathered.

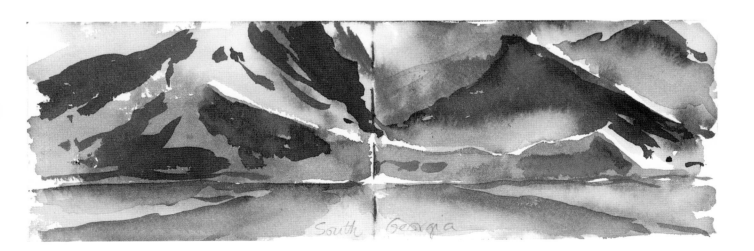

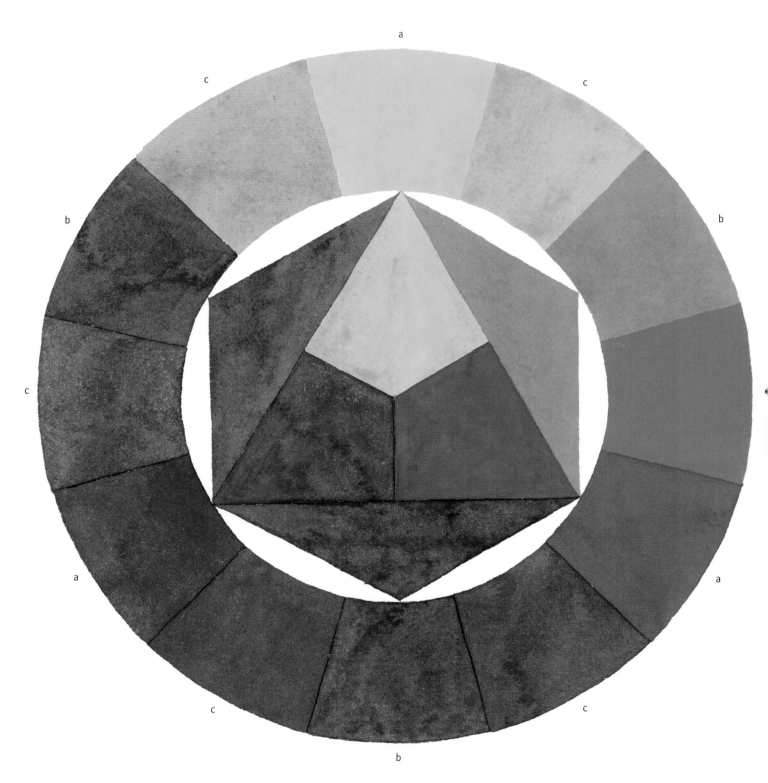

Above: Johannes Itten's Bauhaus 12-hue colour circle shows (a) the three primary colours, (b) the three secondary colours and (c) the six tertiary colours.

5. A world of colour

The natural world is a cornucopia of colours. Some objects scream vibrancy from every pore while others look like subtle, bleached-out ghosts. Throughout the book we give examples of both. All these colours, from the most vibrant to the subtlest, can be mixed by the artist; most are relatively easy, even if some might seem to be impossible. And however pale the colour, you never mix watercolours with white, unlike acrylics and oil paints. All you need to do is to water down the paint so that the whiteness of the paper shines through.

A few people have a natural colour sense and can mix any colour accurately, but most of us have varying degrees of difficulty when mixing correct colours and shades. It is important, therefore, that you have some knowledge of basic colour theory within the context of paints available, so that you can match any colour through understanding and informed application. Both of these will come to you in time.

In this chapter we discuss primary, secondary and tertiary colours and how to mix them, as well as warm and cool colours.

Even if you already have some knowledge of colour theory, it is always worth spending time practising mixing different colours. Try the variety of colour exercises in this chapter. You will need a cheap brush for mixing, a small watercolour pad for testing colours, and initially a small number of paints.

The colour circle

Our colour circle is based on Johannes Itten's Bauhaus 12-hue colour circle. The sequence of the colours is that of the rainbow or natural spectrum. The 12 hues are evenly spaced, with the complementary colours diametrically opposite each other: in other words, purple is diametrically opposite to yellow; blue to orange; red to green.

a. Primary colours

The primary colours, yellow, blue and red, are shown in the triangle in the centre of the colour circle and also at the corresponding position on the outer ring of the circle. Many paint manufacturers produce a variety of these primary colours, but few of them make pure primaries. A true primary colour is neither warm nor cool.

It is therefore important for you to be able to differentiate between cool and warm shades of these colours, otherwise your mixing abilities could be severely compromised. For example, if you are trying to mix earth colours, the wrong blue and the wrong red will not make brown, they will make purple. To help you to differentiate between warm and cool colours, two other colour circles are shown on the next page, giving 12 warm hues and 12 cool hues.

Black

If you mix equal quantities of the three true primaries you should always get black. This will be far superior to any bought black and lends itself to subtle variations in shade. Watered down, it becomes grey.

b. Secondary colours

The secondary colours are orange, purple and green. They are shown alongside the inner triangle (green spanning its component colours, blue and yellow; orange spanning red and yellow; and purple spanning blue and red) and also in the corresponding position on the outer ring. It is easy to see, therefore, how secondary colours are created by mixing together two primaries.

c. Tertiary colours

Also on the outer circle, interspersed between the primary and secondary colours, are the colours made by mixing a secondary and one of its primaries. These are the tertiary colours. Even though the logic is fairly obvious, it is worth looking at how orange, when mixed with yellow, gives an orangey-yellow, but when mixed with its other component, red, gives an orangey-red. Likewise, purple mixed with red gives a plum colour, but mixed with blue becomes grey-blue. Green mixed with yellow gives lime green, but with blue it yields aquamarine.

Contrasting colours

There are several ways of contrasting colours, for example there is light/dark contrast (a bright red with a pale red), cool/warm contrast (orangey-yellow with a greeny-yellow) and complementary contrast (green looks more vibrant in the presence of red than in the presence of blue). Throughout the history of art, painters have used complementary contrast to great effect. Many outstanding paintings resonate with blues and oranges, or purples and yellows, or reds and greens. These are all complementary contrasts.

Varying colours

There are several ways of varying colours: green may become more blue or yellow (lime green or turquoise); red may become more orange or purple (vermillion or crimson); red may become more pink, maroon or cerise; blue may become more navy, turquoise or slate.

Before setting out to create your sample strips in the next exercise, check your own colours against the charts and take some time to think about whether they are warm or cool. Here is how to check:

Warm and cool colours

There are only six basic colours that you should have in your paintbox in order to mix nearly all the shades you will need (the exceptions are vivid pink, turquoise and some of the purples). These six primary colours are:

- **A cool and a warm yellow:** cool yellows lean to green or blue; warm yellows lean to orange or red.
- **A cool and a warm red:** cool reds lean to purple or blue; warm reds lean to orange or yellow.
- **A cool and a warm blue:** cool blues lean to green or yellow; warm blues lean to purple or red.

The two colour circles will help you to differentiate between warm and cool colours, as will the chart on the next page.

Above: Warm colour circle (top) and cool colour circle (bottom) showing (a) primary, (b) secondary and (c) tertiary colours. Notice the difference between the warm and cool mixes.

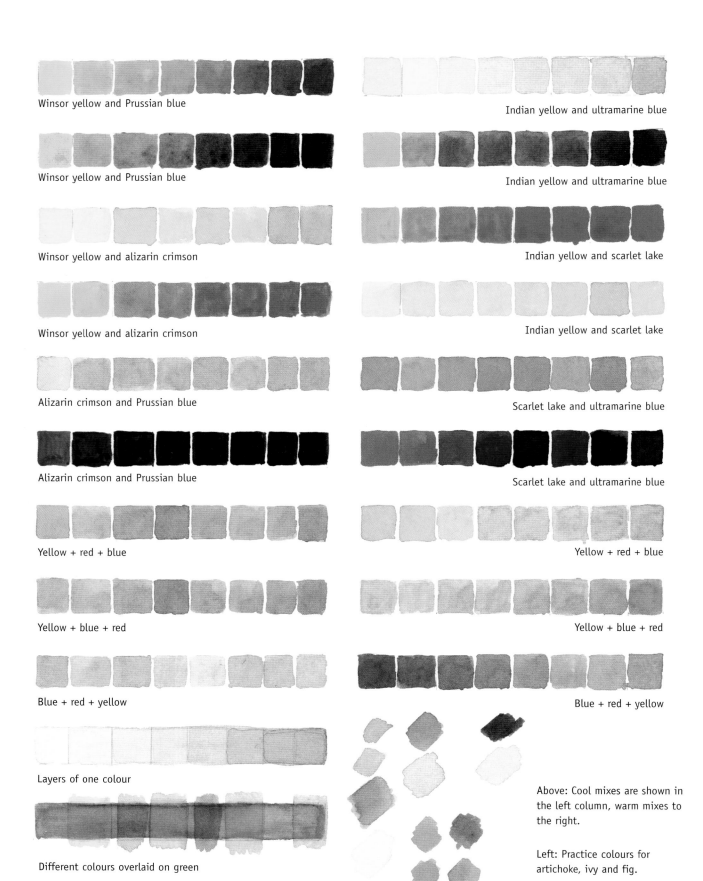

Winsor yellow and Prussian blue

Indian yellow and ultramarine blue

Winsor yellow and Prussian blue

Indian yellow and ultramarine blue

Winsor yellow and alizarin crimson

Indian yellow and scarlet lake

Winsor yellow and alizarin crimson

Indian yellow and scarlet lake

Alizarin crimson and Prussian blue

Scarlet lake and ultramarine blue

Alizarin crimson and Prussian blue

Scarlet lake and ultramarine blue

Yellow + red + blue

Yellow + red + blue

Yellow + blue + red

Yellow + blue + red

Blue + red + yellow

Blue + red + yellow

Layers of one colour

Above: Cool mixes are shown in the left column, warm mixes to the right.

Left: Practice colours for artichoke, ivy and fig.

Different colours overlaid on green

Colour sample strips exercise

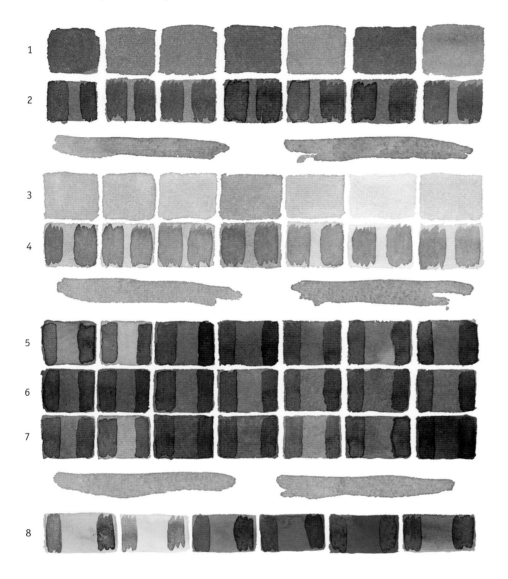

1. Primary mixes.
2. Primary mixes with warm grey (left stripe) and cool grey (right stripe) superimposed.
3 and 4. The same as 1 and 2, but watered down.
5. Warm and cool oranges and browns, with warm and cool greys superimposed as before.
6. Warm and cool purples made with all primaries, with warm and cool greys as before.
7. Warm and cool greens made with all primaries, with warm and cool greys as before.

8. At the bottom of the page are the six primary colours: warm yellow / cool yellow; warm red / cool red; warm blue / cool blue, again all overlaid with warm and cool grey.

Primary colours
The first part of this exercise is to divide your primary colours into warms and cools for mixing purposes:

Warm reds, blues and yellows
- Permanent red orange, scarlet, vermillion
- Ultramarine
- Gamboge or Indian yellow

Cool reds, blues and yellows
- Crimson, carmine, madder
- Prussian or Paris blue, Winsor blue (green shade)
- Lemons, pure yellow, transparent yellow

Think about why certain colours occur when mixed. For instance, if you are trying to mix a brown, use scarlet (warm orange-red) and Prussian blue (cool green-blue). Because you are using a mixture of complementaries – the same as mixing red and green – you will get a brown. If, on the other hand, you need a good purple, use a mixture of crimson (cool blue-red) and ultramarine (warm red-blue).

Complementary colours

Complementary colours are very important in the study of colour because they represent harmonious colour, that is to say, colour combinations that provide balance, harmony and symmetry of forces.

As we saw earlier, a colour and its complementary colour (a complementary pair) are found diametrically opposite each other on a colour circle: in other words, yellow is diametrically opposite to purple; blue to orange; red to green.

An equal mix of any complementary pair should yield black or grey. Therefore you will often find that the complementary colour is the one to use for shadow and shading on a subject.

Many unusual and subtle shades and tints can be obtained by mixing a pair of complementary colours and then diluting with water. Remember that the addition of red will tone down green and green will tone down red; purple will tone down yellow and yellow will tone down purple; orange will tone down blue and blue will tone down orange.

Colour mixing exercises

Before starting these exercises, study the colour charts opposite, which show colours that can be made from the primaries. Each row of colour mixes is echoed immediately below it with a row of the same mixes but in a diluted state.

To start the exercise, paint a small square of orange (such as lemon-yellow mixed with permanent red-orange). Add a tiny amount of blue, the complementary colour of orange, to make a browner orange and paint another square. Add more blue to make an even browner orange and so on. If you carry on adding more and more blue you will make a wide selection of browns, eventually turning into greys.

Repeat with different red/yellow combinations (orange) with blues. Make oranges using different yellows and reds. Use each of these oranges to make sample strips, each with a different blue. Note the range of browns and purple-browns that are achieved.

You could also see how many other colours can be achieved simply by adding water.

As with most things, time spent playing with paint is never wasted. You will learn the characteristics of your own paints, which one mixes well with which other, what to use for a particular green, or brown, or purple.

Opposite: These three columns of colour mixes show how many different hues you can make by mixing as follows; reds + yellows with blues (left), yellows + blues with reds (centre) and reds + blues with yellows (right). The initial components, such as lemon yellow/permanent red-orange, are shown together with the added colour, such as French ultramarine, in progressively increasing proportions. The initial mix is on the left of each strip, but by the time it reaches the right-hand end, the added colour predominates. The lower strip of each pair shows the colours watered down.

Lemon yellow/permanent red orange with
French ultramarine

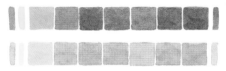

Lemon yellow/permanent red orange with
Prussian blue

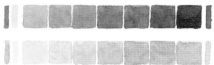

Lemon yellow/alizarin crimson with
French ultramarine

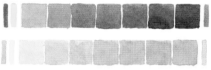

Lemon yellow/alizarin crimson with
Prussian blue

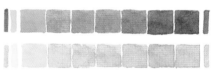

Winsor yellow deep/alizarin crimson with
French ultramarine

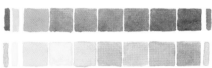

Winsor yellow deep/alizarin crimson with
Prussian blue

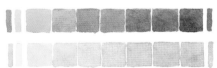

Winsor yellow deep/permanent red orange
with French ultramarine

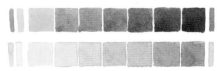

Winsor yellow deep/permanent red orange
with Prussian blue

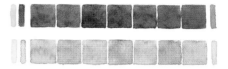

Prussian blue/lemon yellow with permanent
red orange

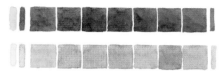

Prussian blue/lemon yellow with
alizarin crimson

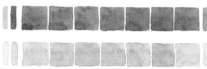

Prussian blue/Winsor yellow deep with
permanent red orange

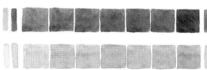

Prussian blue/Winsor yellow deep with
alizarin crimson

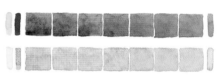

French ultramarine/lemon yellow with
permanent red orange

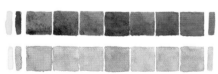

French ultramarine/lemon yellow with
alizarin crimson

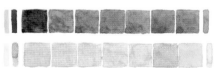

French ultramarine/Winsor yellow deep with
permanent red orange

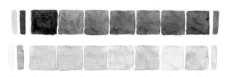

French ultramarine/Winsor yellow deep with
alizarin crimson

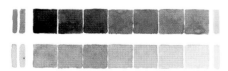

Prussian blue/permanent red orange with
lemon yellow

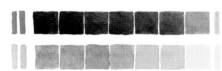

Prussian blue/permanent red orange with
Winsor yellow deep

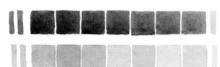

Prussian blue/alizarin crimson with
lemon yellow

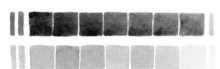

Prussian blue/alizarin crimson with Winsor
yellow deep

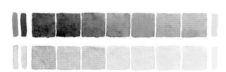

French ultramarine/permanent red orange
with lemon yellow

French ultramarine/permanent red orange
with Winsor yellow deep

French ultramarine/alizarin crimson with
lemon yellow

French ultramarine/alizarin crimson with
Winsor yellow deep

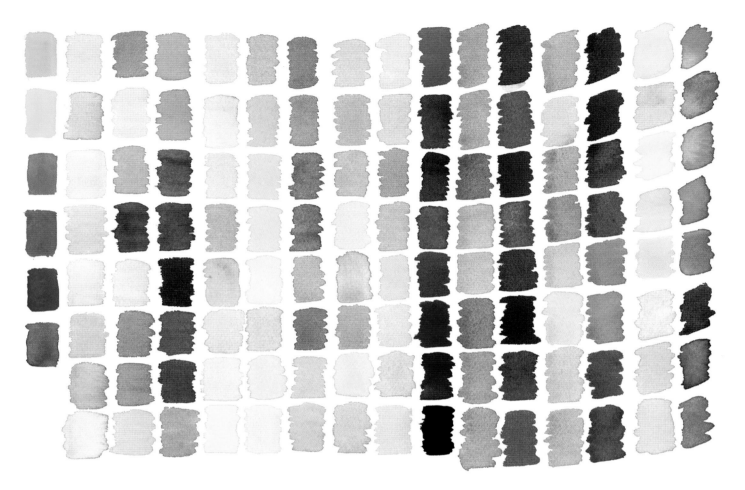

Natural colours made from primaries

A huge variety of colours can be mixed from primaries. You can buy all these colours but this exercise shows that it is expensive and unnecessary. You will learn much more from mixing your own versions of bought paints.

As with our Neolithic rock ancestors, many of the colours that we need are earth colours such as the umbers, siennas and ochres. There is no need to buy them as they are very easy to mix. Because there are only six primaries involved (three warm and three cool), it is not difficult to produce whole ranges of beautiful colours and shades (see above). And the benefit of this is that your finished picture will have cohesion, because it all springs from the same primary source.

Green

Green is a much-discussed colour, and of vital importance for botanical subjects. It is acceptable to buy ready-made greens, but only if you know what you are doing and understand how you can change them to suit a specific subject.

First of all you have to decide what sort of a green you need. For example, a warm yellow (Indian) mixed with a warm blue (ultramarine) will result in a browny-olive green. This is fine if you actually need that particular green and have set out to mix it, but it is not so good if it has simply been arrived at through lack of understanding.

Above: These primary mixes show that it is not necessary to buy more than the basic six paint colours.

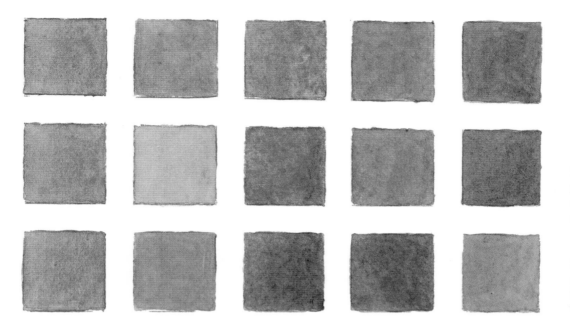

Left: Just some of the greens you can make by mixing cool or warm yellows with cool or warm blues.

Below: This stripy, warty gourd uses many greens, tried out first on the worksheet shown to the left.

Exercise – greens

As with the previous exercise, make colour strips using different combinations of the blues and yellows in your paintbox. You will find these colour strips extremely useful when you need to choose a specific green for a painting.

Practise mixing greens from cool or warm yellows and cool or warm blues so that you can see the enormous range of colours that can be achieved. Only then should you consider using bought greens, as you will understand the qualities of the colour you are seeking to mix.

If you are determined to buy greens, be aware that the colour will hardly ever be exactly what you want in your painting. Experiment with using the paint straight from the tube or pan and find out how to change or regulate it. Try a little crimson (cool) to sharpen your green. Try a little scarlet (warm) to deaden or mute your green. A little purple will darken it.

But there really is no need to go to the expense of buying green – all the colours you can achieve with ready-made greens can be made using the blues and yellows already in your paintbox. Have a go – it's not difficult!

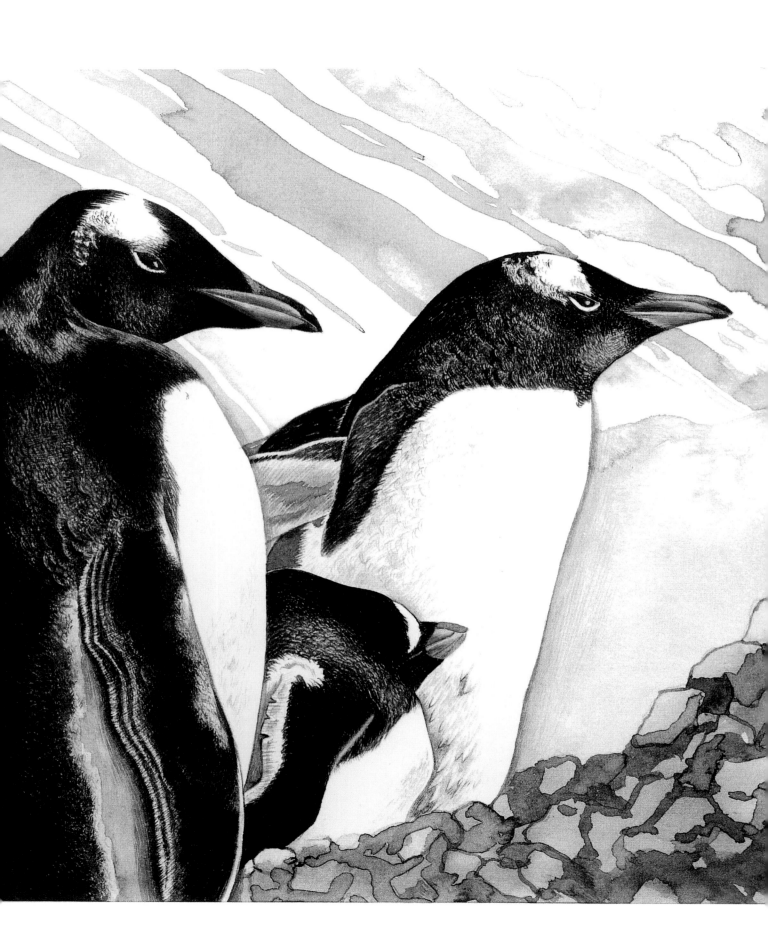

6. Painting

Watercolour painting is a cerebral as well as a physical process. It is a good idea to have some idea of how your material will perform before setting out to produce a finished artwork. Watercolour is dependent on what has gone before and what is to come.

Paint application is an acquired skill similar to pencil techniques, but try to understand what is happening with the paint as you start to experiment. The importance of work pages and test sheets cannot be overstressed, so that you experiment fully *before* you put any paint onto your picture. If you want to paint in a keenly observed and finely detailed way, there are set procedures and techniques that you should learn to use first.

Within these constraints there are many ways to apply paint to paper. In this book we concentrate on using watercolour, the preferred medium of many natural history artists. Some, however, prefer to continue the drawing tradition and work in coloured pencil (see page 22). In its own way, this is a form of dry painting, where no water is used and the colour is layered onto the paper in a series of over-glazes. A good example of this is the study of the three crab shells, shown right.

In both mediums, colours can be overlaid or superimposed to create depth and colour changes; for instance, yellow and blue coloured pencils superimposed one on top of the other can result in green. Alternatively green can be altered by overlaying with a yellow, a blue, a red or a purple. Try some experiments with both paint and coloured pencils.

If you are using coloured pencils, you will probably build up a large range of colours and types (hard and soft varieties – see Chapter 2, Setting up, or Further information, page 140, for details); whereas with watercolour paints, just a very few colours will yield everything that is needed, as detailed in the previous chapter.

On the following pages are a variety of different watercolour applications.

Handling watercolour

Watercolour paintings are built up of lights, darks and mid-tones, so your initial wash or washes must always be very light. You will usually work from light to dark. The lighter the early washes, the greater tonal contrast you can build into the finished painting. If you start off with heavy, dark washes, your picture will become heavy and dark and lose the transparency that is so important in watercolour work.

Proceed with caution and do plenty of trials and experiments before committing to the finished picture. You will see work sheets and trials throughout this book illustrating the importance of the evolutionary process involved in making a piece of work.

Above: For those who would prefer to use coloured pencils, they can produce vibrant and complex overlaid colours, as demonstrated by these crab shells.

Opposite: The starkness of polar wildlife can help to develop your use of blacks, greys and browns.

The initial wash is always very diluted and pale. Decide on its strength and hue by determining the lightest area of your subject. The lighter and more luminous the initial wash, the more tonal contrast you will be able to incorporate into the finished work.

Take care when painting the initial wash that you keep the paint within the drawn lines. You should practise extensively, making fluent lines and neat edges (See the exercise on page 58).

Washes

Good wet-into-wet. Paint stays where it is intended. Merges nicely.

A good impression of a nebula but probably not intended. Too wet.

Water applied and dried unevenly. Some areas drying slower than others.

Too dark. Dark paint added after square has been painted and is damp.

More water added after square has been painted.

Good graded wash.

Wet-into-wet, uneven drying.

Blended wash. Two or more colours blended together smoothly and evenly.

Patchy and overworked.

Too dark and overworked.

Pale blended wash, two or more colours blended smoothly and evenly.

Graded wash with too much water when grading from dark to light.

Patchy graded wash.

Good, flat and even.

Edges have dried before rest is filled in.

Too much water.

Good, flat and even.

Too much water.

First of all, experiment with the different types of washes that you will need to understand:
- Flat
- Graded
- Blended
- Wet-on-wet
- Superimposition

Flat wash

A flat wash is a pale wash painted straight onto dry paper. When doing a flat wash, the consistency of the paint is of paramount importance. Fill your brush with enough of the mixture to cover the area to be painted, but not so much as to flood the paper.

Graded wash

A graded wash is painted onto dry paper. Start with a strong colour and then add water to your brush, stroke by stroke, until the initial colour has practically disappeared. Try to keep the wash consistent as it changes from dark to light.

Above: These broken eggshells are a good example of graded wash. When dry, they have had stippled graded tone added to darken the shells, giving a three-dimensional effect.

Blended wash

A blended wash is painted straight on to dry paper, changing from one colour to another or blending one colour into another.

Wet-on-wet wash

For a wet-on-wet wash, first wet the paper with clean water or a light wash, and then drop in a stronger mixture of paint. The secret of success is to allow the paper to dry out until its bright shine has reduced to an all-over sheen before dropping in the darker paint.

Wet-into-wet painting can be a huge asset for this type of painting as it gives the fluctuations of colour and shade so often found in nature. The technique is a useful antidote to inherent heavy-handed painting. It gives lightness and translucency to what could otherwise be dull and laboured work.

Superimposition

Superimposition uses layers of colour washes, on dry paper, either in the same or different shades. Try this little experiment: take two colours, say, yellow and red. Mix them together to make orange and paint a sample square. Now paint a similar square using just the yellow. When the square is dry, paint over it with the red. Notice how the vibrancy of your paint is so much greater where they are superimposed, rather than where they were mixed together and applied as a single layer.

Wash skills improve with patience, lots of practice and experience. Do plenty of practising with the different washes. Think of different uses. Get into the habit of looking at specimens and working out the best method of painting them: consider whether a certain specimen would benefit from a wet-on-wet technique or a flat wet-on-dry wash.

Sometimes you might need to lift off colour from a painting, but first check the paint for its staining quality. The ones that stain can be difficult to lift off. If the paint is still wet, use a damp or dry brush or blot carefully with a tissue; if the paint is dry, cover the area with clean water with your brush and blot with a tissue. Don't scrub at it, as this will ruin the surface of the paper and make subsequent layers of paint lose their freshness. You might have to do this several times.

If you need to re-paint these areas, make sure they are perfectly dry before you begin.

Handling watercolour
Exercise – painting shapes

The main purpose of this exercise is to familiarize yourself with watercolour and its behaviour. Take your time over this. It is important to be relaxed and not have to watch the clock. Don't feel that it is time wasted when you might be better employed painting a picture – nothing could be further from the truth! It is only by coming to understand these basic techniques that you will be empowered to paint successfully.

The page of shapes shown opposite goes from simple to more complex. Using your watercolour book or pad, lightly draw out some similar shapes and practise filling them in with pale, flat, even washes. Keep a light touch; heavy painting will lead to a generally dull finish and any luminosity will be lost forever.

Experiment with wetting the paper first and then dropping colour into the wet shape, wet-on-wet. Don't mix colour on the paper. Continue practising various ways of washing-in your shapes until you begin to get the feel of paint, water, quantities, drying times and brush handling. Feel free to make as many mistakes as you like! Remember, there is so much to be learned from what goes wrong.

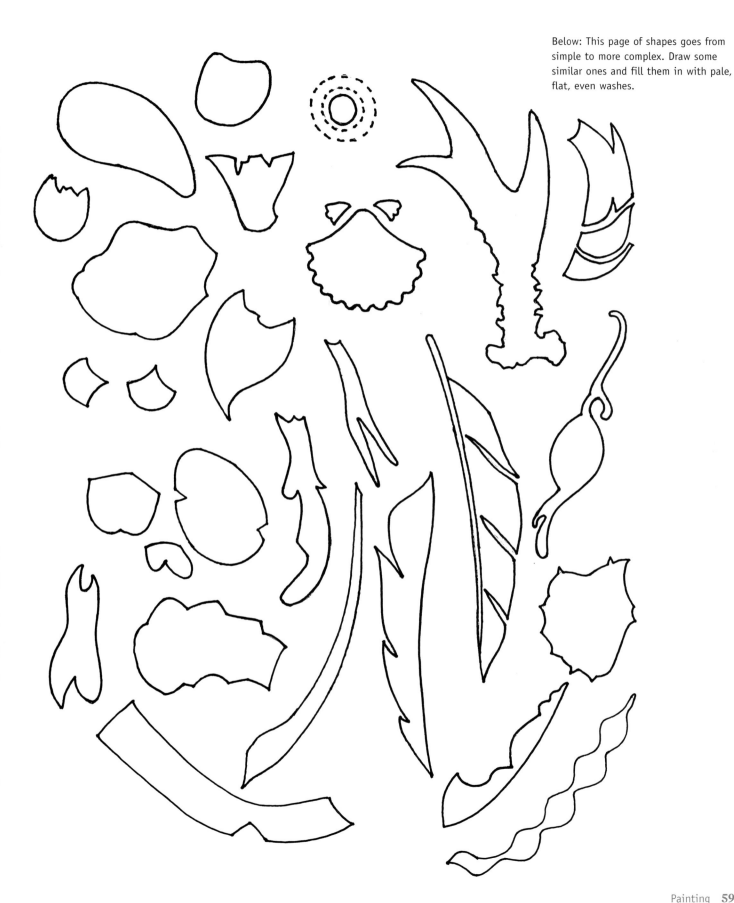

Below: This page of shapes goes from simple to more complex. Draw some similar ones and fill them in with pale, flat, even washes.

Exercise – layered washes, earth colours

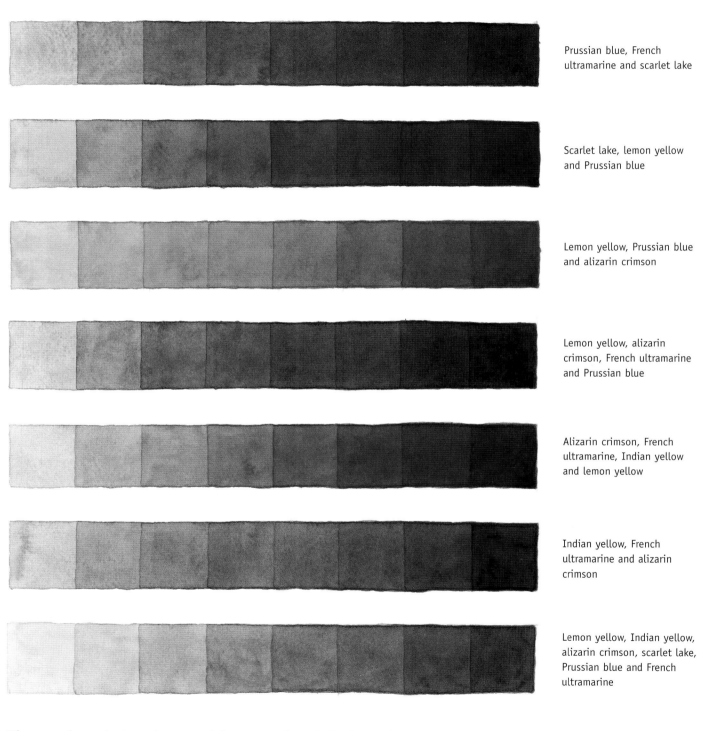

Prussian blue, French ultramarine and scarlet lake

Scarlet lake, lemon yellow and Prussian blue

Lemon yellow, Prussian blue and alizarin crimson

Lemon yellow, alizarin crimson, French ultramarine and Prussian blue

Alizarin crimson, French ultramarine, Indian yellow and lemon yellow

Indian yellow, French ultramarine and alizarin crimson

Lemon yellow, Indian yellow, alizarin crimson, scarlet lake, Prussian blue and French ultramarine

The second exercise is to draw out eight squares about 2.5 x 2.5cm (1 x 1in). Mix up a large quantity of a light wash. Paint all the squares with the wash. Let them dry, and then paint all except the one on the left with a second coat, taking care not to add more water or paint to the mixture. Let them dry; then paint all but the two on the left with another coat. Let them

dry and repeat until the last square has eight coats of the same wash. You should have a build-up of coats ranging from one layer on the left to eight on the right. Notice the differences between them. You can repeat this exercise using different colours if you wish. Although you may not think it, all the strips shown opposite are made from the primary colours.

Controlling paint on paper is not something that can be learned quickly. It takes skill and patience, but like anything else you will find that in time it becomes more familiar and therefore easier. Keep your early efforts – you will see the improvement as you progress.

Exercise – highlights and graded tone

These squares show examples of highlights and graded tones, as described on the following page. Refer to the broken eggshells on page 57 for examples of lowlights lifted out with a damp brush.

Graded tones with mid-tone paint and a damp brush.

Graded tones with different strength tones.

Lowlight lifted out with a damp brush.

Darker graded tones with small area of stippled dark tone, bottom right.

Highlight lifted out with a damp brush.

Bad example of graded tone. Too much water washes away all the tone and leaves drying mark.

Lighter graded tones with an area of light stippling, bottom right.

Highlight left out and softened round edges with damp brush to prevent a hard line forming.

Graded tones just stippled with a small brush and softened lightly with a damp brush.

Tonal gradation

After your initial wash or washes have been laid, and in order to give energy to your subject, this technique is often regarded as being the cornerstone of realistic portrayal. As when working with pencil, the application of tonal gradation is what gives the subject three-dimensional realism. It produces the illusion of solid three-dimensional form (the subject) on a two-dimensional surface (the paper). Your light source will dictate where the tones or shadows fall, so study the light and shade on your subject carefully.

To do this, you could apply stronger mixes of paint on top of the dry washes, again in layers, blending or softening the edges with a damp brush so that the transition from light to dark is smooth and even.

If you prefer a more precise and controlled technique, you can use stippling to produce the same effect. Stippling involves the careful use of fine lines, even dots, laid parallel to one another or overlaid to form a smooth, even tonal change from light to dark. Stippling is done with a very small brush, but make sure your paint is not too dry or it will result in scratchy, uneven results. Examples of stippling can be seen on these pages.

Most artists use a combination of both techniques, choosing to stipple as the painting reaches the stages of finer detail. A very meticulous painter might choose to stipple more than a painter who favours a looser, more fluid style. Whichever technique suits you, tonal gradation is necessary to bring your painting (or drawing, should you use coloured or graphite pencils) to life. The skills you need can take a while to perfect but again, with time and patience, practice makes perfect.

Right: This large fungus, *Agaricus xanthoderma*, shown whole and bisected, is a good example of stippling on the cap and tonal gradation on the stem and gills.

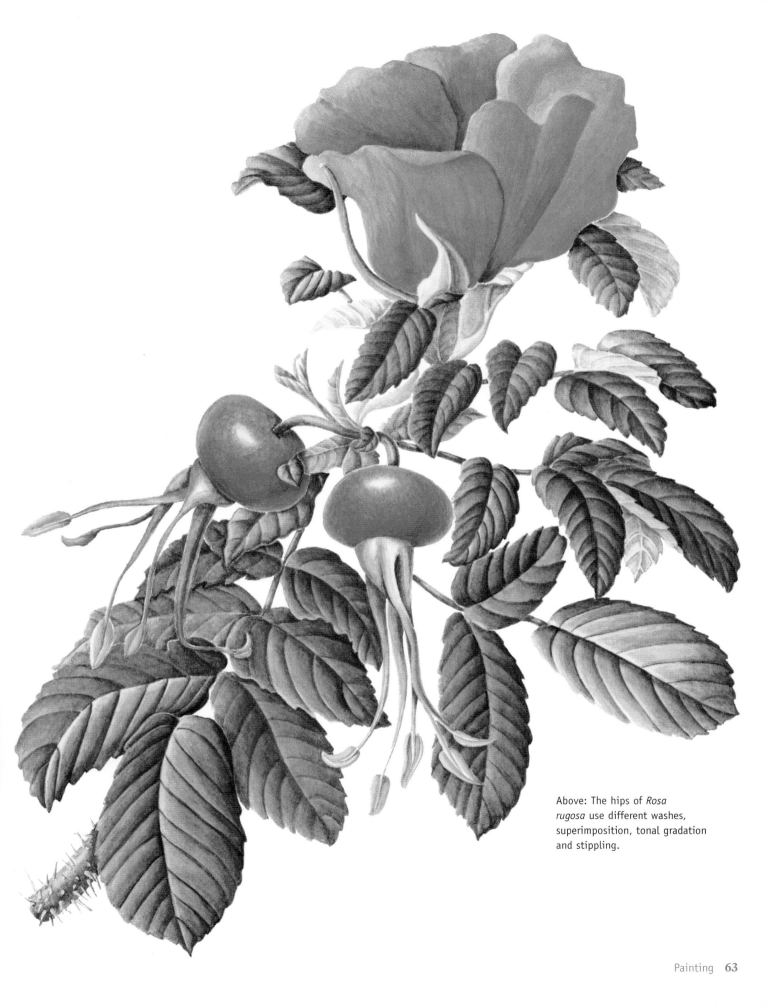

Above: The hips of *Rosa rugosa* use different washes, superimposition, tonal gradation and stippling.

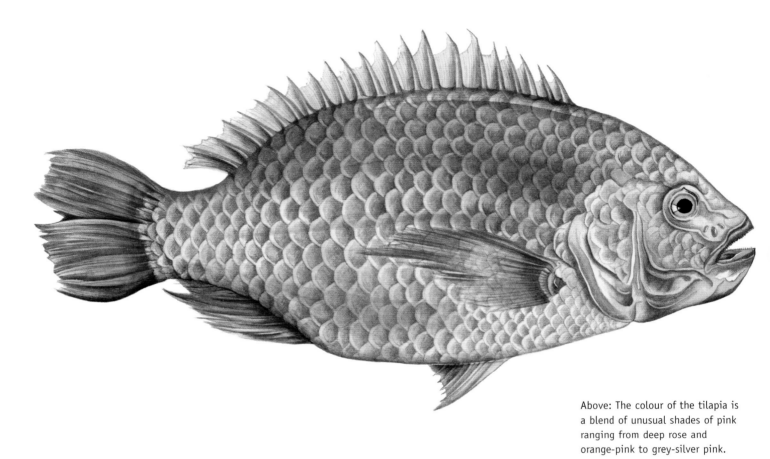

Above: The colour of the tilapia is a blend of unusual shades of pink ranging from deep rose and orange-pink to grey-silver pink.

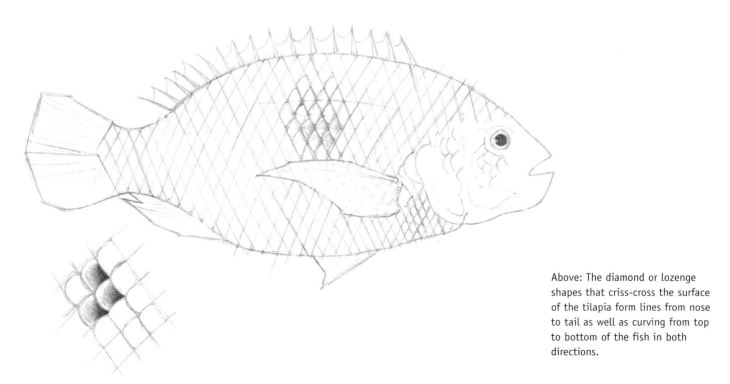

Above: The diamond or lozenge shapes that criss-cross the surface of the tilapia form lines from nose to tail as well as curving from top to bottom of the fish in both directions.

7. Texture and pattern

Every natural thing has either texture, or pattern, or both. Usually texture and pattern are there for a very good reason – camouflage, protection against predators, courtship and so on.

It is important that you understand the reason for the pattern and look carefully to see how it repeats. Is it based on a grid, or perhaps a diamond? Is it stripy, spotty, blotchy, scaly, wrinkly? Write down a list of words describing your subject before you even start to draw it.

If your subject has complicated patterning, it is easy to lose track of where you are drawing, as you continually look at it and then back to the paper. Try putting little markers such as slips of paper or pins to show sections or change of direction of the pattern or texture while you are drawing.

Make sure your subject is positioned in the best possible way to take advantage of the light. Overhead light can rob it of its colour and distort the form, so make sure there is cast shadow to give a three-dimensional effect.

Exercise – fish scales

Notice how the overlapping scales of the tilapia, opposite, form a diamond-shaped grid. Not only do the scales form lines from nose to tail, but they also fall into curved lines from top to bottom of the fish in both directions.

Below: When painting tilapia scales, indicate the darker areas with a pink-grey mix and leave a small semicircle of light at the outer edge.

Unlike many fish, the tilapia has very obvious and large scales. It is sometimes called St Peter's fish or wonder fish because it is believed to have been the fish that fed the 5,000 by the Sea of Galilee.

The pencil study, shown left, indicates the basic shape of the fish and the grid pattern of the scales. If you follow the diamond or lozenge shapes that criss-cross the surface, you will find that there is a pattern within the texture and it is easy to arrive at a convincing representation through systematic construction.

Even though the scales can be seen to overlap one another, from some aspects light and shade can give them both a concave and a convex quality. This causes an interesting visual ambiguity.

The colour of the tilapia is a blend of unusual shades of pink ranging from deep rose and orange-pink to silver-grey pink. Your initial wet-into-wet wash can be built up of these colours, dropping them onto the wet paper. Add some deep concentrations of these colours here and there.

Paint the face area of the fish using the wet-on-dry technique, noticing how there are specific colours in certain areas. When dry, pick out the scales one by one, first with blue-grey paint, and when that is dry use a pink-grey mix to show the darker areas on each scale. Leave a small semicircle of light at the left of each scale. These dark and light areas help to create the overlapping effect. When all the scales are in place, paint some blue-grey tone under the belly to add dimension and shadow.

Exercise – seaweed

The study of seaweed, shown below, is a good example of experimenting with scale. The artist first made a delicate little life-size picture, measuring just over 6 x 2cm (2½ x ¾in). She then decided to enlarge it on the photocopier to three times the size and used this as the basis for further study. This enlargement gave a completely different perspective to the pattern and structure, and when concentrating on its fine details the artist was heard to observe 'Wow! The sand particles are square, with sharp edges!' This was difficult to show using her favoured medium, coloured pencils, so she enhanced them with watercolour using a fine brush to sharpen the edges.

Right and below: This delicate study of a piece of dry, twisted seaweed reveals a very different character when enlarged to three times its original size. The artist has made meticulous records of the coloured pencils she used.

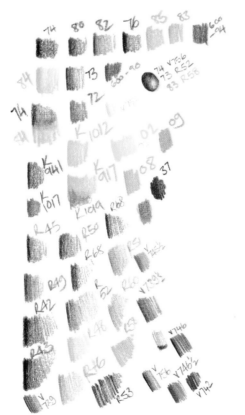

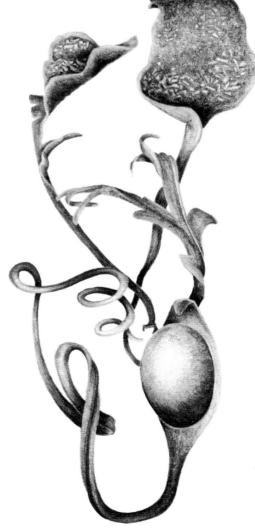

Snake slough

Snakes shed their skin periodically and these make a fascinating study, the dry, papery texture lending itself to a simple pencil drawing.

Below: This pencil drawing of a discarded snake slough looks dry and papery, although the artist felt she could improve it by using a different paper.

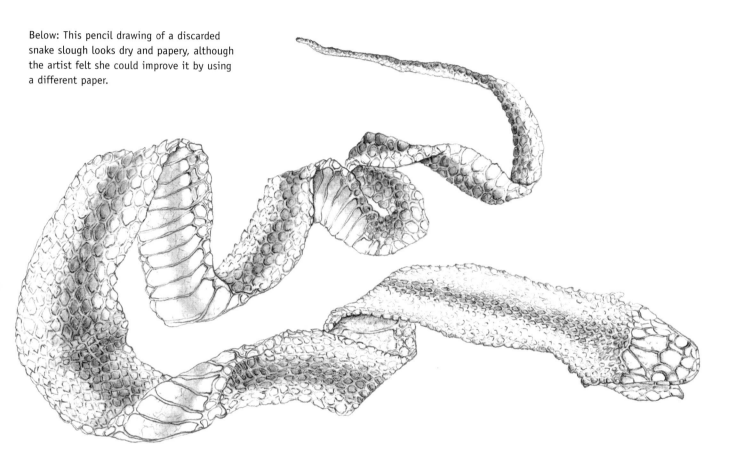

The artist of the snake slough, shown above, says: 'I drew the snakeskin straight onto cartridge paper. I think in retrospect this was a mistake, and I should have drawn it onto layout paper. I would have been able to achieve a more "papery" effect. I found the cartridge paper a bit heavy. I drew the outline and pattern of the skin using a hard 6H Faber Castell, the soft line following through the skin. I shaded with a Staedtler H and softened the edges with cotton buds. I progressed with a Staedtler 4H and 3H, outlining the scales and shaded with an HB along the centre scales. Finally, with a very sharp Faber Castell HB, I went back over the drawing and outlined various points for more effect.'

Exercises in texture and pattern

The composition opposite shows a variety of textures and patterns that are found in different natural history subjects.

Make a collection of a dozen or so items displaying different textures and patterns. Don't restrict yourself to the ones shown here – try woven fabric, knitted fabric, moss, a shiny leaf, pet fur, a kiwi fruit, cheese, the skin of an orange, the flesh of an orange, a cabbage leaf, a slice of bread, a shell, some lichen, a piece of dry wood, a mushroom, some seaweed, a furry leaf, the skin of an avocado. Make a drawing or painting of a small part of each, no more than 2.5cm (1in) square. Take your time and notice the fine detail. Write down a description of each one, and how you portrayed it. Notice how you used different treatments for different textures and patterns.

Doodle!

As with all artists, there will come a time when you suffer from a complete mental block. Don't fight it, give in. Stop what you are doing and do something else, even if it is simply to pull out a piece of rough paper and doodle on it.

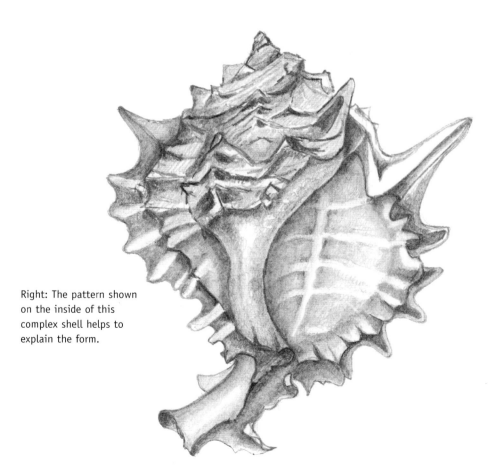

Right: The pattern shown on the inside of this complex shell helps to explain the form.

1. A detail from the large snake's skull on page 33 shows the separate plates and the intricate pattern formed by the texture of the bone.
2. Another pencil drawing, this time a detail of the picture of a roe deer's horns (see page 32), gives a good idea of their hard, uneven protuberances, contrasting with the smoothness of the bone below.
3. This pencil drawing shows the skeletal structure of part of a cactus washed up on the beach, its flesh completely worn away by the action of the waves. The fine pencil work is ideal for showing the intricacy of the lacy pattern of the remaining fibres.
4. Cherries are round, smooth, hard, glossy and shiny.
5. A piece of driftwood in pale colours gives a good feeling of dry weightlessness.
6. The rather scratchy technique used for this peacock feather gives an airy, light and 'feathery' effect.
7. Another section of driftwood shows texture in many shades of brown.
8. Detail of a pebble picked up on the beach.
9. The section of a rook's wing from page 81 drawn in pencil, not only shows the way the feathers lie, but also their shiny texture.
10. The pheasant's claw is a good example of dry, scaly shine.
11 and 12. Treatments of the same python skin by two different artists, one a delicate study in coloured pencil, the other using a heavier and bolder approach. Both indicate the distinctive pattern and colour.

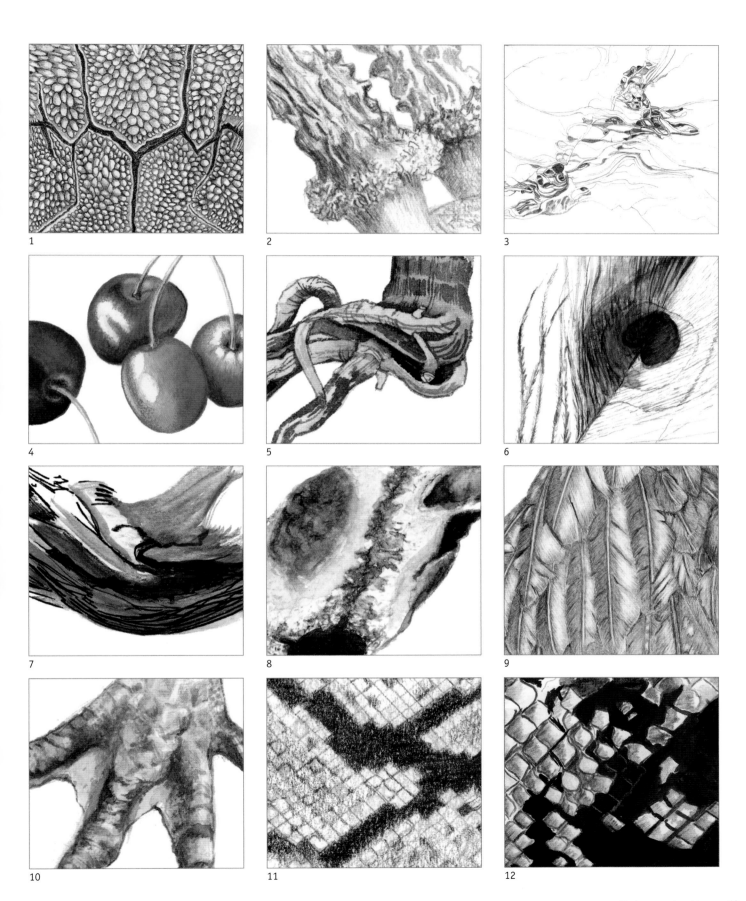

1

2

3

4

5

6

7

8

9

10

11

12

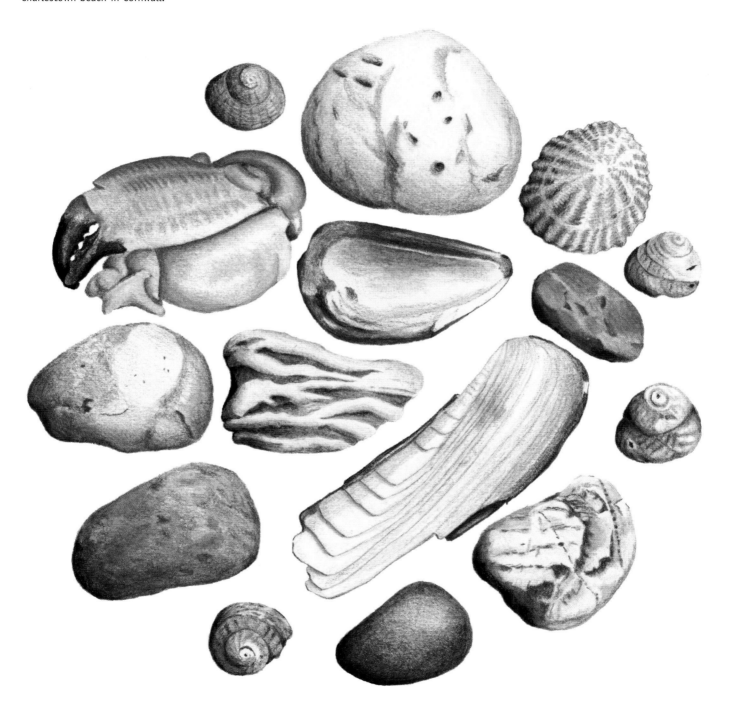

Below: Coloured and patterned pebbles and a collection of beach finds make a unique portrait of Charlestown beach in Cornwall.

8. Rocks

Few of us are able to stroll along a beach without picking up the odd shell or pebble that catches our eye. Others are positive hoarders and travel home from their holidays with a suitcase heavy with beach finds. These make very good natural history subjects for painting and can be turned into a pleasing composition, capturing the essence of place. In the illustration opposite, the pebbles are interspersed with various shells and other marine finds from Charlestown beach in Cornwall.

Exercise – pebbles

Start with very simple shapes such as a group of two or three pebbles, preferably smooth ones. They should vary in size and be both light and dark in colour and shade.

Spend some time examining the pebbles. Is one rougher than another? What are the surfaces like? Are they textured or patterned? Where do lights and darks occur? What sizes and shapes are they? Are they wide or long; if so, how wide, how long? Do they have any lumps, bumps or other distinguishing features? Are they hard, smooth, rough, shiny, dull, matt, wrinkled, pitted?

All these questions will help you to form a working relationship with your subjects, not to mention building up an understanding of them. If your picture matches your words, you are on the right track, but if your drawing of a hard, smooth pebble resembles soft animal fur, think (or rather, look) again.

Pebbles can be fairly random in scale and proportion but try to aim for accuracy, even so. When you tackle more specific subjects that rely on accuracy, your early attempts to 'get it right' will surely pay dividends.

This page: Here, semi-precious stones include leopard jasper, jade, opals, rose quartz and amethyst.

Take note also of the tones or shadows that are cast by one stone overshadowing or overlapping its neighbour. How does that tone vary from the tones found in other areas of the pebbles? Try to record as many tones as you can see. Look hard and you will probably find more. Check your tonal drawing against your tonal chart (see page 31).

Although nature consists of powerful forces, proportional harmonies, structure, order, repetition and basic pattern-forming processes, the majority of us can be content with making bold and sometimes adequate attempts at capturing, in some small part, these incredibly complex features.

By spending time looking and recording, using different materials in different ways, we are able to enjoy discovery and interpretation.

Pebbles using colour

In the natural world, colour can be as vibrant and startling as it can be subtle.

Some subjects found in the world of nature may occasionally require the use of brilliant or fluorescent colours, but for the most part natural subjects require the use of colours mixed from the primaries.

The majority of colour found in nature is subtle and understated, although areas of extreme contrast can often heighten the drama of something usually thought of as quite subdued. A good example of this is the contrast between dry and wet pebbles on the beach. When they are dry, they appear insignificant, but when they are wet with spray, rain or seawater they take on a shiny and robust brilliance, due mainly to the reflected highlights caused by the water.

How to evoke mood

Compare the different approaches used by the artists of the two paintings below. The different feelings evoked are reflected in the style of painting and the choice of composition. One, image A, is a very clear study, halfway between formal illustration and a freer interpretation, where the stones are arranged in a loose group. The other, image B, is more free-style and less representational, but they both bring to mind the sound and smell of the ocean. In each, the viewer is made to feel very much in contact with the elements and the shoreline environment.

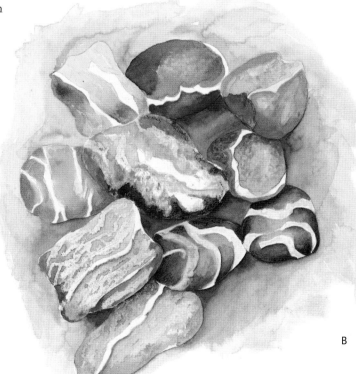

B

A

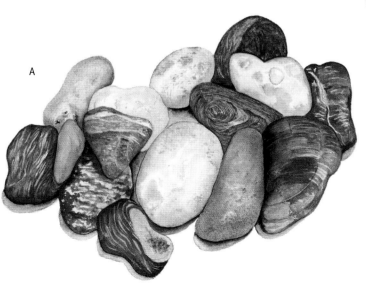

Above: These two drawings show different approaches by two artists, but both evoke the sound and smell of the ocean.

In the first drawing, image A, the beach pebbles have been painted without any shiny highlights, but the artist uses the heightened colour contrast to create a bold and realistic effect. The stones are each given their different character, and would probably be identifiable from their portraits.

Left and below: A more abstract approach, evolved from image B (shown opposite) via experimentation and selection.

The closer, more abstract approach, below, was the end result of a process evolving from the second drawing, image B. The artist masked out different sections of the painting (shown above) until a satisfactory and visually appealing area was found. This selected area was then re-painted as a scaled-up section. While not necessarily scientifically accurate, it is evocative of both substance and environment.

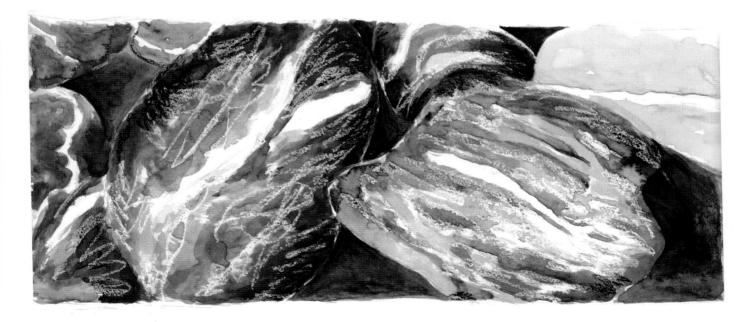

Crystals

The portrait of a piece of quartz crystal, shown right, is all done in coloured pencils. The artist's notes and colour tests can be seen on page 22, showing how she diligently made notes to herself about her work as she went along, testing all her colours. She also made a list of words describing the crystal – sharp, milky, chalky, broken teeth, clear, crisp-edged, glassy, faceted.

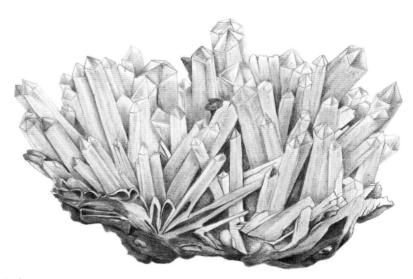

Above: This quartz crystal is full of colour and subtle shades. For the artist's notes and colour tests, see page 22.

At first appearance this subject has very little colour in it, but upon closer scrutiny it can be seen to contain many subtle shades, both light and dark. There is a lot of reflected light in the crystal because of its glassy surface and different facets.

It is interesting to note that some aspects of Picasso's cubist paintings contain the same kind of faceting as the crystal. It is therefore quite possible that Picasso was influenced by this kind of crystal formation – who knows? Similarly, most of us are familiar with the Hall of Mirrors found in fairgrounds, which gives viewers a similar multi-faceted distortion of themselves.

The rose quartz, shown below, is a good example of a light subject which, to give it more impact, has been portrayed on a dark background. Once again, this subject has been drawn using coloured pencils. The soft brown of the background is an interesting choice, giving the pink quartz a hard, glassy character in contrast.

Left: To give more impact, a light subject such as this rose quartz may be portrayed on a dark background.

Blue agate

Museums and geological collections often display cut sections of beautiful rocks and minerals. One such is the slice of blue agate shown below, which is rendered entirely in coloured pencil. All lines have been kept crisp and sharp to give the hard-edged appearance that is so vital with this type of subject.

It is often impossible to find a pencil that is exactly the right hue, and in any case the pure pigment tends to look unnatural on its own. Build up the intensity and complexity of the colour with lots of thin layers from several different pencils, using them as a dry medium.

The blue rings around the outside are a good example of this technique. The various hues were obtained with combinations of approximately 12 different blues and greens, ranging from a very pale blue-green through ultramarine to indigo with a touch of violet.

Once you have obtained the right colour, burnish each section with a white or champagne-coloured pencil. Scribble quite hard on the selected area to flatten the surface and merge the various hues together. If you find that this has dulled the colours a bit, go over the surface again with the brightest pencil in the mix. Experiment and note the results. You will find that with practice you can indicate different textures by the way you place the colours on the paper and the way they are blended together. Look at the smooth, shiny surface in the centre of the slice and compare it with the harder crust around the outside.

Below: The outer rings of this slice of blue agate used combinations of about twelve different blue and green coloured pencils.

Work slowly and patiently. Often a very light application of colour can make a dramatic difference. If you are working on a large and complex piece such as the blue agate, keep notes and sample swatches so that you can return to it and know exactly what combination of colours you have used. It goes without saying that your pencils should be kept finely sharpened if you want to achieve fine work. Watch out for a build-up of wax on the tip, which means that the pencil needs re-sharpening.

Without the use of hard coloured pencils it is difficult to achieve the crisp edges as seen here, so when using coloured pencils it is important not only to have a wide range of colours but also a wide range of brands, ranging from soft through to hard.

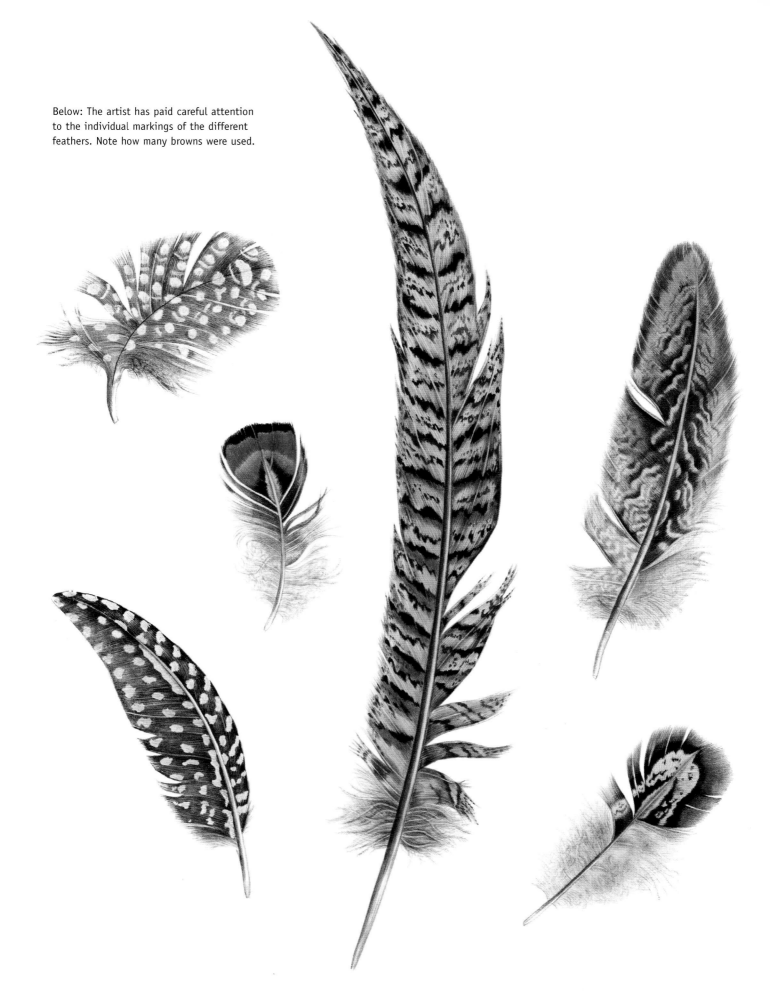

Below: The artist has paid careful attention to the individual markings of the different feathers. Note how many browns were used.

9. Birds

We are all familiar with the birds that brighten our lives with their plumage, their behaviour and their song. Country dwellers are the most fortunate, but even city dwellers have their garden birds, pigeons and house sparrows; and what more evocative sound of the seaside can there be but the mewing of seagulls?

If you have a garden with a bird table you will find that it quickly becomes a very popular avian restaurant and, if you put out the right food, you may be lucky to attract some generally rather shy birds such as treecreepers and woodpeckers.

But birds move quickly, rarely remaining still for more than a second or so, and for that reason are particularly difficult to capture on paper. So unless you use a stuffed bird or casualty as your subject, you are going to need to be able to do lightning sketches of these fast-moving creatures.

As an artist wanting to understand and paint birds, you will find it helpful to study their anatomy, not so much all their internal muscles, bones and tendons but the creative potential of interpreting flight, discovering how the various elements fold and move, looking at the various feather tracts and how they stack and slot together. Spend some time watching and marvelling at a bird on the wing, then attempt to capture its energy and the unique individual character of each species in flight, and you will find there is a grammar instantly at hand in the memory to speed the process of interpretation.

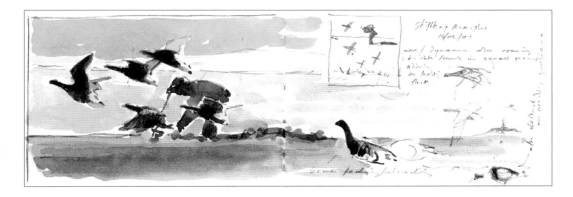

Left: Lightning sketches of fast-moving brent geese provided inspiration for the woodcut *Bait Digger and Brents*, shown on page 130.

The artist of the above illustration, *Brent Geese Ideas Development*, says: 'To my eye the relationship between wildlife and people whose work is out in the natural landscape is particularly interesting. There's something very dramatic and powerful in compositions that dwell on the interface between human activity and the cultural landscape they help create, and the surrounding natural landscape with all its animal, plant and bird life.' This sketch of brent geese on the North Norfolk coast is one of the ideas developed for the woodcut on page 130.

Left and below: Puffins (left) and red-necked phalarope (below). It is important to record differences accurately. There is no point in producing a puffin that looks like a goose, or a duck that looks like a chicken.

This artist's observational skills are so accurate that even though these are only basic shapes it is easy to see at a glance the different characteristics of the puffins (above left) and the red-necked phalarope *(Phalaropus lobatus)* (above right). It is important that differences are recorded with accuracy and sensitivity. There is no point in producing a puffin that looks like a goose, or a duck that looks like a chicken.

Notice how the habitat of the birds has been recorded and shows distinct differences between them; the puffins are shown on a rocky, windblown outcrop and the phalarope in still water. Note how the artist has used a scratchy texture for the former and smooth, textureless brushstrokes for the latter.

Try taking photographs of birds and concentrate on details such as their feet, tails, heads, eyes – take very specific, close-up photographs, or look at the work of good wildlife photographers in order to study different parts and the whole. Do not copy direct from your photographs, but use them merely as a tool to inform and to corroborate information that you have obtained visually. While photography can play a part, it is no substitute for close, live observation.

Feathers

For a start, why don't you try some feathers? They are probably the most widely available part of a bird and do not move, wilt, die or change colour. We look at feathers again in Chapter 13, Iridescence (page 117), but there are so many lovely feathers that are not iridescent and they can be extremely interesting and enjoyable to do. One example is the jewel-like blue jay feather shown below right.

The brown and white feather, below, demonstrates how to let the white of the paper do a lot of the work for you when using watercolour. There is no white paint used on this feather, yet areas of white and light grey are still apparent.

Exercise – painting a feather

Using a hard pencil (4H) lightly draw the central quill, making sure it is the correct length and thickness. Check the thickness of the quill from base to tip. It may taper towards the tip. Mark off any sections where the barbs have separated. Shade carefully the areas of tonal and colour change. If these patterns are wrongly placed at this stage, the true nature of the feather will be lost.

Taking a section at a time, lay a very pale grey wash and grade it to reveal the white paper. Complete all sections of the feather this way. When dry, start painting very fine, hair-like lines with a very small brush, using a stronger mix of paint. It is important that the lines are extremely fine and placed next to and parallel to each other. They must at all times follow the rhythm of the section, whether their direction is up or down.

In places where the feather is brown, place fine brown lines on top of the existing grey ones. This will give the correct thickness and depth to the patterning on the feather. For the darkest areas, simply repeat the process, layering a stronger mix of brown paint on top of the existing layers.

Where the paper shows white and an edge is needed, such as at the tip of the feather, paint a series of short, hair-like brown lines parallel with the barbs. You can repeat this on the edges of any section that might need it.

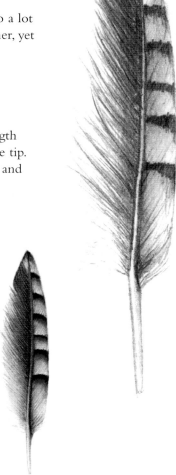

Below: This gull's feather shows a multitude of markings. Because it is painted in watercolour, the white of the paper is allowed to shine through.

Above: The jewel-like jay's feather uses a surprising number of blues.

Exercise – determining the medium

This is a page of trials by different artists using watercolour or coloured pencil. See if you can decide which is used for which. Some of the feathers are finely drawn, with lots of detail, whereas others give more of an impression of featheriness.

Feathers from game birds are shown on page 76, demonstrating an extensive range of different browns, from a grey-brown through to a yellow ochre-brown, through to a red-brown. Note how every feather has a different quality and look for the variations in the stripes.

The two spotted feathers has masking fluid applied before any colour was put on (see page 25). This is because it is virtually impossible to paint the extremely fine lines that go to make up these delicate feathers without blanking out the white spots first. If you don't use masking fluid the brush stops at every space and there is no continuity from one side to the other. With masking fluid, the brush can pass over the masked areas without breaks.

Note that on several of the feathers there are different qualities including feathery, furry or fluffy. The down at the base of the shaft is called the after-feather.

A picture of a feather needs constructing, as for any other subject. For example, any spots need to be clearly marked in the correct pattern, and stripes or markings need to be clearly defined, otherwise the end result will not display the correct characteristics of that specific feather.

You might like to try a complete wing like the one shown opposite. This beautiful specimen came from a rook that was found lying dead beside the road. If you can bring yourself to handle and dissect a casualty, it can increase your access to specimens. In order to kill any mites, the specimen should be well wrapped and placed in the freezer for a few days. Any raw flesh may then be treated with borax to prevent it rotting.

If you happen to find a dead specimen in very good condition, you could always get it stuffed and mounted by a taxidermist. Again, the whole body would need to be well wrapped and put into the freezer until it can be prepared – not something that many families would agree with!

This drawing of a rook's wing was carefully constructed with all the feathers in place. Each feather has been treated individually, showing its size and shape in relation to the others. The convex effect has been produced with the light and shade applied down either side of each feather. The feathers overlap one another and the shiny effects achieved with different grades of pencil give it depth and dimension.

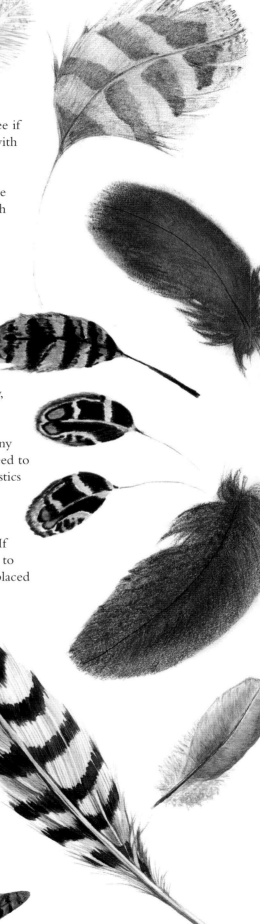

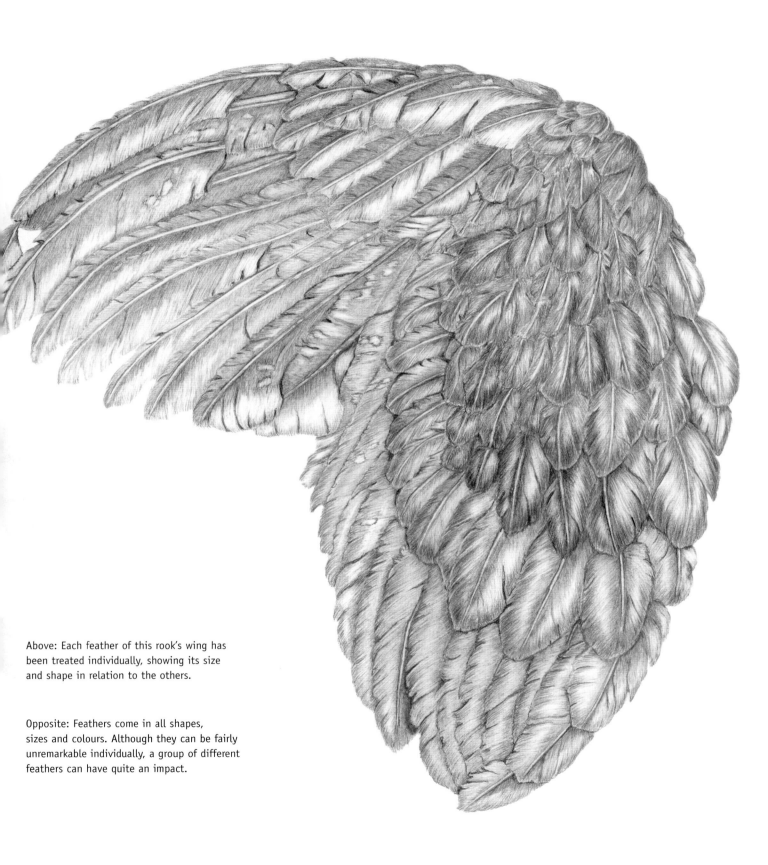

Above: Each feather of this rook's wing has been treated individually, showing its size and shape in relation to the others.

Opposite: Feathers come in all shapes, sizes and colours. Although they can be fairly unremarkable individually, a group of different feathers can have quite an impact.

The artist used just two graphite pencils, 4H and 2H. She prefers to use mechanical pencils because the balance of the pencil in the hand never changes, honing the lead to a fine point on a piece of fine emery paper.

Because graphite smudges easily she worked through a small square of paper, thus protecting the majority of the work. Even so, there were places on the finished picture where it was grubby; careful use of a small eraser was needed to clean it up.

The drawing of the wing was built up in layers, taking care to retain the delicacy and featheriness of the subject, and as a final touch, part of the wing was treated with coloured pencils to give an idea of the colouration itself.

The whole project took about six weeks, working for two hours a day, with a whole day at the end to finish it off to presentation standard.

Stuffed museum specimens

Look in your local museum to see what there is in the way of stuffed birds – or any other animal, if it comes to that. It is always possible to set yourself up with a little stool and a drawing board in museums and zoos in order to study, paint and draw natural things. Some museums have collections that they lend out to schools, and you might be able to arrange to borrow some of these. Speak nicely to your local museum curator!

The pheasant shown below is exactly that – a stuffed specimen in a glass case in the local museum. The artist was able to make close-up studies of all parts of the bird before settling down to draw it. Some of the feathers have been left as pencil and some have been coloured using coloured pencils. This drawing could also form the basis of a finished painting, which could include some of the habitat of the pheasant to give more rounded information.

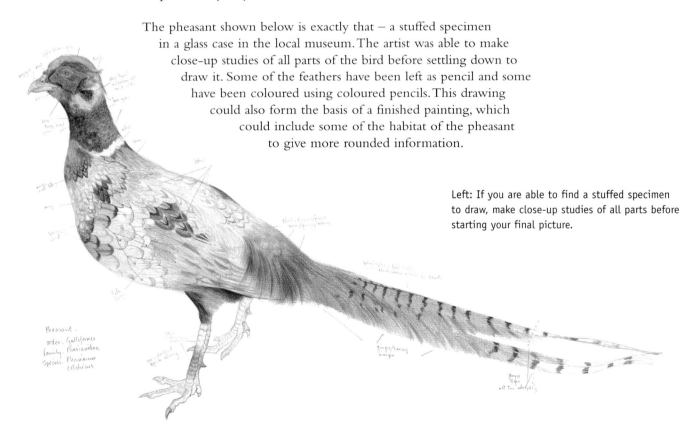

Left: If you are able to find a stuffed specimen to draw, make close-up studies of all parts before starting your final picture.

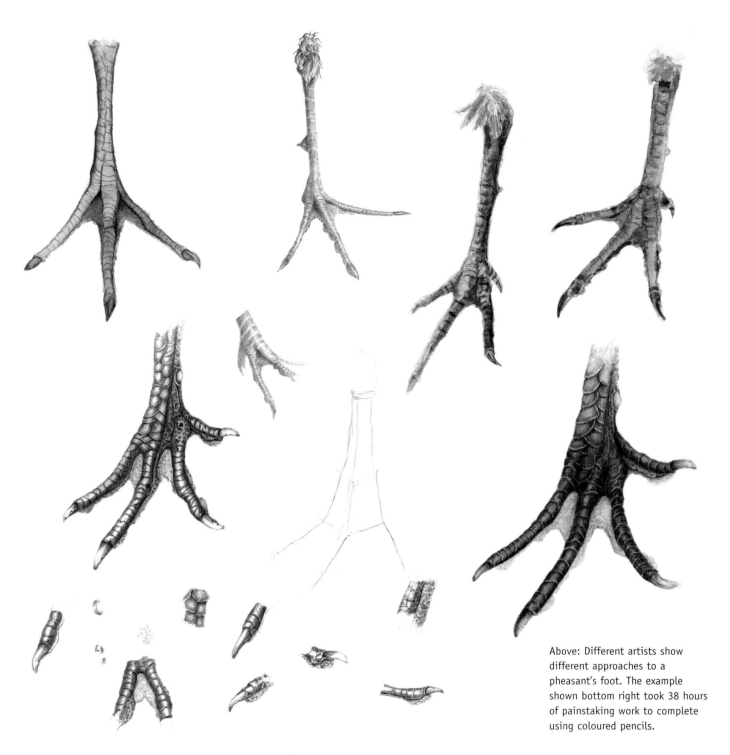

This page of pheasants' feet, each drawn by a different artist, shows the many diverse ways in which a simple subject can be portrayed. Each little study shows the scaliness of the limb, and there are some superbly sharp claws.

The pheasant's foot, shown bottom right, is worked entirely in coloured pencils. It took the artist 38 hours in all to complete the work, which can be justified by the fine detail and immaculate presentation.

Found specimens

The heron shown below was found frozen in the depths of winter in the River Chess in Hertfordshire. The person who found it gave it to the artist, who then used it as the subject of an etching. Even though the bird was dead, the etching conveys elegance and shows the bird's sharp, predatory beak and powerful wings.

The blue petrel *(Halobaena caerulea)* is one of the most enigmatic and beautiful of the small petrels of the Southern Ocean, Antartica. At sea they are wonderfully light and buoyant in flight, and on their breeding grounds on remote sub-Antarctic islands they come and go at night. Therefore, when they are briefly on the ground during the breeding season, and when at sea, they are extremely difficult to observe and draw.

For a period, each austral summer, the artist lived on Bird Island, South Georgia, where the blue petrel is a common breeding species. Sometimes, when the visibility at night was very poor because of mist and fog, even the faintest light from a window or generator shed would act like a homing beacon and attract these and many other nocturnal burrowing seabirds. Despite the best efforts at a complete blackout sometimes birds would crash land – and occasionally there would be fatalities.

He found this blue petrel dead early one morning before the predatory and scavenging skuas had got to it, so was able to study closely the structure of its 'tubenose' bill and the subtle colouration of its head plumage.

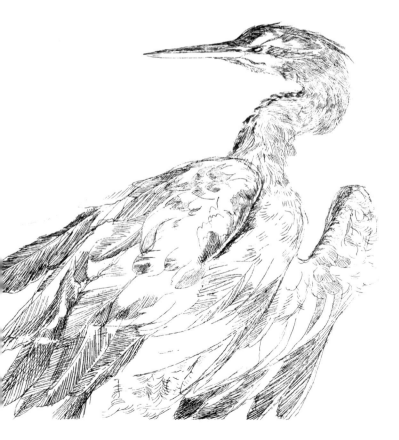

Left: Even though this heron is dead, the etching conveys elegance and shows the bird's sharp, predatory beak and powerful wings.

Below: The blue petrel comes and goes at night so is extremely difficult to observe and draw. This window casualty was found on Bird Island, South Georgia.

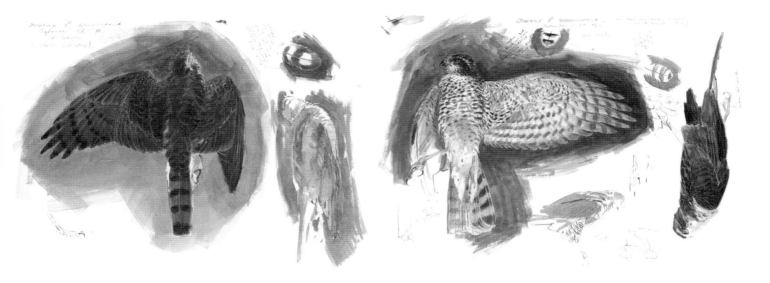

The artist chose a green mid-tone paper and accentuated the background for the various studies with aquamarine. The various notes read: 'bottom of eye part markings and part 'pine-cone' effect; contour lines on upper mandible; and [of the underside of the beak] – pouch (skin).'

The same artist painted the juvenile male sparrowhawk *(Accipiter nisus)* (above), making two studies from a dead specimen after the bird had flown into a window in Cambridgeshire in September 1993. He notes 'rufous spots larger and more distinct/progressively on upper chest and flanks', 'undertail coverts' and 'stacking tail underside', and that the two sections of the leg are of equal lengths.

Above: Studies from a dead juvenile male sparrowhawk were made in Cambridge in 1993 after it had crashed into a window.

Stylized portraits

There are no hard and fast rules about how you should portray your subject, except to say that your picture should be as informative and factual as possible.

The pelican, shown right, has been designed in a very representational way, with every feather and wrinkle lovingly shown. Look at the perfection of the cruel eye, and the attention to detail given to the various different textures: in the long beak, the light feathers, the dark neck feathers and on the breast and back.

Right: This pelican portrait has been designed representationally – look at the perfection of the cruel eye, the long beak and the different types of feathers.

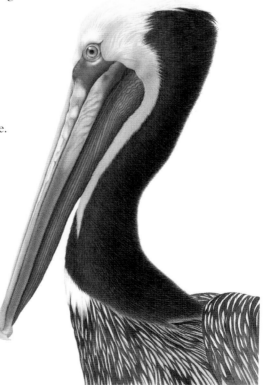

Above: The wasp, bluebottle, spider, stag beetle and dragonfly all demand a fine brush and a steady hand.

10. Bugs

Bugs are almost as difficult to draw as birds – they move about just as much and perhaps even more quickly.

In many cases, catching bugs is not an option as it is still extremely difficult to keep them captive and motionless for long enough to draw and paint. However, unlike birds, dead insects are often found around the home or on a walk, and these can be quite challenging to paint.

The dragonfly, left, had been dead for a very long time. Its body was completely dried out and it had lost all its iridescence and some of its legs. But the challenge was still there – to get the colour of the abdomen right, to show the minuscule hairs on the thorax and legs, to get the right shine on the huge black eye and, most important and challenging of all, to show all the minute tracery of the wings.

The bluebottle was equally challenging, with its tiny size and rather coarse hairs on the thorax and abdomen.

The wasp was in the hunched-up pose typical of a dead wasp, and it was interesting to note the size and solidity of its antennae and the oh-so-thin 'waist' (petiole) between thorax and abdomen. The black and yellow stripes are a clever warning – 'Keep away from me, I'm dangerous'. (See Chapter 14, Display and mimicry.)

The spider had drowned itself overnight in a bowl of water. The artist was able to spread out its limbs while it was still wet and supple. Being an arachnophobe, she would never have been able to paint it if it had not committed suicide first. Even so, the mere act of painting the fine hairs on its legs, abdomen and pedipalps (the short appendages near the spider's mouth) was a real trial.

The robust stag beetle is a symphony of blacks and browns. Its hard, shiny body and wing cases were painted with controlled graded washes, often several superimposed one on another, and the legs and antennae needed a very fine brush.

Above: Whereas the dragonfly on the opposite page could be in flight, this one looks as though it has momentarily settled on the page.

To paint small insects, unless you have perfect close-up vision you will need to use a powerful magnifying glass. If possible, use one that is on an adjustable stem, either clamped to your painting table or with a heavy base. You will be looking through it for quite a long time, and holding one in your spare hand is not an option, as you will need that hand for other things.

Something reasonably robust like the dragonfly could be held in place with a 'third arm', an adjustable apparatus with rods and wing nuts and miniature clamps, available from model-makers' shops and art suppliers. In contrast, the spider was arranged on a piece of white card and was held in place by its own adhesive feet.

'The bluebottle and the wasp were more of a challenge,' writes the artist. 'They were too fragile to hold in the clamp of a third arm, but after several abortive experiments I discovered that I could hold them in the right position by rolling a strip of masking tape round a finger, sticky side out, sticking it to the drawing board and then gently attaching them to it.'

To paint a life-size portrait of something as small and delicate as an insect, you will need to use very smooth paper. The insects mentioned above were painted on Arches HP paper. You will also need some very fine brushes. The smallest used here was a size 4/0 with a very good, fine point.

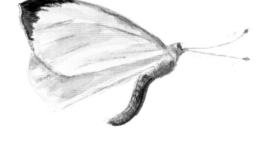

The principle of painting an insect is much the same as for any other watercolour subject. Having drawn it, being careful to get all the proportions correct, establish where the highlights are (for instance, on the eye) and mark them lightly in pencil.

There are two ways of setting about painting a tiny insect, particularly its legs. The first is to mix up a small amount of the lightest colour – the advantage of a subject as small as this is that it is extremely economical with paint – and apply it as a wash, avoiding the areas of highlight. Then build up the colours where necessary to denote areas of shadow.

Above and left: Although these butterflies were already dead when found, they have the appearance of being in flight.

Alternatively, since you have to be so very precise in your work, you might prefer to paint in the darker areas of the legs first, using your finest brush and making a very fine line on the side of the subject nearest the light and a stronger line on the shaded side. This has the benefit of clearly defining the edges of your painting area. It is then a simple matter to grade these lines away from the edge and finally fill in with a light wash – again taking care not to cover any highlighted areas.

Where a subject is segmented, such as the abdomen of the dragonfly or wasp, treat each segment separately and notice how the colours vary from one to another.

Wings need a gentle, steady and precise hand. Keep the veins fine and light. Study the wings carefully. Even though they may appear colourless, you might well find that a slight wash is needed where one wing overlaps another. Proceed cautiously – you may need just a smidgen of paint with a lot of water to create the right effect.

At the very end, paint in any fine hairs. Take your smallest brush, pick up a small amount of paint and – this is extremely important – test it on a piece of scrap paper to make sure that you have got enough paint to make a fine line but not so much that you get a blob. Work on each hair from base to tip, raising your brush at the tip of the hair so that the line of paint is tapered.

A row of colourful beetles, shown below, can make a pleasing composition. It is important to make sure that even with such a small subject you get a range of tones from very light to very dark. Notice also where any highlights are on the shiny elytra (hardened forewings) and make sure that you leave them unpainted until the very end, when you might want to give them a light colour.

Below: A row of colourful beetles. From the left: flower beetle (*Torynorrhina flammea*), Asian frog beetle (*Sagra femorata*), another flower beetle and a jewel beetle (*Chrysochroa rajah*).

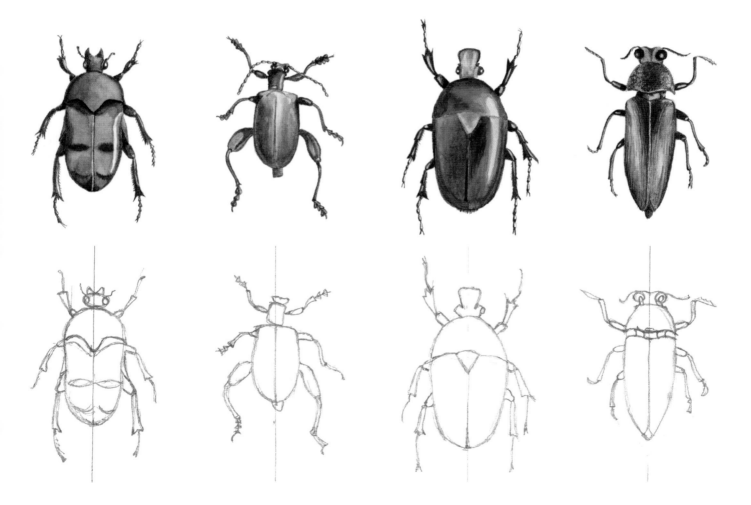

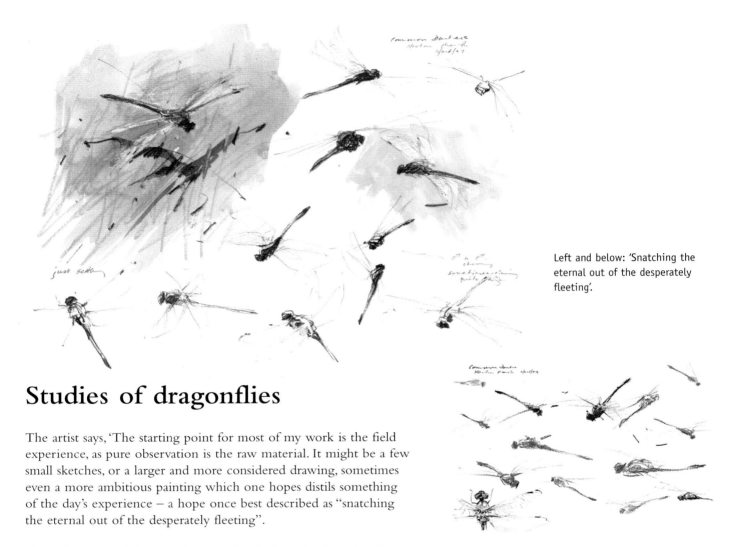

Left and below: 'Snatching the eternal out of the desperately fleeting'.

Studies of dragonflies

The artist says, 'The starting point for most of my work is the field experience, as pure observation is the raw material. It might be a few small sketches, or a larger and more considered drawing, sometimes even a more ambitious painting which one hopes distils something of the day's experience — a hope once best described as "snatching the eternal out of the desperately fleeting".

'Sometimes something straight from the field can be framed and exhibited, but mostly one finishes the day with a whole range of snatched ideas, detailed sketches, themes and notes, which can be taken back to the studio to be viewed in a new light and worked through in many different ways using a range of methods and materials. The above sketches from an autumn day out on the North Norfolk marshes in October were made in a small (A6) pocket sketchbook that I have with me almost all of the time.

'In every sheltered pocket along hedges and between ditches there were dragonflies galore — lots of common darters, some brown hawkers and one or two much larger common hawkers. It was the warm, rusty red colour of the male darters that immediately caught my eye. One moment suddenly seen against the cold blue of the sky as they climbed high, then low down crossing the tangled autumn colours of brambles and hawthorns, then darting in and out of the sunlight and shadows and sometimes settling — once on my sketch pad!'

Exercise – butterflies and moths

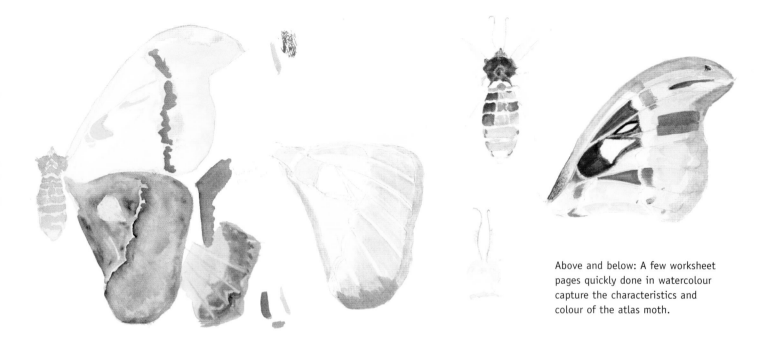

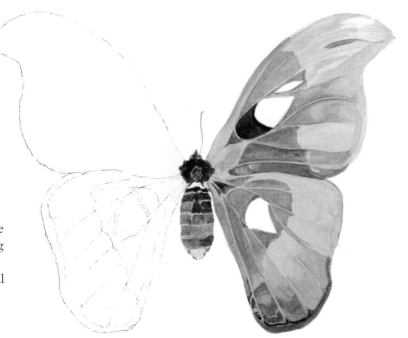

Above and below: A few worksheet pages quickly done in watercolour capture the characteristics and colour of the atlas moth.

You may be fortunate enough to find a large and beautiful insect, such as the atlas moth shown on page 92, but run out of time to paint it. Even a few worksheet pages quickly done in watercolour (as shown on this page) are better than not attempting it in the first place. Even though you will not have a fine finished painting, you will have learnt so much about the colours of the wings, the formation of the body, the set of the legs and the antennae.

If you do have the time to work up a finished picture, it is worth first of all doing a lot of research on colour and techniques, such as:
• Layering of colour
• Scratching with a scalpel
• Stippling
• Shading and burnishing

Close inspection of your subject will reveal multi-layers of colours and textures.

Use coloured pencils for this exercise, as these enable lightness of touch. Draft the outline lightly with a hard pencil, or use a coloured pencil in one of the pale colours of the moth. But be careful with the colouring of the moth to ensure that base colours are identified and laid before you begin the layering process. You will find that you can achieve texture and the density of colours by blending many tones.

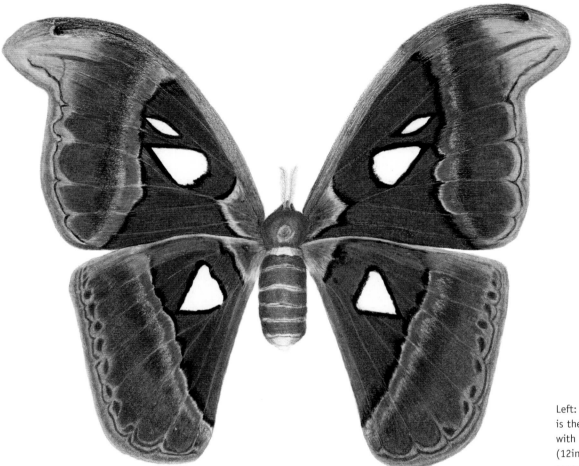

Left: The atlas moth *(Attacus atlas)* is the largest moth in the world, with a wingspan of up to 28cm (12in). Treat the picture as five separate units; two for each wing and one for the body.

Notice how, because of their complexity, colours and textures vary even within specific colours, so there is no truly consistent relationship between colour and texture. You may also find that only certain forms of daylight permit true identification of these areas.

Treat the picture as five separate units: two units for each pair of wings and one for the body. You may well find that they have differing colour and texture characteristics.

Don't hurry your work; it is more important to portray all the fine detail faithfully. The atlas moth shown above took 60 hours to complete and in most places there are at least 15 layers of coloured pencil that have been blended and scraped. You will find a magnifying glass very useful to help you to establish the fine colour and textural transitions of the moth.

Right: The female oak eggar moth *(Lasiocampa quercus)* is a particularly furry moth, needing very fine strokes with a fine brush.

When painting butterflies and moths for identification purposes, it is not necessary to show both wings as they are fairly symmetrical. The fine painting of a female oak eggar moth *(Lasiocampa quercus)*, opposite, is a good example of this. Some artists show the upper wing on one side and the under-wing on the other. However, if you can show both wings, and particularly if you make a composition of several different butterflies one above the other, as shown right, it can be extremely attractive.

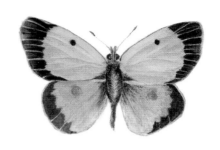

A good example of how to draw wings is shown below, the purple emperor butterfly. With careful observation, draw just one wing and the body. Put in all the necessary markers such as shape, pattern and structure. If you prefer to show both wings, transfer it to your watercolour paper using a light-box or by taping it to a window (see page 28), then turn the drawing over, align it with the tracing of the body on the watercolour paper and trace off the other set of wings.

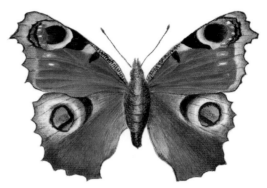

The colouring of the purple emperor butterfly demonstrates the difficulty of portraying the shimmering wings of some butterflies. The purple lights on the wings are rather like a hologram – they show up only when the wing is held at a certain angle. This is ably demonstrated by painting the wings on the right with more purple than those on the left. When the purple patches are not visible, the butterfly appears a drab brown.

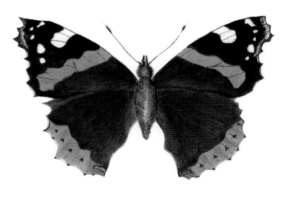

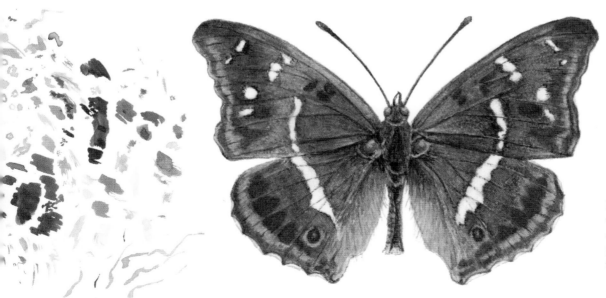

Above: Placing butterflies one above the other makes a pleasing composition.

Left: The shimmering wings of the purple emperor butterfly can present difficulties for the artist.

Left: As with this monarch butterfly *(Danaus plexippus)*, paint a wing at a time, taking care to note where they divide and overlap.

The blue *Morpho adonis* butterfly, shown below, also presents problems because of its iridescence. From one angle it appears bright turquoise, at another angle it is deep sapphire blue and occasionally there is a glimpse of various pale shapes that appear, and then disappear, like half seen bubbles in a mist.

To try and achieve all these effects in the one painting can be quite tricky. If you are going to try to paint a butterfly like this, you will find that you will need to use several very thin layers of paint in order to show all the colours, shapes and effects. Paint a wing at a time, taking care to note where and how the wings divide and overlap. Wash clean water over the area to be painted and then drop in the various different blues wet-into-wet. When dry, enhance the area of each different blue with more layers of the same colour. Don't forget to leave out any areas that are without colour to let the white of the paper shine through.

Build up the small areas of detail after all the background layers have been painted, using a fine brush and slightly deeper colour.

Paint the body and the antennae at the very end, using a very fine brush, strong paint and careful strokes.

Left: The colours of the *Morpho adonis* butterfly appear and disappear due to its iridescence.

The American moon moth *(Actias luna)*, shown below, has an extremely furry body, the fur extending for quite a way onto the wings.

Again, paint each wing separately. You could use masking fluid on the four pink spots and allow it to dry thoroughly before applying any paint. Paint each wing with clean water and then drop in pale blue, pale green and pale yellow, wet-into-wet. Take care to avoid the furry areas, as they must remain white for the time being.

As with the *Morpho adonis*, allow to dry and enhance each area with more of the same colour. It is important not to paint the tails with any strong blues and yellows because of the rusty-pink patches, which have to be applied over the top. This is because if you put pink on top of green it becomes brown, and if you put pink on top of yellow it becomes orange.

When the washes are dry, paint in the detailed areas, such as the sides of the wings. Make sure your painting is completely dry, then gently rub off the masking fluid with a hard, white rubber and paint in the four pink spots, leaving a small, white inner spot. Use a strong self-mixed black paint and a fine brush to put in the darker marking on the spots.

To paint the head, body and the fur on the wings you will need both grey and pale brown paint. For the grey, you need to water down some of the black paint that you have already used. Do the same for the brown but add a small amount of red and yellow. Build up the furry texture by overlaying tiny strokes of grey and brown paint until the body has a furry three-dimensional appearance. Note that the body is slightly darker on one side, indicating the light source.

See also that the dark red band on the leading edge of the upper wings extends across the back of the head. Mix a dark brownish red and use this diluted for the first wash. When dry, apply the same dark colour making sure that areas of the light wash are left showing. Lastly paint the antennae and the legs. The antennae are a series of extremely fine lines like miniature feathers. You may need to practise on a piece of scrap paper to make sure that you can get the lines fine enough.

Above: The American moon moth *(Actias luna)* has an extremely furry body, the fur extending for quite a long way onto the wings.

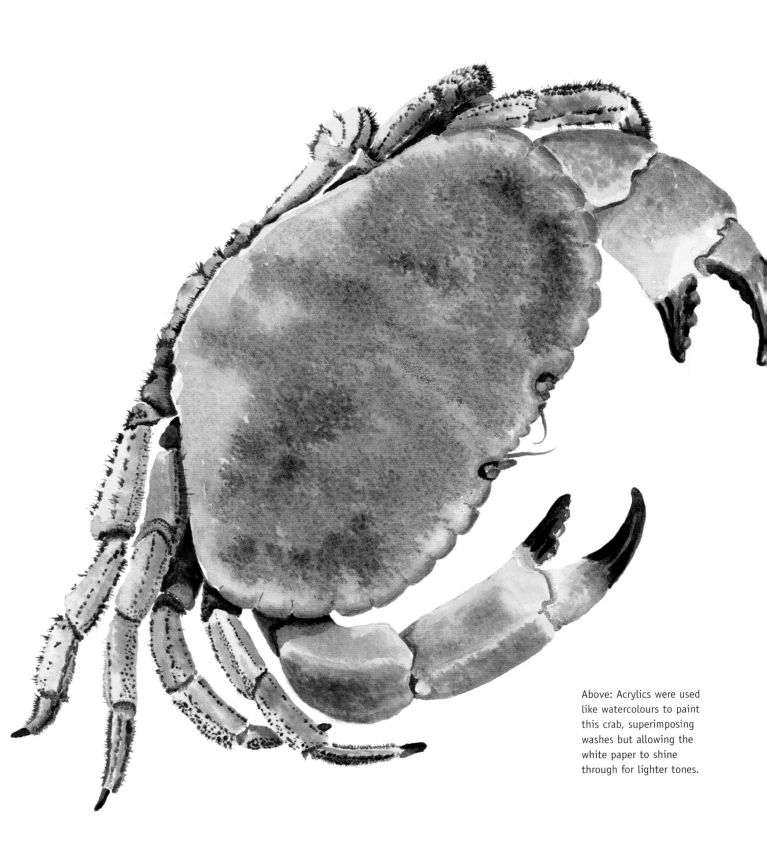

Above: Acrylics were used like watercolours to paint this crab, superimposing washes but allowing the white paper to shine through for lighter tones.

11. Sealife and spirals

Beautiful beaches, rock pools and marine wildlife provide a veritable cornucopia of crabs, fish, shells, seaweed, snails, bugs, gemstones, pebbles and fossils, and are a wonderful source of inspiration for the natural history artist.

Whether it is the pearly sheen on the skin of a mackerel, the density of a pebble, the glitter of a shell or the robustness of a crab, there are so many wonderful subjects for painting.

The crab (opposite) is an example of the use of acrylic paints. They are usually used rather like oil paints, mixing white with other pigments to give lighter tones. However, the crab was painted using acrylic paints as if they were watercolours, applying them wet-into-wet and superimposing washes one on another. It is a very demanding discipline to use acrylics as watercolours, as they have to be sufficiently diluted to allow the white paper to shine through.

The disadvantage of using acrylics in this way is that you have to be much more focused on what you are trying to achieve. Once the paint is dry you are not able to move it around in the same way as you can with watercolour. Many artists find that when using watercolour they lift off almost as much paint as they put on, laying and removing washes until the effect they seek is achieved. With acrylic paints this is not possible.

Compare the tough texture of the crab shell with the robust, shiny claws and its delicately fringed legs.

Barnacles have a very rough, ridged texture. Their shapes are reminiscent of small volcanoes. This artist has used watercolour in a linear way to create the serrated exterior of the barnacles (below). The painting could be called monochromatic, as the colours used are variations on pinky-purples in different strengths. Even though the painting is unfinished, the character of the subject is displayed very well.

Below: The artist has used watercolour in a linear way to create the serrated exterior of these volcano-like barnacles. Notice the attractive way she has tried out her colours on the worksheet first.

Exercise – Beach finds

An interesting exercise is to walk along a beach collecting anything that takes your fancy. It may be shells, pebbles, feathers, crabs, driftwood or seaweed. Whatever you end up with, the challenge is to paint everything so that it is realistic and to the correct scale.

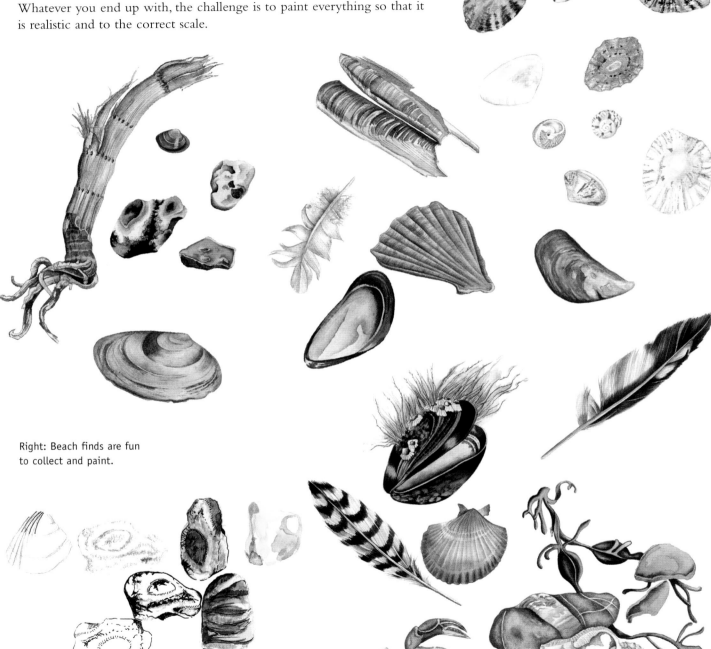

Right: Beach finds are fun to collect and paint.

Once you start beachcombing in this way you will notice the subtle differences between beaches – the predominance of red in the colour of the pebbles, perhaps, or the type and size of the shells, or the type of seaweed that is most common on any particular beach.

Some of the flotsam and jetsam brought in by the tide is fascinating too, such as pieces of timber, smoothed by time and riddled with holes made by the teredo worm, also known as shipworm, which bores into wooden structures such as wooden ships and piers found in sea water. A subject such as this, shown below, lends itself to a simple pencil study, using rough shading and defining the knots and worm runs with darker (softer) pencils.

Right: A piece of sea-worn timber, riddled with shipworm holes, makes a good subject for a pencil drawing.

The extraordinary, rather menacing creature shown below is a crown-of-thorns starfish *(Acanthaster planci)*. Its appearance echoes its nasty character: it is believed to be threatening the 'coral triangle' in Indonesia, which is the home of the world's richest coral reef biodiversity. Large numbers of the starfish are destroying the coral by feeding on it. The starfish spreads its stomach over the coral and liquefies the tissue by the use of digestive enzymes. This particular specimen was found on a beach. The artist used just two pencils, a 2H and a 2B, and it took her 20 hours to plan and draw it.

Left: The menacing appearance of the crown-of-thorns starfish echoes its destructive character.

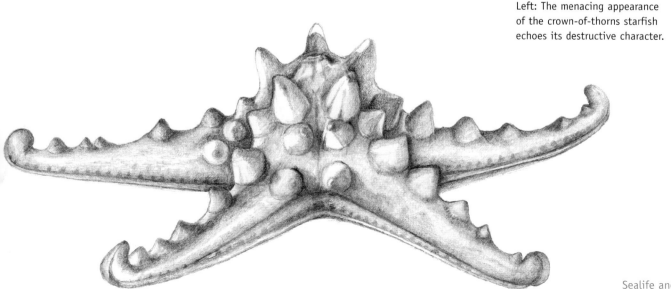

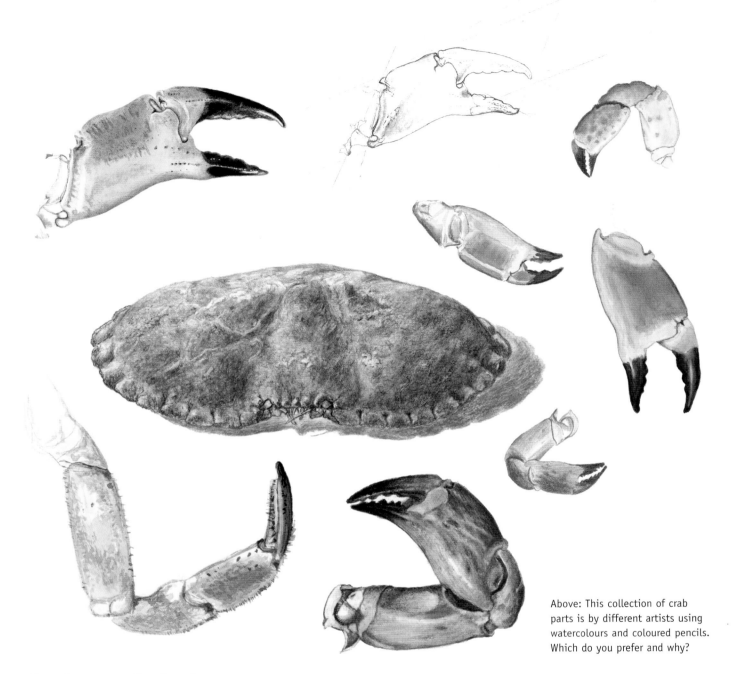

Crabs and their parts

Any beach walk is likely to reveal crab shells, claws and occasionally the whole creature. They are colourful and small and lend themselves to experimentation.

The worksheet, shown right, shows where the artist has tried out her materials first, using watercolour. This sort of experimentation is never time wasted, especially if it gives you a chance to try out different mixes of colours – and notice what a broad range of colours she found in the simple crab's claw.

The above illustration is a collection of small crab studies by different artists, using watercolours and coloured pencils. Study them carefully. Notice the different treatment according to the medium used. Decide which you prefer, and why. Is it because you find it closely resembles the subject, is it decorative, is the colour good, has the medium been handled well? All these questions can help you to understand and appreciate the different ways of handling a subject.

Above: This collection of crab parts is by different artists using watercolours and coloured pencils. Which do you prefer and why?

Below: Notice how many different colours the artist has found in a simple crab's claw.

Exercise – shells

The composite illustration below is of seashells by different artists. Along with all other subjects, shells must be carefully observed to understand their form (see page 28). Make quick studies of the basic shapes of the shells, and if you choose a complex shell, use your drawing techniques to plot the overall shape before starting to decorate with pattern and texture.

Study the shells on this page, the methods of portrayal, the mediums used and their effects. Next time you walk on a beach, see what you can find so that you can make your own studies of seashells. Don't confine yourself to using just watercolours, or just coloured pencils. Try using mixed media so that you combine different materials and see what happens. Be adventurous – you have nothing to lose.

The worksheet, bottom right, shows a decorative way of treating a mussel shell that is covered in barnacles and strands of seaweed on a coloured ground. The artist has used a loose style here, but it suggests movement and solidity.

Below: Make a collection of seashells and try combining different mediums – be adventurous!

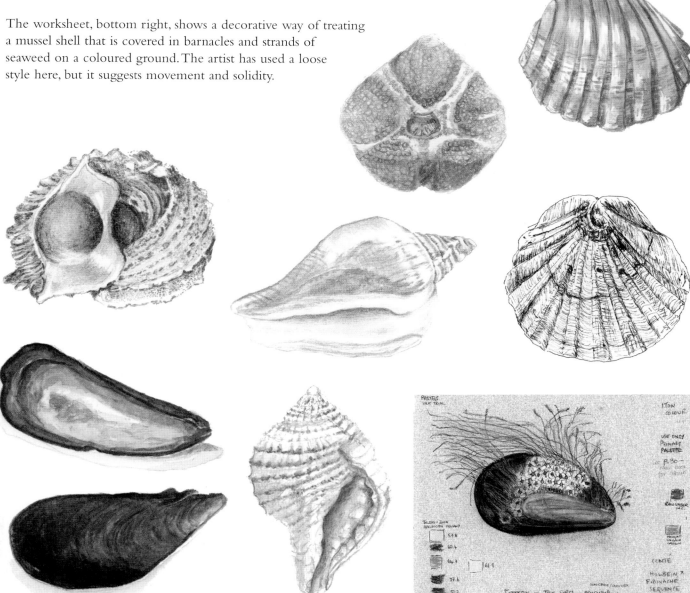

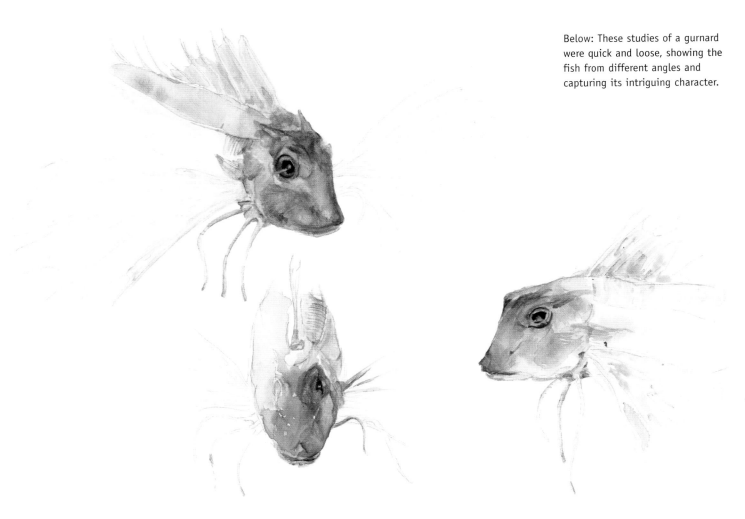

Below: These studies of a gurnard were quick and loose, showing the fish from different angles and capturing its intriguing character.

Painting moving fish

Drawing fish and other aquatic creatures while they are swimming in tanks is difficult but not impossible. Begin by carefully observing the animal you have chosen to draw, noting its posture and demeanour and its position or pose in the water. Using a pencil, draw its overall shape, checking the length and width of the body, the head and tail, and its size in relation to the other fish. Look carefully at the eye, noting its size and shape and whether it lies flush to the head or protrudes.

Gradually build up the rest of the fish by concentrating first on one part of the body, for example the head. When you are satisfied with what you have drawn, move on to another part of the body. It requires patience and concentration to build up the drawing, adding more details, perhaps adjusting parts of it, or making further drawings of a particular part of the fish that proves difficult to capture. Make written and colour notes of things to consider when you work on the final painting.

When you are happy that you have captured all aspects of your subject, put them all together into one drawing. At this stage you can add any patterns or markings and colour. Concentrate on putting down all the information accurately while keeping an eye on its movement and habitat.

If necessary, use scientific reference books to check details and to make sure that you have included any specific features that may be vital for distinguishing different species.

If you are working in an aquarium you may find that the general light level is low, making it difficult to see what you are drawing. This lighting can distort colours when mixing paints together, so it can be sensible to abandon your paintbox in favour of coloured pencils. You will also find that colours are affected by different depths in the seawater. Red light is absorbed rapidly near the surface while blue light penetrates to the greatest depth. An animal may appear drab when submerged at 10m (33ft), but display myriad colours when brought to the surface. For this reason, try to choose the animal in surface light as this is when its colours are the most beautiful.

When you have noted enough information, carefully trace the drawing onto watercolour paper (see page 16). This takes concentration, as it is very easy to alter the lines so that something is lost from the original drawing. Use a putty rubber to erase the graphite, leaving a faint line drawing. Then gradually build up the colour by applying thin washes of watercolour, working the image up as a whole and finally adding the details. You may find that you can enhance certain areas or detail by using well-sharpened coloured pencils.

Painting motionless fish

A gurnard is a very colourful fish, obtainable from fishmongers, but it loses its colour after a couple of days on the drawing board. The watercolour sketches, shown opposite, were of necessity quick and loose, showing the fish from different angles and capturing its intriguing character.

Another fish that is easy to obtain is the mackerel, shown below. Here the artist has concentrated on the head, working in very fine detail. Probably the most difficult part of the head is the eye, and if you don't get it right it will affect everything else. Study it with a magnifying glass and make several trial drawings and paintings. More information on mackerel can be found on pages 120–121.

Below: Concentrate on the head of the mackerel, particularly the eye, and work in very fine detail.

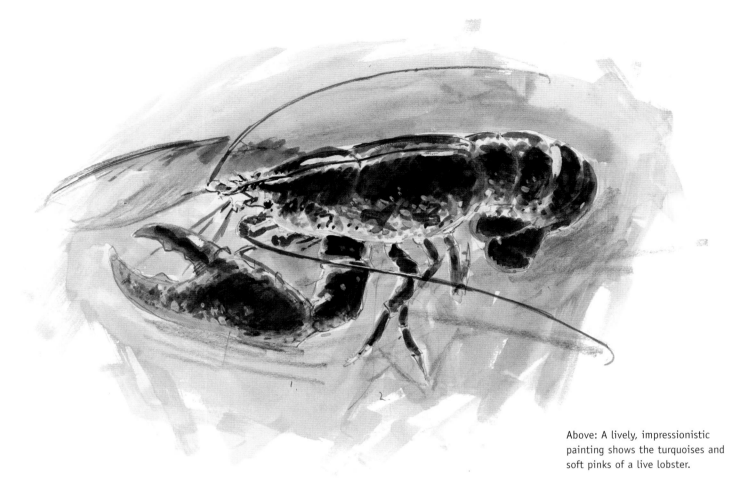

Above: A lively, impressionistic painting shows the turquoises and soft pinks of a live lobster.

On a trip to the Western Isles of Scotland a friend of the artist caught this lobster (above). Many of us think of lobsters as being essentially red (as they are when cooked) but the iridescent blues, turquoises and soft pinks of this specimen are astonishing and very beautiful.

The painting shown opposite (far right) is also from a sketchbook page, but it gives a very detailed portrayal of a common lobster *(Homarus gammarus)*. This formal arrangement correctly shows all aspects of its construction. Notice how it is only necessary to show the legs on one side of the body, since they are identical on both sides. However, both the claws have been shown as they differ, one being larger than the other.

The artist writes: 'Having made a series of drawings in my sketchbook, I decided to use 600gsm Arches HP paper to work out just how I was going to tackle all the markings on this lobster. The finished painting would be very large, so I needed to use a large sheet of paper as the watercolour block was not big enough.

'Common lobsters are at their most blue as juveniles. They grow by casting their shells. At each moult the blue gradually darkens until it is blue-black in a mature animal. I decided to use masking fluid (with a fine-nibbed pen) for all the markings. I put these in first, which meant I could cover the whole lobster with blue washes until the desired depth of colour and tone was achieved. Once thoroughly dry, I carefully rubbed the masking fluid off. This exposed the white paper underneath. As the markings on the lobster were cream, I then had to paint each one in.'

Galathea squamifara (squat lobster.)

Left: Two sketchbook pages of the squat lobster *(Galathea squamifera)* and the common lobster *(Homarus gammarus)* show how the artist has made notes to help her tackle the final picture.

A good example of dividing elements of a large picture is the antenna on the left-hand side, shown above, which has been 'cut off' and placed alongside to avoid having to draw the lobster on a long, thin piece of paper to accommodate the antenna in situ. However, the artist comments: 'Although the very long antennae are shown incomplete in the drawing, the finished painting would show them full length, reaching forward.'

Another sketchbook page is shown above left, of the squat lobster *(Galathea squamifera)*. The lobster was placed in a shallow tank in good light, lending itself to the use of watercolour paint.

Shell spirals

Because a lot of shell shapes are based on a spiral, it is important to study and understand the formation of the spiral and to build it into the basic shape of the shell. See how the spiral broadens as it curls its way to the outer edges of the shell, starting very tight and becoming gradually wider and wider.

Right: Some shells are built in the form of a spiral, which broadens as it curls its way to the outer edges.

Nautilus

It would be perfectly possible to draw a complicated subject such as the cross-section of a nautilus shell without knowing anything about it. But how much more interesting it is to do a bit of research and discover a bit about its life and why it is shaped as it is.

The shell of the chambered nautilus is a wonder of nature and is among the best examples of an animal conforming to a striking mathematical shape in its body structure. The nautilus grows its shell in a spiral form known as a logarithmic spiral. This allows the nautilus to maintain a consistent shape and always to be protected as it develops into an adult. The chambers of the nautilus shell are used to control its buoyancy, allowing it to sink or rise at will as it hunts crustaceans on the sea floor. As the nautilus grows, its body moves further into the expanding shell and it periodically closes the chambers, leaving a hole between each one and its neighbour in order to control the amount of gas and water in the chambers.

To draw the cross-section of a nautilus shell below, the artist admitted that he actually ended up doing it by measuring the shell with a ruler and tediously plotting points in a somewhat haphazard manner. He said, 'the correct mathematical way of plotting the shell defeated me (terrified of maths) so I'm afraid I don't have a method I can describe other than to state that I spent a great deal of time measuring and getting very frustrated.'

His pencil drawing indicates the slenderness of the chamber walls by using a complete range of tones from the very lightest to pitch black, the sort of tonal shading that can only be done if the subject is studied under extremely good and well-angled lighting. The delicacy of the nautilus is enhanced by placing it on a dark surround.

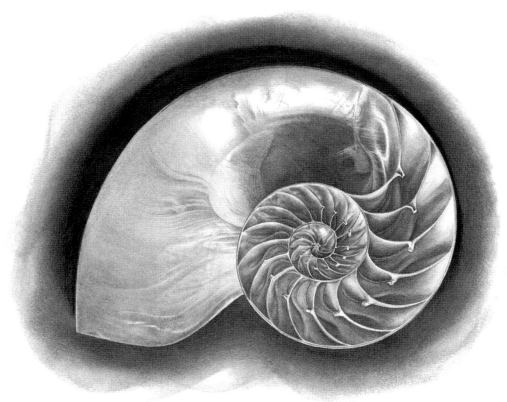

Left: The artist may well have spent a great deal of time 'measuring and getting very frustrated', but the magnificent result clearly made it worthwhile.

Exercise – the Fibonacci sequence

You will need a sheet of A4 paper, a sharp pencil, a ruler and a drawing compass. Even if you are not mathematically minded, this is a very easy exercise. Just follow the instructions below.

A nautilus shell, and that of certain snails, is a logarithmic spiral, constructed on the principle of the golden mean, also known as the golden spiral or the golden proportion, which itself is based on the Fibonacci sequence of numbers, discovered in 1202 by Leonardo of Pisa, who was known as Fibonacci.

The Fibonacci sequence is not found only in nature – it is the most efficient way for plants to assemble seeds, leaves and petals. It has also been used in innumerable ways by artists, architects and designers. The Eden Project's Core building in Cornwall and Peter Randall-Page's *The Seed* within it (see page 132) are both examples. It can also be found in the inner ear, violins (Stradivarius's F-shaped holes on the top of a violin), goats' horns, the spirals of a sunflower seed head or a pineapple, a hurricane and the flight pattern of certain bats, to name just a few examples.

The Fibonacci sequence begins with zero and one and then each subsequent number is the sum of the previous two:

0+1=1, 1+1=2, 1+2=3, 2+3=5, 3+5=8, 5+8=13 ...

Giving 0 1 1 2 3 5 8 13 21 34 55 89 144 233 377 610 ad infinitum.

Typically the spirals on a sunflower head, for instance, go in two directions and relate to two consecutive numbers in the above sequence, for example, 34 in one direction and 55 in the other.

To make your own Fibonacci spiral, take a sheet of A4 paper and rule a rectangle 27.5 x 17cm (the numbers 55 and 34 halved). For simplicity we are using centimetres, not inches.

Using the shorter dimension measure a square and rule a line. The remaining rectangle is 17 x 10.5cm (21 halved). Remove a square from that and you will have a rectangle measuring 10.5 x 6.5cm (13 halved). Continue in this way and you will be left with a tiny square measuring 0.5cm. (1 halved).

With the tip of your drawing compass at point *a*, draw a quarter circle from corner to corner of the smallest square. Repeat at points *b*, *c* and so on until you have a neat Fibonacci spiral.

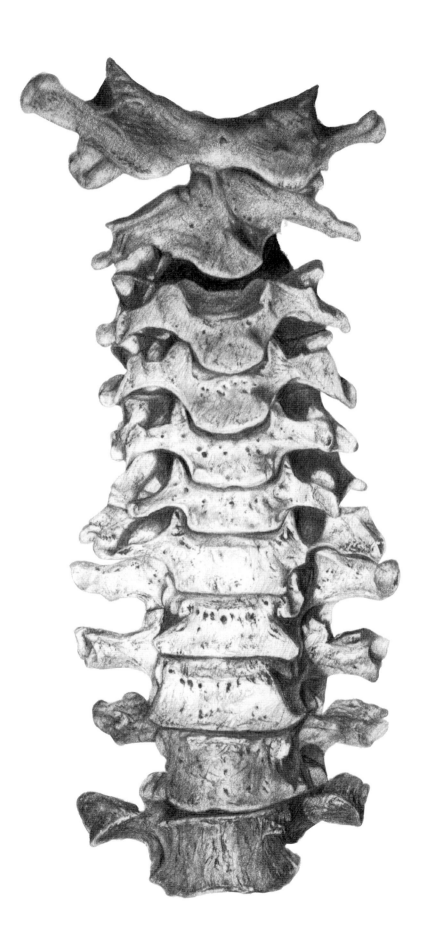

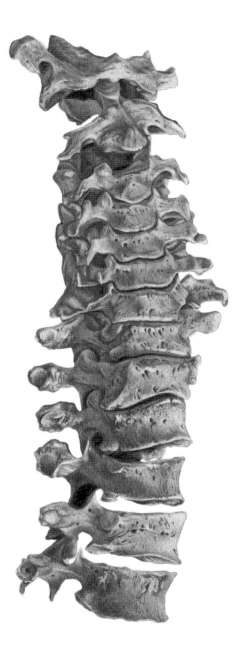

Above: Two pencil studies of a section of human spine, the essential component of the skeleton. Each segment is unique but bears close similarities to its neighbours.

12. Bones

Bones are the framework of the body on which everything else hangs, allowing movement in a highly complicated way. Animals with bones are known as vertebrates; among this large group can be found fish, amphibians, reptiles, birds and mammals. Bones are fascinating as a whole skeleton or simply as individuals in their own right.

Physicians, surgeons, veterinarians and other medical practitioners such as osteopaths and physiotherapists are trained to understand the mechanics of bodies, whether human or animal; without this knowledge they would be unable to practise their trade. Similarly the artist would be unable to practise his or her trade without certain fundamental information.

If you are going to draw people or animals you need to understand basic anatomy because this establishes how the body works. To have no comprehension of the structure that underpins people or animals or other forms of moving life is to be without the most fundamental information. The outcome of this lack of information is that more often than not your work will appear formless, lacking in substance and visually inaccurate.

The spinal column is the essential component of the skeleton. The human spine is curved in a way that allows standing and walking on two feet with ease. The price we pay for standing upright is the variety of back problems to which humans are so prone.

Each individual segment of the spine is unique but bears close similarities to its neighbours. This is true of many segmented forms in nature and it is important to achieve the happy medium where each part has its own individual treatment without disturbing the unity of the whole.

The artist of the human spine, opposite, writes: 'The spine was illuminated from the right by a bright lamp in order to increase the contrast of light and dark and emphasize its form. I began the drawing by establishing the overall shape with a single line. Following this I marked a few landmark areas such as the thickest or narrowest sections before methodically constructing each segment. With the line drawing complete I began to work lightly in pencil to suggest some of the main masses of dark values – getting increasingly darker as I became confident of their placement. The drawing was produced on a neutral grey paper in order to have a mid-tone already provided, thus reducing the amount of paper I had to cover. My primary purpose in using the grey paper was to allow me to heighten the drawing with a white pastel pencil.'

Below: If you are going to draw people or animals you need to understand how the body works. But sometimes found bones have lost many of their finer details through weathering.

Preparing bones

You might decide to obtain some bones from your butcher or fishmonger, but not know how to prepare them for drawing. The following notes have been taken from the website www.boneroom.com. Be aware, though, that many localities have laws protecting native species. These laws may apply to found remains as well as to the live animal. It is worth checking before you go any further.

The recommended way of preparing bones is by soaking them in warm water. This method is not suitable for any bone structures that you wish to remain articulated, as the soaking will destroy all the connecting tissue. Do not boil or bleach bones to clean them – this can cause problems with fat and grease, and can damage the bone so that it crumbles.

First, remove any remaining tissue or hide from the bones, then immerse them in a container of water. Leave somewhere warm – be warned, it will smell!

From time to time replace with fresh water, pouring the smelly, greasy stuff onto your garden if you have one – it makes good fertilizer. Do this until the water finally runs clear, when the bones will be clean.

If you want to whiten or sterilize the bones, soak them in hydrogen peroxide until they have reached the desired whiteness.

Exercise – bone colours

Left: Bones display a range of gentle, muted colours all made from the primaries.

Although bones may initially appear to be monochromatic, they usually display a range of gentle, muted colours, from the palest of cream to the deepest of grey-blue, or even black. Some of the colours used when illustrating this chapter can be found in the above chart. They are all mixed from the three primary colours – a warm and a cool yellow, a warm and a cool red, and a warm and a cool blue – mostly used fairly well diluted. Using the primary colours for all paint mixing gives the finished painting unity and strength.

Select your bone specimen. You may have found a rabbit's or bird's skull on a country walk, or a fish's backbone on the beach; you could talk to your butcher or fishmonger; maybe a friend has something interesting that they would lend you. You may be fortunate enough to be able to borrow specimens from your local museum.

Place it close to your drawing board in good light. Spend some time looking at it. Note its overall shape. Look at where the light falls, which bits are shaded, and write down a list of its characteristics. Is it shiny, matt, rounded, pockmarked, smooth, jagged, curved, straight? Which base colour are you going to use for your first wash? This can be determined by noting whether the colour of the bone veers towards yellow or red or blue.

Make a small mix of your darkest bone colour, using just the primary colours, and paint a square on a sheet of watercolour paper. Then dilute the colour, painting squares as you go, until you have the very palest colour you can achieve with that mix.

Check the pale and mid colours. Are they correct? Do you need to add anything to them to make them more yellow, or more blue, or more reddish (cooler or warmer)?

Time spent in observing your specimen, making colour swatches and generally getting the feel of your subject is never time wasted. By giving a bit of thought to your task at the outset you will achieve better results. If you rush it, you may well find that your finished painting will have glaring errors that could have been avoided by a bit of thought and careful consideration at the outset.

Exercise – baby elephant's tooth

The baby elephant's tooth below was found 150 years ago in what was then British East Africa and has been in a case of curios in the artist's family ever since. It is 6.5cm (2½in) long and the longest root measures 5.5cm (2¼in), whereas a full-grown elephant's tooth can be up to 21cm (8¼in) long and weigh as much as 4kg (9lb).

It demonstrates a range of bone colours, from the palest creamy-grey to almost black. The enamel on the grinding surface of the tooth still retains its creamy whiteness, but the surrounding bone has dried out and cracks have appeared between the teeth and the jaw.

Start by mixing a pale creamy-grey and wash over the roots, working on one at a time. Drop a darker creamy-grey in wet-into-wet on the shadowed side and grade it carefully to give roundness to the root. The tooth has an overall dull surface so there are no highlights or lowlights, but take care to leave the lightest areas untouched by the second and subsequent applications of paint.

The dark band between the roots and the upper surface of the tooth should be painted in a range of browny-blacks, diluting the paint for the lighter areas. One side of each crack is left pale, where it catches the light, but the rest is defined with the darkest brown-black.

Below: A baby elephant's tooth, measuring 6.5 x 5.5cm (2½ x 2¼in). An adult elephant's tooth can weigh up to 4kg (9lb). Note the wide range of bone colours it uses.

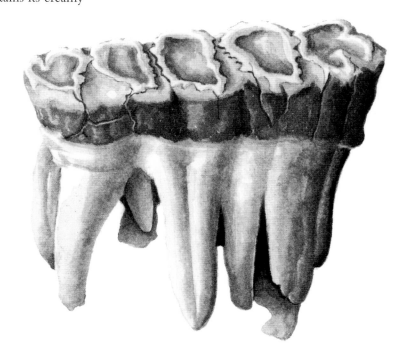

Animal skulls

Disparate skulls, placed together, can make quite a pleasing composition. This painting (right) shows the skulls of a rabbit, a rook and a badger. They were all found objects and are somewhat the worse for wear: the rabbit skull lacks its teeth and lower jaw; the rook skull is missing its lower beak; and the badger, despite its massive boniness, is missing its upper canine tooth.

The most delicate skull of the three was that of the rabbit. Some of the bones were paper-thin and its colour was bleached white with overtones of grey and pink. The rook's skull was more yellow, whereas that of the badger was a bleached grey with touches of deep yellow, particularly around the teeth. All three appeared to have been out in the open for quite a long time, so their colours probably owed a lot to weathering.

All the colours were mixed from the primary palette. The initial wash in each case was a well watered-down version of the colour, with darker areas dropped in wet-into-wet and carefully graded to avoid a watermark. Darker areas were gradually worked up and fine detail was applied with a 4/0 Kolinsky sable brush.

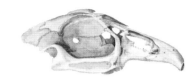

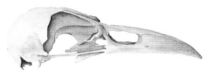

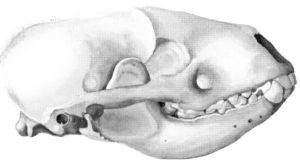

Above: These skulls, of rabbit, rook and badger, are somewhat the worse for wear, but make a pleasing composition one above the other.

Right and below right: Two views of a badger's skull demonstrate careful shading and skilful use of hard and soft pencils.

The human skull

The human skull is perhaps one of the most recognizable bone structures, from the stylized version on the Jolly Roger pirate flag to Damien Hirst's £50 million diamond-encrusted version in 2007. The skull's shape and features determine the appearance of the face; it is a known fact that the outward appearance of any particular face can, with the use of modern technology, be reconstructed using the measurements and structure of the skull, a procedure often used by biologists and forensic pathologists.

The disarticulated skull, shown opposite, has had various sections either hinged (not shown) or cut away to show what lies underneath or inside the bone. Here a section of the brow, above the eye socket, has been cut away to show the thickness and structure of the bone, as also has a section behind the ear canal. Most noticeable, though, are the upper and lower jaws, where bone has been removed to reveal the tooth roots, and fine red, blue and white filaments have been inlaid to represent the nerves and blood vessels.

Because all skeletal parts for teaching purposes have to be certified as over 100 years old, modern hospitals and universities now tend to use reproduction bones, skulls and skeletons, but they are often unsatisfactory as they fail to give a true idea of density, weight and structure.

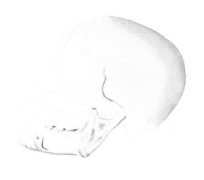

1 Having drawn the skull, wash over the areas of bone with a pale creamy-yellow, and drop in a darker grey-brown, wet-into-wet, to show shaded areas.
2 Mix a pale creamy-red and lay a wash onto the areas of cut bone – over the brow, behind the ear and in the jaws. Take care to leave fine lines where the blue, white and red filaments will go. Drop in a browny-grey, wet-into-wet, where shadows fall. Use the same browny-grey to deepen the eye and nose sockets.
3 Paint the teeth in detail, using a pale, deep yellow and a neutral grey. Enhance the shaded areas around and between them. Deepen the creamy-red mix and paint in the texture of the cut bone in the brow, the jaws and behind the ear. Increase the shading on the top and back of the skull, taking care to leave unpainted a strip behind the irregular lines where the plates of the skull join. With a yellow-grey, paint the small sections of the underside of the skull, visible through and behind the lower jawbone. Using a very fine brush (size 1 or 0), paint in the red and blue filaments, leaving white paper for the white filaments in both jaws and below the eye socket.
4 Still using your fine brush, carefully paint in the irregular lines between the plates and enhance the shading on and between the teeth. Mix washes to add more colour to the rounded part of the skull, giving tonal gradation and shadow.

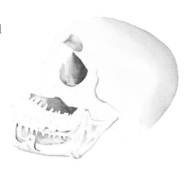

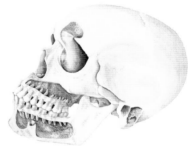

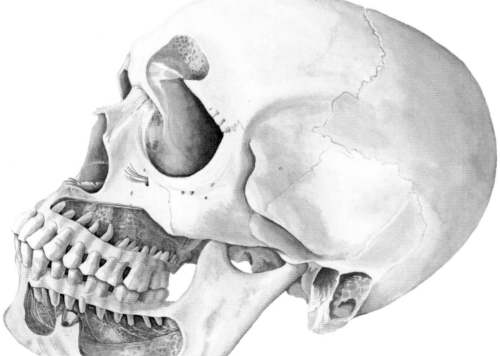

Above and left: This disarticulated human skull has had various sections cut away to reveal what lies underneath or inside the bone. Use many washes to build up the colour.

Print-making ideas using skulls

This pencil drawing, right, is of a skull showing both line and tone. Using this as a base, the artist has produced a linocut (shown below) of the skull, from a slightly different angle. The linocut has a particularly stark quality with its black and white linear effect. It gives the finished print the rather sinister look that is often associated with this subject.

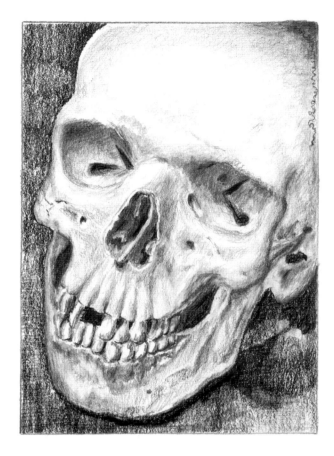

Above: The linocut (above left) evolved from the drawing of a human skull (above right) but from a slightly different angle.

Left: The artist used just one colour when preparing this watercolour of a ram's skull, complete with curving horns.

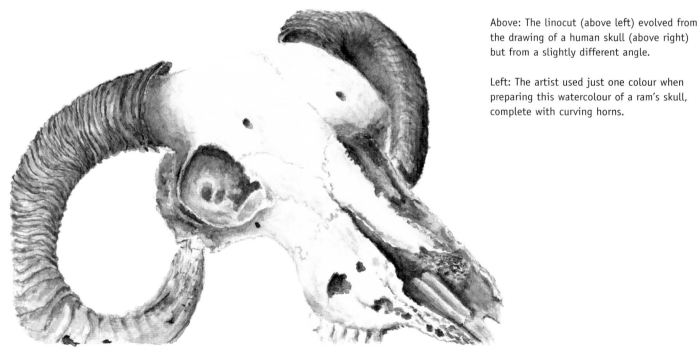

The drawing shown at the bottom of the
opposite page is a watercolour preparation for
an etching of the ram's skull, using only one
colour. The artist has then taken a side section
of part of the skull and one horn to turn into
his finished design. The drawing shown right
is a pen drawing in the style of an etching,
from which the final aquatint (below) has
been developed.

Print-making is an art form in itself. The subject
is so broad that we really cannot go into details
here. Hopefully we have inspired you to explore
these fascinating techniques, as shown either in
this chapter or in other parts of the book. If
you feel that you would like to try any of these
processes, you should not find it too difficult to
find a suitable print-making course in your area.

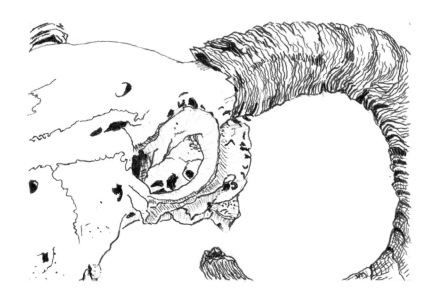

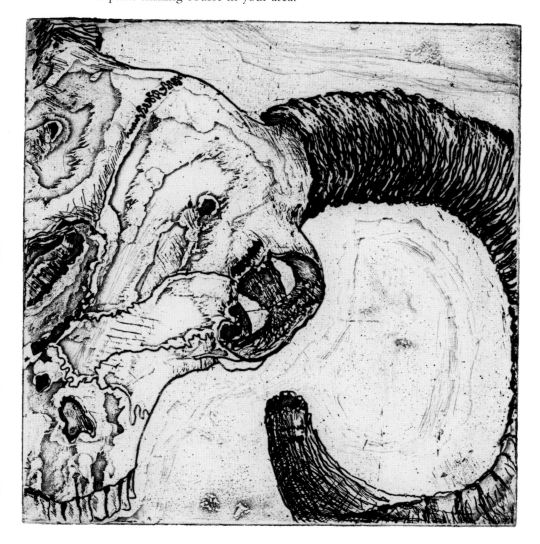

Above: Based on the ram's
skull shown opposite, this
drawing was made with a pen
in the style of an etching.

Left: The final aquatint of the
ram's skull was developed
from the previous drawing.

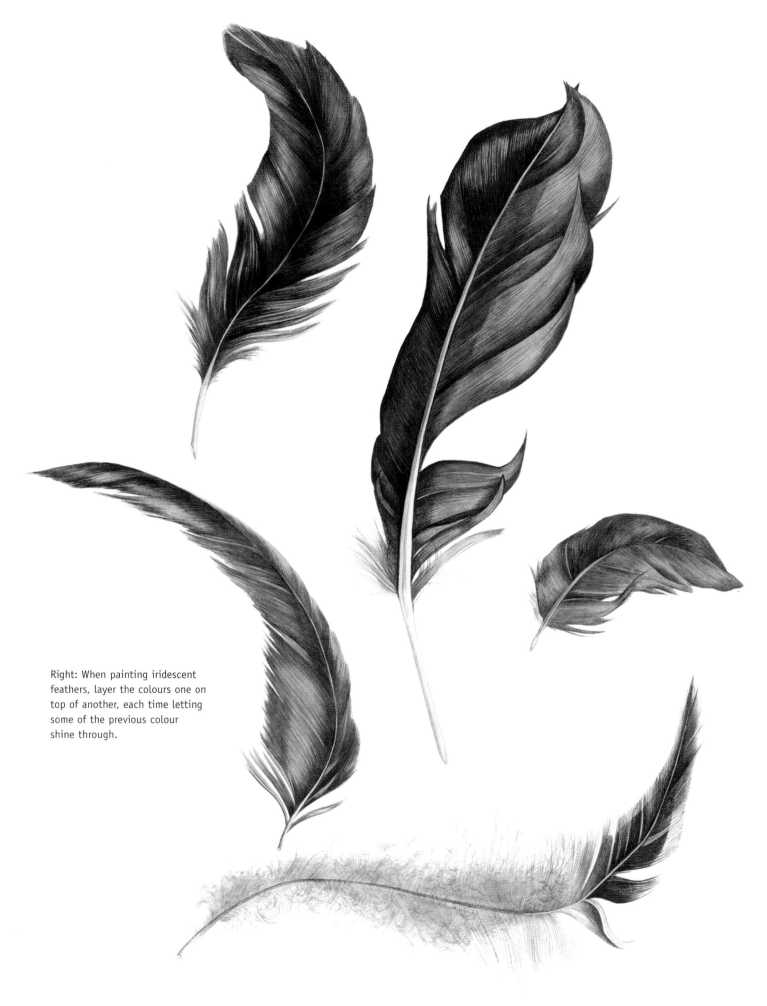

Right: When painting iridescent feathers, layer the colours one on top of another, each time letting some of the previous colour shine through.

13. Iridescence

You might look at an iridescent subject, a beautiful effect that is quite difficult to portray – the mother-of-pearl lining of a shell, a feather, a beetle – and wonder how on earth to cope with it. In this chapter we aim to simplify the method of painting it and explain how to do it.

To paint iridescent feathers

After drawing the basic shapes, you should build up the colours by layering one on top of another, each time allowing some of the previous colour to shine through. The colours used for the feathers shown opposite were indigo, purple, navy and various greens, all mixed from the primaries.

By placing lines one on top of another, you can achieve the fine, wispy quality of the feathering, especially the downy sections towards the base of the quill (the after-feather).

It is interesting to note that no white was used anywhere on these feathers. But if you wish you could use some of the very palest colour (blue mixed with white gouache) on top of the very darkest (indigo) to show further iridescence. This is one of the rare occasions when we suggest using white paint with watercolours.

Exercise – peacock feather

The feather on the right is from the tail, or train, of a peacock, which he displays to attract a mate. Incidentally, the pattern of the eyes on the peacock's fanned plumage has the same spiral pattern as that found in the centre of a daisy (see page 107 for the Fibonacci sequence of numbers).

First make an initial drawing to determine the size of the different shapes within the eye, the positioning of the main shaft and the size and direction of the branches, or barbs. Notice how the colours in the feather form concentric rings radiating out from the central ochre-brown patch.

Right: The colours in the peacock feather form concentric rings radiating from the central eye. Try out all your colours and brushstrokes on a worksheet before committing to paper.

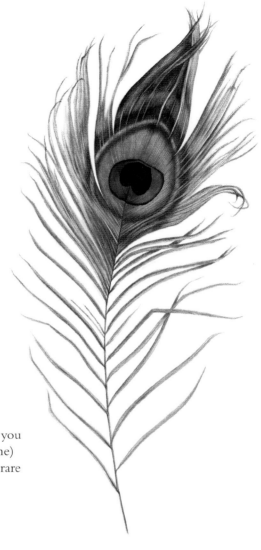

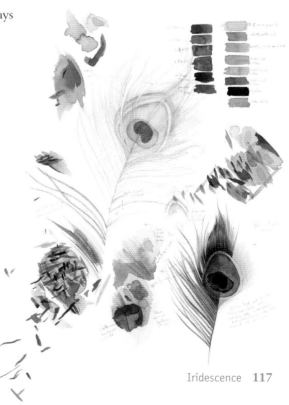

Paint a light wash of pale green over the whole of the eye section, making sure that it is blended out at the edges with clean water and a damp brush so that there are no hard lines. Then paint the largest part of the eye, as shown, with an ochre-brown colour. Take care to avoid the inner turquoise area. You can paint this now if you like, or leave it until later. As this is the focal point of the whole feather, you might like to leave it until you have completed the rest, so that you can give it the attention it demands.

Gradually build up layers of paint in fine lines from the outside strip of the ochre-brown section right out to the extremities of the barbs, using a stronger green. Take care to make your lines even and tapered towards the tip.

Leaving a pale green ring outside the ochre-brown one, add into the lines some layers of even stronger green paint, using more fine lines. To repeat the eye shape, stroke on some purple lines over the existing green lines. This forms a purply-green ring beyond the pale green one. It sounds complex, but if you refer to the feather on page 117 you will see how it has been done.

Notice how successive rings have been cleverly shown, with breaks in between where the barbs have separated. These must be clearly demarcated at the drawing stage so that they stay free of paint.

The widely spaced barbs further down the feather are painted with a fine central line, with tiny barbules shown, using an extremely small brush (size 0 or smaller). They are pink and green laid over each other. Finally, in order to soften the tiny barbules, apply a damp brush (size 3 or 4) along the length of the barb. This will slightly soften the edges of the paint to give a feathery effect.

Below: The metallic effect of the scarab beetle (painted x2) was achieved by laying lines of tiny pale yellow dots (mixed with white gouache) on top of dark colours.

Scarab beetle

For the scarab beetle (right), painted twice its normal length, note how the preliminary drawings were carefully constructed, maintaining the necessary dimensions of both aspects of the insect. A simple palette of colours was used, with a couple of additions besides the primaries – viridian green (a vibrant blue-green) and Venetian red (a brownish-red). The primaries used were lemon yellow, Prussian blue and vermillion (mixed with Venetian red) for the eyes and the outer edges of the wing cases.

The colours were built up with several washes overlaid on top of one other, and the iridescence was shown by mixing a light greenish-yellow using white gouache, which was then dotted on with a tiny brush – a further occasion when the use of white paint is effective.

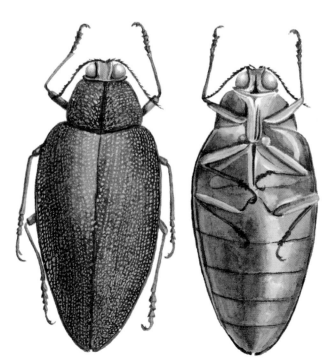

Abalone shell

The abalone shell is regarded by many as a very daunting subject. Its colourful iridescence, reminiscent of an opal (see page 71), changes according to the light and where you are in relation to it. So you need to be aware of the position of your head throughout the time you are working on the shell.

We show on this page five examples of an abalone shell. The first two pictures concentrate on the graphic surface pattern, whereas the third and fourth examples give a good idea of the bowl-like form of the shell. The drawing shown top right is worked in watercolour pencils, but with minimal use of water. The one at top left is by the same artist, but this time using pearlescent acrylics and a fine felt pen.

The next drawing, shown right, uses coloured pencils (not water soluble) and gives the bowl-like effect of the shell while being portrayed in a very graphic way. The image shown below right is a study in watercolour over pencil, an extremely good example of a little-used technique, favoured by those more at home with drawing materials than with paint.

The painting below uses acrylic paints. It can be viewed more as a semi-abstract painting and the paint has been put on in broad brushstrokes. In spite of this, it still portrays the shimmering lustre of the shell. A lot of bright colours have been overlaid to try and give this effect.

All the pictures pick up on the extraordinary range of colours, many influenced by their surroundings at the time of painting, and the lovely marbled pattern in the mother-of-pearl lining of the shell. You will see that a variety of materials can be used very successfully.

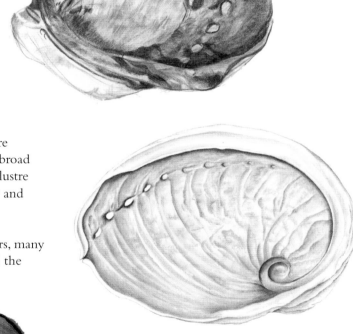

Above and left: The patterns and colours of an abalone shell change according to the light and where you are in relation to it.

Mackerel

Mackerel are included in this chapter because of the iridescence of the underbelly. Even the top of the fish shimmers with a dark, pearly look.

Mackerel are in a family group with tuna and like many fish they make use of camouflage to avoid predators. (See Chapter 14, Display and mimicry.) The mackerel's upper side has dark stripes, which, seen from above, merge with the darkness of the deep water and mimic its subtle movement; while if the fish is viewed from underneath, the underbelly could be mistaken for the sky seen through water. This form of camouflage is known as counter shading and is also used by predators such as sharks, which have white undersides. Among land animals, many have dark upper sides for similar purposes.

Exercise – mackerel

For some of the exercises in this book you may have found it difficult to obtain the subject matter. However, all that is needed for this exercise is a visit to your local fishmonger or fish market.

When drawing your fish, take care to place the stripes at the correct intervals along the upper side of the body.

Below: Mackerel worksheet – try out your colours and techniques before committing to paper.

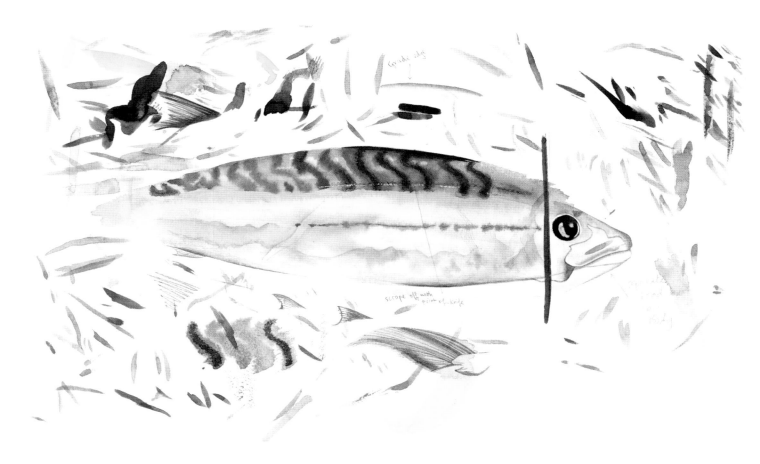

The painting of the fish can be divided into five sections:
• Head
• Top of the body
• Underbelly
• Fins and tail
• Eye

When laying washes in watercolour, always find a natural division for your picture. In the case of the mackerel, these natural divisions are found along the curved line of the gills and as an almost straight line at the lower extremities of the dark stripes. It is important to blend any hard edges at the wash stage.

Lay a wet-into-wet wash for the striped top and for the underbelly, but use a wet-on-dry wash for the head for greater accuracy.

The iridescence of the mackerel is painted using a wet-into-wet wash. This technique when properly done has its own shimmer, even when done simply as an exercise.

The water on the striped area should be nearly dry, with a sheen rather than a shine, before placing on the stripes so that they spread only very slightly; this will give the desired shimmer. When this area is dry, enhance the stripes by stippling on some dark blue-black paint.

Allow the painting to dry, then wet the underbelly with clear water and when this is damp but not totally dry, drop in a variety of pale pinks, yellows, blues, purples and greys, so that they all merge together. The combined effects produce the iridescence.

After the washes are dry, small areas of detail can be applied with pale colours mixed with grey, using a small brush and either blended with a damp brush or stippled. The head needs to be carefully modelled with sharp lines blended on one side with a damp brush to give three-dimensionality.

The tail and the fins, which will already have a light wash over them, are then painted with a small brush and blue-green-grey paint, using fine, tapering lines.

Paint the eye with black (mix the three primaries for a dense, lively black). Leave a small area of white paper for the highlight. The small fold of skin around the eye is a fresh, pearly-grey.

Above: The iridescence of a mackerel's skin is a form of camouflage. Use a wet-into-wet wash to bring out the shimmer.

Below: As long as the stick insect remains motionless it is difficult to discern among twigs and branches.

14. Display and mimicry

A fascinating exercise for the more advanced student with an interest in natural history as a science is to study and illustrate why creatures are made the way they are.

In the natural world, colour is present for many reasons. Colour is used as a signal to friend, foe or predator – 'Come hither!' or 'Leave me alone!' Bright colours in butterflies and other insects are often a signal to predatory birds that they are poisonous or distasteful.

Many insects protect themselves by mimicking their surroundings. You may be familiar with the stick insect, which, as long as it remains motionless, is cleverly camouflaged. It is a good example of animals and insects that use colour or shape to merge into their surroundings, as part of a defensive or offensive system. Another instance of this is shown below, a composition for a watercolour painting of a weedy seadragon *(Phyllopteryx taeniolatus)* – its shape helps it to blend into its surroundings of seagrass.

Left: The shape of the weedy seadragon *(Phyllopteryx taenolatus)* helps it to blend into the surrounding seagrass.

Exercise – getting the right colour

Colour helps closely related species to distinguish each other. Markings help to prevent mating that cannot hope to produce viable offspring. The differences between species can be very slight indeed, meaning that accurate depiction is vital for identification.

Therefore, for an artist to use the wrong colour could be very confusing. Correct colour analysis and mixture is very important, and you could usefully spend many an hour simply mixing colours to match as many natural objects, substances and forms as you can find. After all, vast quantities of suitable samples are all around us.

Use good watercolour paper and a fairly large mixing brush. Refill your water jar as soon as it gets murky. Keep a record of the colours you mix, making notes for yourself such as 'too yellow', 'needs to be a bit darker', and so on, so that you have pages of trials to which you can later refer. See some of the worksheets in other chapters.

Display

Masters of camouflage are the squids and octopuses (cephalopods), many of which are able to blend seamlessly and instantaneously with their surroundings, squirt potent ink when threatened and communicate with stunning displays. The colour-changing capabilities of an octopus make a chameleon seem crude by comparison.

Chameleons are a large family of lizards, which change colour depending on their mood, displaying a variety of colours to indicate aggression, submission or other temperaments. They do not in fact change specifically to match their surroundings – this is something of a popular myth.

The colours we observe in an animal often give us a clue as to how that animal itself sees. The bright and lavish colours of insects, reptiles and birds for instance tell us that these creatures possess good colour vision. The dull colours of many mammals hint at the fact that the great majority of them have limited colour vision. Brightly coloured monkeys are a give-away that primates (humans included) are an exception and are able to see the world with more complete colour vision.

Insects such as bees are able to distinguish a greater variety of colours than we do, and they perceive colour higher up the spectrum into ultraviolet. Many flowers are adorned with patterns and markings visible in ultraviolet, but invisible to us, which help pollinators to identify them.

Reproduction is at the heart of all things in the natural world and the most extravagant examples of colour are for this purpose. Males use colourful plumage to attract a mate (depending on the species, this role may be reversed) or to warn off rivals. Females will often choose as a partner the one that has the most lavish or colourful display; over the generations this causes the genes for elaborate male displays to dominate. The most outrageous displays in the bird world have resulted from generations of using colour in this way.

The peacock, a type of pheasant, is among the finest. It must surely be the most widely recognized exotic bird, displaying his wonderful, shimmering, green and blue tail to the rather drab peahen, despite the increased vulnerability to predators caused by carrying such an appendage. How could the peahen not be impressed?

Mimicry

Some creatures mimic other, more dangerous creatures as a form of protection, thus repelling potential predators. To this end, colour is often used as a warning system. Insects such as wasps and bees use black and yellow (colours widely recognized by modern humans to denote danger) to proclaim forcefully that they are quite capable of defending themselves. The bumblebee moth *(Hemaris diffinis)*, shown right, bears a striking resemblance to a bumblebee (below right), with its furry yellow-and-black striped body and transparent, veined wings, and thus could easily be mistaken for an unappetizing bumblebee by a bird or other predator.

Exercise – painting bugs

For tiny subjects like the bumblebee and the bumblebee moth, you will need fine brushes, a steady hand, carefully mixed paint and a magnifying glass. Spend time looking at your subject, note how the fine hairs lie in relation to the body and the structure of the veining on the wings. You might find it helpful to make a scaled-up preliminary drawing on layout paper, so that you can make sure you can see everything and draw it in the right place.

With such tiny subjects it is hardly necessary to lay down washes. You will find that most of the work is done by stippling. Practise fine lines on a separate sheet before committing to the picture. There is nothing worse than spending time painting a delicate subject only to mess it up with splodgy antennae or veining. Indeed, you could paint the antennae and veining first, just to make sure they are of the correct weight, so that if you get them wrong you can scrap that picture and start again.

Above: The bumblebee moth *(Hemaris diffinis)*, shown top, protects itself from predators by mimicking a bumblebee (bottom).

Exercise – walking leaf insects and stick insects

Walking leaf insects (below) and stick insects (page 122) are masters of the mimicry of plants by animals. Most of them are slow moving in order to maintain the effect of their extensive camouflage. Stick insects mimic the grainy bark of their host plants and their limbs imitate the branching of the plants they inhabit. The walking leaves are similarly equipped with venation and some have false bite marks on their flattened limbs. Scientists have suggested that the swaying movements of members of this order may even mimic the movement of foliage in the breeze. The sheer perfection of these mimics to their environment is suggestive of the power and complexity of all evolved creatures.

Whether you use pencil or paint for this exercise is your choice. These insects are basically monochrome, so colour is not absolutely necessary. Whichever method you choose, the stick insect should end up looking 'twiggy' and the leaf insect should have the same characteristics as a leaf. Make notes for yourself: are they dry and papery, or hard and shiny? This will depend on the species. Look carefully at the markings on the leaf insect and note how closely they mimic the veins on a leaf.

Right: Walking leaf insects mimic leaves in shape and venation, some using a swaying motion to suggest the movement of foliage in a breeze.

Exercise – hummingbirds, sunbirds and hummingbird hawk-moths

If you have ever seen a hummingbird hawk-moth hovering by a flower, you could be forgiven for mistaking it for one of the hundreds of species of tiny hummingbirds, a unique family of beautiful, often jewel-like birds, native to the Americas. They feed in part on sweet, energy-rich nectar and their elegant and specialized form has arisen as a result of this feeding habit. Their hovering flight is perhaps their most distinctive feature, allowing them to rest almost motionless above each flower they visit. They are the only birds that can fly backwards with precision.

Similar to hummingbirds in form and behaviour are the sunbirds, a family of Old World tropical birds. Distantly related to the hummingbirds, they too feed on nectar with a specialized tongue and sometimes hover in order to do so. Sunbirds cannot fly backwards or hover with as much precision as hummingbirds; instead they prefer to perch and feed wherever possible. The close similarities of these different creatures arise from their occupying analogous niches in their respective environments. The flowers they feed on have embraced these nectar feeders, using them as pollinators and producing differing forms of nectar better suited to either bird or moth.

The hummingbird hawk-moth *(Macroglossum stellatarum)* is a species of hawk-moth with a long proboscis, which serves the same purpose as the hummingbird's long bill – to reach deep into flowers for the nectar. While hovering, they both make an audible humming noise – hence the name.

Their movements are so similar, the rapid movement (in the case of the hummingbird, as much as 80 wing beats a second) making their wings seem no more than a haze. To depict movement like this in either pencil or paint is far from easy. One way would be to blur the edges of the wings, as shown below, thus giving the sensation of rapid movement. In contrast, those parts of the bird that remain stationary can be given a bold, sharp treatment, seen here in the birds' heads and long bills.

Below: Hummingbird, sunbird and hummingbird hawk-moth – all three have incredibly rapid wing beats, which can be suggested in a pencil drawing by blurring the edges of the wings.

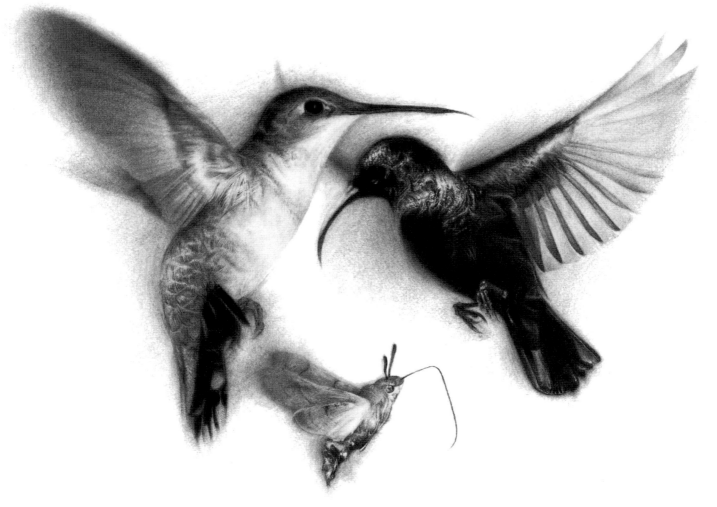

Artificial mimicry

In some cases, similarities are made by humans in order to bamboozle specific creatures, usually in a hunter-gatherer scenario. *Flies, which are Food for Trout and which The Fisherman Should Know About* is a small booklet compiled in the 1950s by the father of one the authors, a keen dry fly fisherman who had a fondness for capital letters, illustrated by her when in her early teens. He credits F. M. Halford's *Dry Fly Entomology*, still available today, as the source of much of his information.

This little booklet, which was printed in an edition of just one copy, laboriously typed on an old manual typewriter, describes the life cycle of the insects, from eggs through to spinner – the perfect insect – some of which live for only a day. The booklet enumerates the various types of insect and gives instructions on how to tie a convincing replica.

Shown below are four examples of the insects that form the basis of many fishing flies. Ephemeridae (top left) include mayfly, artificial spent gnat, March brown, olive, pale watery, blue or iron blue and blue winged olive. Trichoptera (top right) is the blueprint for caperer, large red sedge, Welshman's button and grannom. Perlidae (bottom left) includes willow fly, otherwise known as needle brown or Spanish needle, and stone fly. And Sialidae (bottom right) represents just one fishing fly, the alder.

Below: Examples of insects on which artificial fishing flies are based. Clockwise from top left; Ephemeridae, Trichoptera, Sialidae and Perlidae.

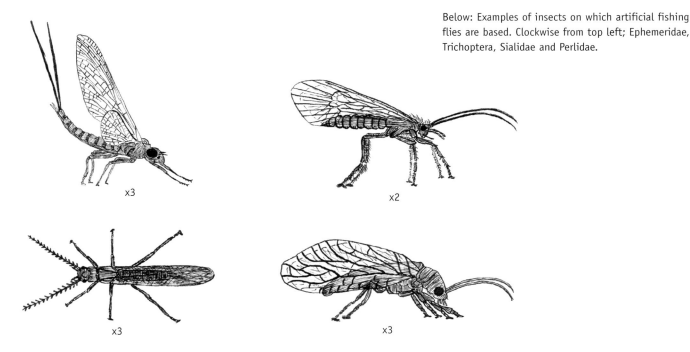

x3

x2

x3

x3

It would appear that fishermen are still masters of deception, having vastly more varied materials available to them than were to be had in the 1950s. Page 129 shows a selection of modern dry and wet fishing 'flies'. Clockwise from top left they are: crab imitation made of Mylar and with rubber legs (note that its movement at the end of the line would be in true sideways crab style); a black stonefly; another crab; a green stonefly; shrimp; sinking crane fly (daddy longlegs, also known as skeeter eater, gallinipper, gollywhopper or jimmy spinner); shrimp imitation; another green stonefly; fry imitation; sedge; salmon fly.

Compare some of these illustrations with the 'real thing' in other chapters, such as the spiders (very similar in appearance to daddy longlegs) and crabs.

Drawing and painting these tiny masterpieces of construction, which are usually composed of feathers or fur bound onto a hook with fine silken strands, takes a steady hand and a good eye. The principles of setting about the work are much the same as when painting feathers or insects – you will need a fine brush, not too much paint, and light, fine strokes. Unless you have perfect vision, you will probably need to use a magnifying glass.

Above: Artificial fishing flies are often made of feathers or fur bound with fine silken strands, so a fine brush and a steady hand are needed when painting them.

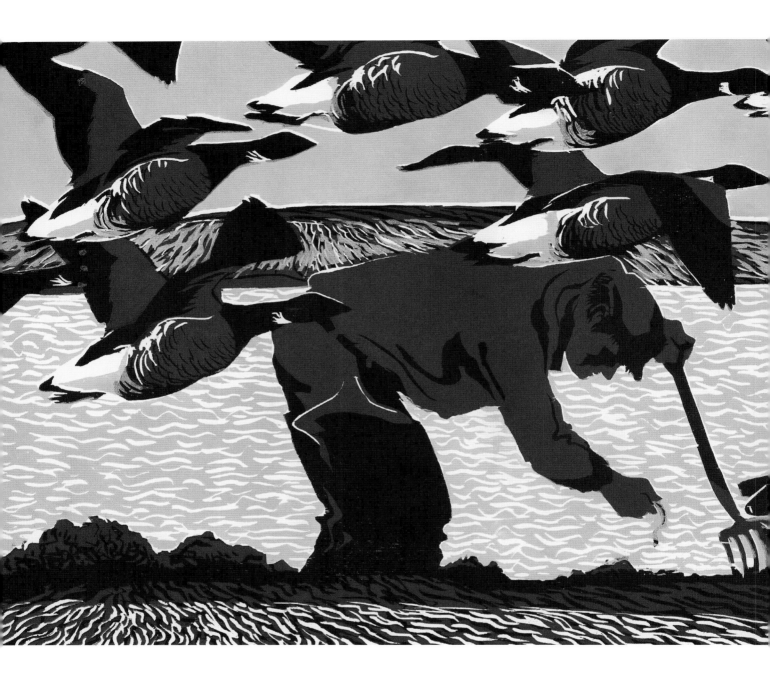

Above: *Bait Digger and Brents*, woodcut
print, 61 x 46cm (24 x 18in), was developed
from the sketchbook pages on page 77.

15. Where now?

It seems only natural for us to respond to the natural world by way of imitation, and the options for a natural history artist are limitless. In this chapter we give some examples of how natural history is being used in many different ways, in the hope that it will inspire you to broaden your horizons and push the boundaries, using natural history subjects as your inspiration.

The stories behind pictures are often fascinating, and we are privileged if we can get the artist to tell them. *Bait Digger and Brents*, the woodcut print shown opposite, developed from a morning spent observing the mussel fishermen and bait diggers who work along the North Norfolk coast during the winter months. One of the preliminary sketches was the study of brent geese shown on page 77.

'I was out on the marshes,' says the artist, 'working on a large landscape for most of the morning, then in early afternoon as the tide receded a bait digger walked out on the mudflats some distance out towards the sea. So I changed my focus for the afternoon and through binoculars sat watching and drawing him, and making many notes about his place in the landscape. His busy hunched form, the sense of isolation of the lone figure presented in a huge flat space, and his dark tones both complemented and contrasted with the numerous brent geese feeding slightly closer in and shuffling about the mudflats in small flocks. It all added up to a wonderfully graphic image that I immediately began to work through when back in the studio.'

We have already referred to one of the practical applications of natural history illustration, that of the medical artist. Internationally there will probably always be artists, craftspeople, architects and engineers who use and adapt natural forms in their work. These can be used in many ways: to reveal a mathematical formula, to tell a story, to emulate, to reinvent. All branches of fine and applied art including sculpture, painting, textiles, print-making, jewellery, furniture, architecture and ceramics both utilize and seek to explain the natural world.

One branch of this is a relatively new discipline called bio-mimicry (from the Latin *bios*, life, and *mimesis*, to imitate), which takes inspiration from nature to create a more bio-diverse and ecologically friendly planet.

A well-known object derived from nature is Velcro, the hook-and-loop fastener designed by a naturalist and a textile weaver who were inspired by the clinging burdock seed; and what about the correlation between dandelion seeds and parachutes? A study of the echolocation of bats in darkness led to the development of a cane for visually impaired people. Boat manufacturers study the structure of sharks' skin to achieve energy efficiency for boats' hulls; buildings have been inspired by passive cooling in termite mounds; fabric finishes are inspired by water repellant plants such as the lotus. These are all examples of bio-mimicry. The list goes on and on.

Sculpture and mathematics

You might be attracted to the mathematical element in natural history. Sculptor Peter Randall-Page works with a mathematician to lay down complex mathematical formulae for his works. *The Seed* is a monumental example of his work, being designed on the principle of the Fibonacci series (see page 107) and carved from a 167-tonne block of granite from a Cornish quarry.

Peter's brief was to incorporate botanical imagery in a genuinely contemporary and meaningful way into the design of the Core, a world-class, iconic building. The purpose of the Core itself was to help to redefine education at the Eden Project in Cornwall, an internationally renowned centre where exhibits, events, workshops and educational programmes are used to remind people what nature gives to us and to help people to learn how to look after it in return.

'One of the major areas of enquiry in my own work has been the Fibonacci sequence and the golden proportion, and the way in which plant growth is determined by these fundamental mathematical principles,' says Peter.

Left: Two preliminary drawings of *The Seed* at the Eden Project in Cornwall, carved from a single block of granite. The size can be determined in both pictures by the figures viewing it.

The Seed was designed as a symbolic kernel of the building as well as a distillation of the structural principles of the roof, which itself is an example of the use of the Fibonacci series of numbers. There are nearly 2,000 circles on the three-dimensional form of *The Seed*, and because the sculpture is based on an organic growth pattern rather than a grid, a great deal of precision was needed in their placement.

The complex wooden structure of the roof of the building (designed by architects Grimshaw) shown on the right, relates to natural organizational patterns and there is a sense of spatial harmony and balance. Its asymmetrical spirals echo the structure of a sunflower seedhead, with 21 spirals in one direction and 34 in the other.

The Seed engenders a variety of emotions among visitors to the Core. To some it is an object of contemplation and meditation; others marvel at the more practical engineering feat of designing it, carving it and lowering it by vast crane through a hole in the roof, all of which involved a huge team of experts. Most visitors find it extraordinarily tactile and need to touch it or stroke it. Whatever happens to it, this is all part of its evolution, a typical characteristic of a seed.

Above: The design of the roof of the Core education building at Eden is derived from the Fibonacci series of numbers (see page 107).

The applied and fine arts

Flora and fauna figure universally in drawings, paintings, sculptures and the applied arts. The range of portrayal is extremely wide, from the 18th-century equine artist George Stubbs, who devoted much of his working life to the intensive anatomical study and depiction of the horse, to the environmental installations of Andy Goldsworthy in the 21st century, whose work often manipulates the roles and functions of natural subjects.

The next five illustrations are sketches by sculptor Peter Randall-Page. They are inspirational and explore some of the many ways that natural forms can be used in both the applied and fine arts.

The linocut design of four palm trunks by Peter (below left) coherently illustrates the patterns found on different palm tree trunks. The black and white graphic representation provides visual information at a glance. The viewer is left in no doubt as to the nature of the growth patterns and the stark, clear simplicity of the black and white linocut is informative and aesthetically pleasing.

Below left: The black-and-white linocut design of four palm tree trunks provides visual information at a glance.

Below right: The spiral in this charcoal drawing takes shape where light and dark meet.

In the drawing of a spiral (above right), the black density of the charcoal contrasts with the coils where the white paper shines through. The spiral takes shape where light and dark meet and this suggestion can be seen as forceful yet ambiguous. The suggestive elements contained within the drawing stimulate our imagination in a way that perhaps the real object would not.

Below: Is it a seed? Or perhaps an insect? Using pen-and-ink on paper, the artist calls it *Sketch B* and leaves it to the viewer to decide.

Left: Charcoal on paper makes a much-enlarged representation of a walnut kernel with a certain botanical accuracy.

Whilst conveying relevant botanical information in some depth, the pen and ink drawing (above left), called simply *Sketch B*, also appears highly sculptural and evocative of a number of images; you might think it resembles a seed, or an insect.

The charcoal drawing *Walnut VII* (above right) could be said to have undertones of artist H. R. Geiger's bio-mechanical art. Geiger is best known for his bizarre designs and sets for the science fiction film *Alien*. The three-dimensional effects of the charcoal drawing again display a certain botanical accuracy. However, these effects also give rise to feelings of other-worldliness and a somewhat unsettling sense of duality.

Fingers and Thumbs (right) is a study in burnt sienna on paper, using fingers and thumbs in place of a paintbrush, of a greatly enlarged or magnified view of the patterns typically found in fingerprints. The rhythms and patterns engender endless possibilities for application within a range of artistic disciplines – textiles, ceramics, jewellery and the fine arts. You may also think that it resembles indigenous tribal art from different continents. Sometimes the obscure can offer the artist other avenues of approach and the results are limitless.

Right: *Fingers and Thumbs* is not only a greatly magnified view of the patterns found in fingerprints, but also was made using fingers and thumbs in place of a paintbrush.

Exercise – studies out of your comfort zone

Make your own studies, using natural history subjects. Take inspiration from the illustrations in this chapter, and working with this information try to expand it in new and unfamiliar ways.

Try using a medium you are not used to and break out of your comfort zone. For example, if you have always painted in watercolour, try acrylics, gouache or coloured pencils. For monochromatic studies, if you normally use pencil, try charcoal. If you have always been frightened of watercolour, have a go. You will be amazed at the results.

Left: Beautifully drawn and painted textile designs can also illustrate a more sinister story, as with (shown clockwise from top left) *Poppycock*, *Blood Ties*, *Butterthorn* and *My Lords, Ladies and Spiders*.

The early textile printed fabrics of artist Ione Rucquoi tell stories that refer to the functions of natural history subjects and her titles are a play on words. The textile designs, beautifully drawn and painted, often show the exquisiteness of the subject matter, while also illustrating another, possibly more sinister side of the story, such as the relationship of insects, plants and humans, as in *My Lords, Ladies and Spiders* (bottom left). Note the extremely fine detail in the limbs and the sense of location given by the subtle background images of ferns and leaves.

Blood Ties (top right) and *Poppycock* (top left) draw attention to both function and environmental suggestion – the association or bond between flies and blood in one, and a challenge to the rural idyll often associated with farmyard fowl in the other.

The design *Butterthorn* (bottom right), a transfer print on fabric, is disturbing and has an element of black humour about it. The butterflies are sensitively drawn, their delicate bodies and veined wings truthfully shown. What a contrast with the sharp, evil, blood-red thorns on the stalks and the disquieting blackness of the background.

Domestic

Your interest may verge more towards domestic ingredients. The photograph below shows a wedding cake, an intriguing way of interpreting natural history subjects in an altogether original medium.

The cake was made for a childhood friend of the artist's daughter to mark her marriage to a fellow marine biologist. Both bride and groom were interested in scuba diving, and wanted a cake that reflected their interest. The artist immediately thought of casting seashells in sugar.

She collected as many shells as she could and selected the most suitable ones. Moulds were made using Elastosil M4601, a food grade flexible mould material. These were then filled with purchased modelling icing. The coral was royal icing, squiggle-piped onto non-stick baking parchment using a plastic bag with the corner snipped off as a piping bag. The ribbons of seaweed were modelling icing, rolled into long sausages, pinched with the fingers to flatten and then twisted slightly.

The artist says, 'It was a huge learning curve, from estimating the amount of cake required for the number of guests, to working out how to transport it to the wedding without too many breakages. The whole thing was ongoing for about three months, during which time my dining table was occupied by trays of drying shells and coral. I am not sure I would want to do it again, although the knowledge we acquired would make the next one easier.'

Left: Moulds were made from seashells to decorate this exquisite wedding cake for two marine biologists.

Greetings cards

Greetings cards are always fun to do and can incorporate different genres. Here, the artist has combined her love of natural history illustration with that of botanical illustration. The illustrations below show the first painting of weedy seadragons *(Phyllopteryx taeniolatus)*, which lives on the Great Barrier Reef, off the Australian coast, and can grow up to 45cm (18in) long. It could also have been included in Chapter 14, Display and mimicry, because the seadragon's 'weedy' fins give it perfect camouflage among the seaweed. The artist drew these gorgeous seahorses as they drifted gently around their tank.

She was looking for a marine image for a Christmas card and decided that the seadragon colours were sufficiently festive with the addition of the mistletoe, the shape of which echoes the seadragons' fins.

Below: The weedy seadragon and a sprig of mistletoe (left) make a quirky design for a Christmas card, shown beside the preliminary drawing (right).

Polar ice

So many elements of our natural world are threatened with extinction; perhaps none is more topical than the disappearing polar ice. One of the authors spent time over several years painting and writing in the Arctic and Antarctic, and it seems fitting to include polar ice and its plight in this book.

'I love the wildness and sheer vastness of Antarctica, and find it a more challenging landscape than the Arctic. It's the seventh continent and it is monumental, unmanageable, beautiful and terrifying.'

This wildness is reflected in the artist's watercolours, which are often quite abstract. 'I work from life with the immediacy it requires. Photography just doesn't do it for me; photographs show that moment in time whereas painting shows the lingering savagery and the force of the timeless elements. This may be something to do with the effort of manipulating water, brushes,

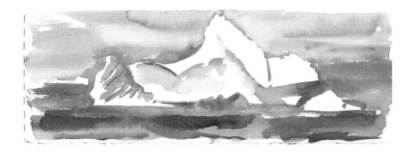

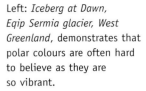

Left: *Iceberg at Dawn, Eqip Sermia glacier, West Greenland*, demonstrates that polar colours are often hard to believe as they are so vibrant.

Below left: An extra dimension was added to *Snow Over Yankee Harbour* when snowflakes fell onto the wet paint.

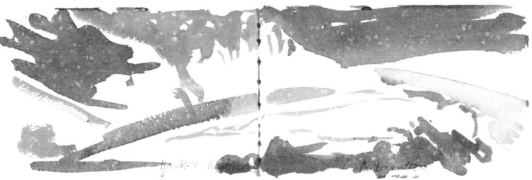

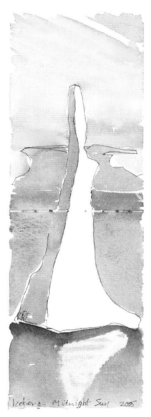

paper and paint in extreme conditions. Sometimes it snows on the paintings, as in *Snow Over Yankee Harbour* (above). The curious mottling effect enhances the sense of place but it can be a battle to save work from total wipe-out. With several paintings on the go at once, you must work quickly, disengaging from the conscious mind and relying on intuition born out of knowledge and experience. Everything is moving – ship, ice, elements. There is no time to think, plan or moderate.

'I try to distil the core elements with which I am confronted: the scale, mood, time, colour, shapes and texture, to name a few. One of the main features is colour. The blues are out of this world – iridescent turquoises, vibrant ultramarine, pastel eau-de-nil. I ran out of one particular turquoise. Next time I'll take vats of it!

'Sometimes the sun casts blood-red hues over the ice and water, or the 24-hour daylight renders everything an opaque puce at 3am. The seas appear indigo; the stormy skies a dark lemon yellow. When you are painting fast and furiously, these colours must be mixed and applied with lightning speed in order to seize the moment. Not easy, but the humility crossed with exhilaration defies description.'

That she is recording an endangered species weighs heavily with the artist. 'I have very mixed feelings; whilst highlighting the plight, I'm perpetuating this with my carbon footprint. A big part of me thinks, "I shouldn't be here, I don't want to be here, but I am!" There are no excuses and I can say nothing in my own defence. I do it because I'm compelled to; it's a two-edged sword.'

Above: The midnight sun gives the colours a milky opacity.

Hybrids

(**Hybrid – n**. an organism which is the offspring of a union between different races, species, genera or varieties; a mongrel. To *hybridize* – to cause to interbreed.)

It is fun to play around with the concept of hybrids. Designs of hybrids push the boundaries, stretching credibility and inviting you to use your imagination and inventiveness.

An easily recognized hybrid is the mule, a cross between a horse and a donkey. And you may well have hybrid plants in your house or garden. But you can really let your imagination rip when designing hybrid creatures. Think of the mythical hybrids: the centaur (man-horse), griffin (lion-eagle) or harpy (bird-woman).

The three-dimensional quality of the etching *Nine Banksia Inventions* (below) beguiles us with its variables. It could be this, it could be that: seeds, cells, beetles. These hybrids borrow and change the nature of the banksia and can be regarded as credible or incredible. They are inventive, imaginative, misleading, provocative, but never flippant. Sound observational principles give them solidity and gravitas.

Marine Orchid (above right) is a two-fold hybrid. First, it is a composition of shells and other marine items assembled in the form of a slipper orchid. Each element was drawn individually, and connecting tissue was invented to graft one to another. Some of the parts had to be distorted in size or shape, or both, in order to fit in with the overall concept.

The second reason why the marine orchid is a hybrid is that it was conceived and worked on by the two authors, taking it in turns to add their own interpretation of the subject matter. And they are still friends...

Above: *Marine Orchid* is a hybrid in two ways. It is a composition of shells in the shape of an orchid and it was conceived and worked on by both authors.

Right: Although titled *Nine Banksia Inventions*, these images could be seen as seeds, cells or beetles.

Further information

Recommended materials

Paper
Arches Aquarelle HP
Fabriano HP
Sennelier HP
Bristol board

Pencils 4H–6B
Mars Lumograph
Staedtler
Caran d'Ache
Faber Castell

Kolinsky sable brushes
Winsor & Newton series 7
Da Vinci Maestro series 10 or 35
Raphaël series 8404
Escoda series 1212

Watercolour paints
Schmincke Horadam
Winsor & Newton
Old Holland Classic
Holbein
Sennelier

Coloured pencils
Caran d'Ache Pablo
Derwent Artists
Derwent Studio
Derwent Signature
Prismacolor Verithin (USA)

Useful contacts

Biomimicry Institute
www.biomimicryinstitute.org

Dick Blick Studio
Tel. (USA) 1.800.828.4548
www.DickBlick.com

UK Coloured Pencil Society
www.ukcps.co.uk

Colored Pencil Society of America
www.cpsa.org

Jackson's Art Supplies
1 Farleigh Place,
London N16 7SX
Tel: +44 (0)207 254 0077
www.jacksonsart.co.uk
sales@jacksonsart.co.uk

Ken Bromley Art Supplies
Curzon House, Curzon Road
Bolton BL1 4RW
Tel: 01204 381900
www.artsupplies.co.uk
sales@artsupplies.co.uk

**Plymouth City Museum
& Art Gallery**
Natural History Collections
Drake Circus
Plymouth PL4 8AJ
Tel: 01752 304774
www.plymouthmuseum.gov.uk

Grimshaw
www.grimshaw-architects.com

Eden Project
Bodelva, St Austell
Cornwall PL24 2SG
www.edenproject.com
Tel: 01726 811911

Rosie Martin
www.rosiemartin.co.uk

Meriel Thurstan
www.merielthurstan.co.uk

Note: Details correct at time
of going to press.

Right: The zebra lionfish
was painted from the
information amassed
in a sketchbook.

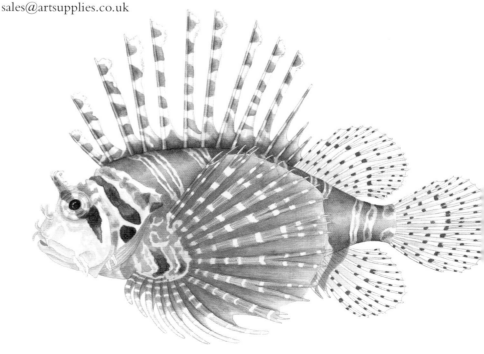

Acknowledgements

We would like to assure our readers that no living thing has been harmed in the making of this book. All specimens, whether painted by us or by our students, came from reliable sources.

For their help in creating this book, we would like to thank all our workshop students at Dartington, West Buckland and the Eden Project, whether we have included their work or not. As always, they are an inspiration and a delight.

Five of our students need particular mention for the artwork projects they carried out for us: Linda Howard-Davis, David Lewry, Pam Hargreaves, Rhett Harrison and Liz Rousell. Linda and David also deserve thanks for their notes on coloured pencils, and to Rhett our especial thanks for the hours he spent researching on our behalf and the subsequent essays he wrote explaining some of the finer points of natural history.

We received welcome assistance from staff at Plymouth City Museum and Art Gallery, and are grateful to Jolyon Brewis of Grimshaw for his permission to use the photograph of the design for the roof of the Core educational building at the Eden Project.

To Kristy Richardson, Tina Persaud and Komal Patel at Batsford – as ever, it has been a joy to work with you. Thanks also to Penry Archer, Dr Laurie Baxter, Jeanne Argent and Judith Chant (who baked the cake), Peter Cowlishaw, Stephanie Crockett and Elizabeth French; to Juliana Depledge for her notes on her method of working as artist-in-residence at the National Marine Aquarium, to John Dorning for allowing us to use his art college notebooks, to Joe Yunnie for his photographic reference material, to Mike Jonas, Duncan Lawie, Jim and Hilary Olney, Dr David Wilson, and Anna Yunnie; and last but by no means least, to Bruce Pearson and Peter Randall-Page for their inspiring artwork and generosity in giving us information on their work.

Picture credits

Penry Archer 53, 99 (centre), Jeanne Argent 136 (photo), Deborah Barton 69 (3), 119 (upper middle and bottom), Mary Bedford 83 (part), Sue Bennet 101 (part), Salli Blackford 22 (top), 74 (top), Sandie Carlton 2, 12, 83 (part), 91, 102, Mat Chivers 134 (photo of image Walnut VII), Rosemary Claxton 100 (part), 105 (bottom), Juliana Depledge 38, 39, 105 (top), 123, 137, 140, Freda Dormand 55, 100 (part), John Dorning 27, 114, 115, Delia Elliott 80 (part), 87, 88, 100 (part), Jane Erith 101 (part), Anne Evans 80 (part), 119 (top), Diane Flux 100 (part), 101 (part), Betty Fox 72 (B), 73, Ruth Gawel 69 (6), 101 (part), Grimshaw Architects 132 (photo), Pat Gunn 69 (12), Sheila Hadley 5, 85 (bottom), Pam Hargreaves 41, 67, 93 (bottom and left), 103, Rhett Harrison 14, 19, 26, 32 (bottom), 106, 108, 126 (bottom), 127, 142, Jessie Hill 31 (top), 34, 35 (top), 79 (right), Linda Howard-Davis 69 (9), 81, 83 (part), 92 (top), Lindsay Jagger 92 (bottom), Ann Jelley 68, 80 (part), 83 (part), 99 (bottom), Sue Kemp 37, 69 (7), 98 (part), Claire Layland 97, David Lewry 75, Karen MacLellan 101 (part), Lucy Manningham-Buller 101 (part), Anna Maratt 36 (top), 40, 78, Sandra Marten 32 (top), 69 (2), 72 (A), Rosie Martin 21, 25, 28, 29, 30, 31 (bottom), 42, 43, 44, 47, 49, 52, 54, 56, 57, 59, 60, 61, 64, 65, 69 (5), 76, 79 (bottom), 80 (part), 82, 94, 95, 98 (part), 116, 117, 120, 121, 125 (top), 138, 139 (joint top), Lindsay Middleton-Scarr 98 (part), Jackie Murgatroyd 48, 69 (4), 100 (part), Linda Nicholls 69 (8), 83 (part), 101 (part), Bruce Pearson 36 (bottom), 77, 84 (right), 85 (top), 90, 104, 130, Herbert Ponting 6 (photo), Peter Randall-Page 132 (left and centre), 133, 134, 139 (bottom), Mo Reid 80 (part), Shirley Richardson 69 (10), 101 (part), 109, 112 (lower), Ann Roberts 100 (part), Penelope Rodrigues 74 (bottom), Liz Rousell 13, 93 (right), 119 (lower middle), Ione Rucquoi 135, Sally Scott 35 (bottom), 84 (left), Caroline Shove 22 (bottom), 66, Joss Shove 69 (11), Ed Thurstan 8, Meriel Thurstan 4, 15, 16, 17, 23, 33, 51, 53 (top), 62, 63, 69 (1), 70, 71, 86, 89, 96, 107, 110, 111, 112 (top), 113, 118, 122, 125 (bottom), 126 (top), 128, 129, 139 (joint top), 141, Catherine Van Luttmer 100 (part), Edward A Wilson 7.

Image shown on page 9 copyright of Jean GRELET / SEMITOUR – Lascaux II, reproduction of the caves of the Lascaux (Montignac – Dordogne/Périgord), www.semitour.com.
Image shown on page 10 courtesy of Museum Meermanno Westreenianum, 10 B 25, folio 12v.

Bibliography

Attenborough, David; Owens, Susan; Clayton, Martin; Alexandratos, Rea. *Amazing Rare Things, The Art of Natural History in the Age of Discovery*. Royal Collection Publications, 2008. (ISBN 9781902163994).

Attenborough, David. *Life in Cold Blood*. Ebury Press/BBC Books, 2007. (ISBN 9780563539223).

Attenborough, David. *The Life of Mammals*. Ebury Press/BBC Books, 2002. (ISBN 9780563534235).

Attenborough, David. *Life in the Undergrowth*. Ebury Press/BBC Books, 2005. (ISBN 9780563522089).

Attenborough, David. *The Life of Birds*. Ebury Press/BBC Books, 1998. (ISBN 9780563387923).

Attenborough, David. *Life on Earth*. Little, Brown, 1988. (ISBN 9780316057455).

Cumming, Robert & Porter, Tom. *The Colour Eye*. BBC Books, 1991. (ISBN 0563215283).

Darwin, Charles. *On the Origin of Species (1859)*. Wordsworth Editions Ltd, 1998. (ISBN 853267805).

Darwin, Charles; Quammen, David (editor). *On the Origin of Species: The Illustrated Edition*. Sterling Publishing Co. Inc., 2008. (ISBN 9781402756399).

Dawkins, Richard. *The Ancestor's Tale*. Phoenix, 2005. (ISBN 0753819961).

Doczi, Gyorgy. *The Power of Limits, Proportional Harmonies in Nature, Art and Architecture*. Random House Inc., 2005. (ISBN 1590302591)

Drummond, Maldwin; Rodhouse, Paul; illus. Rignall, John. *The Yachtsman's Naturalist*. Angus & Robertson (UK) Ltd., 1980. (ISBN 0207958084)

Elworthy, Dr. Jo; Petty, Mike (consultant editor). *Journey to the Core*. Eden Project Mail Order.

Gombrich, Ernst. *The Story of Art*. Phaidon, 1995. (ISBN 0714815225).

Images from Nature. The Natural History Museum, London, 1988. (ISBN 0565090291).

Itten, Johannes. *The Art of Color* (translated by Ernst van Haagen 2004). John Wiley & Sons Inc, 1961. (ISBN 0471289280).

Le Fanu Hughes, Penelope. *History & Techniques of the Old Masters*. Tiger International Books. (ISBN 855010135).

Poortvliet, R. *The Living Forest*. New England Library, 1979. (ISBN 450048071).

Royal Academy of Arts. *Post Impressionism*. Weidenfeld & Nicolson, 1979. (ISBN 0297777130).

White, Christopher. *Dürer the Artist and his Drawings*. Phaidon, 1971. (ISBN 0714814369).

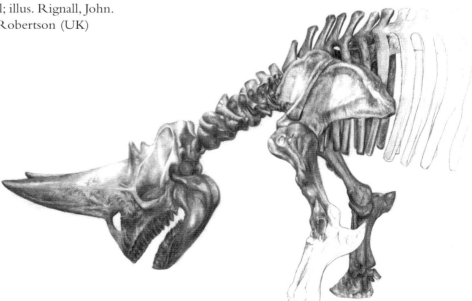

Right: THE END – and the beginning. Drawing and painting are like walking and running. Try to master the former before attempting the latter!

Index